AGAINST THE GRAIN

AGAINST THE GRAIN

Bombthrowing in the Fine American Tradition of Political Cartooning

BILL SANDERS

FOREWORD BY JULES FEIFFER

NEWSOUTH BOOKS

Montgomery

NewSouth Books
105 S. Court Street
Montgomery, AL 36104

Library of Congress Cataloging-in-Publication
data is available on request

ISBN-13: 978-1-58838-294-8

Edited and designed by Randall Williams

Printed in the United States of America by Sheridan

To Joyce Mary Wallace Sanders

This book would not have been written, this life would not have been lived, were it not for the extraordinary good fortune of having met my future soulmate in the cafeteria at Western Kentucky University. Joyce was an immediate beacon of stability illuminating a path I could have never imagined possible. In addition, she blessed me with four wonderful daughters—Cathy, Vicky, Cheryl, and Denese—whose love and insight brooked no deviation from the destiny of our journey. I am eternally grateful.

Contents

'Citizen Bill'

JULES FEIFFER

My God, I thought, as I read Bill Sanders's story, and reminisced over his fifty-six-year career as an editorial cartoonist, how could I have forgotten this kind of man existed, still exists, if you can woo yourself away from the current rage and hubbub?

There used to be a name for such a fellow. I'm old, and I remember these things, although, at times, I make up what I think I remember. But I'm sure I'm not making this up. You look at the life and the collected works of Bill Sanders, and out of our long-lost past one thinks of a type we don't hear much of anymore. Strange to our ears in our time, but once we had a name for such men and women . . . Wait, it's coming back to me—

"Citizen"!

A now obscure honorific, this title was a reference to—what did we call it then?—"The common man." Or "A man of the people." That is to say, "Citizen" referred to a person whose point of view extended beyond the confines of his geographic background, his fraternity, club or clique. Whatever exclusionary tribe was making the most noise among its factional rivals, the "Citizen" had another interest that went beyond tribal loyalties. It was known in those days of innocence as "the Public Interest."

You look at Bill Sanders's small-town Southern youth, and you see a boy growing up amid values, good and bad, not very different from Mark Twain's Tom and Huck. Developing an old-fashioned individualism, a trouble-making curiosity, a free-wheeling openness that we once took pride in as purely "American." A generosity of spirit that was recognized and envied (at times, condescendingly) all over the world and was romanticized in Gary Cooper's "Mr. Deeds," Jimmy Stewart's "Mr. Smith." Breaking the art-

ist away from the traditions that limited him, to seek alternative American traditions that freed him.

Bill, improbably, chose for himself the job of explaining to us who we were at a time when most of us didn't care and surely didn't want to know. And the form he used was the editorial cartoon, which for generations of Americans—dating back to Thomas Nast over a century ago, to Herblock and Bill Mauldin in Bill's time and mine—laid waste, in single-panel, deft ink-drenched bombshells, to our institutional lies and more brazen hypocrisies. Being in the business, five days a week, of yelling, as the parade of puffery passed by, that the emperor had no clothes.

Bill responded to our Cold War domestic paranoia with cartoony baths of bracing sanity. One wonders what he will make of this Trumpian era when we have unofficially but effectively replaced the United States of America with the Fractured States of America. Tribalism has taken the prize and split us asunder.

Citizen? The very concept of "Citizen" has been shooed offstage.

My old friend, Bill, the spirit that inspired you and made you so, so "American" has now, in data-driven 2017, been digitalized and dismembered. And we have become a carnival instead of a country.

But, hell, that's only for four years. We'll be back, right?

Bill?

Jules Feiffer has a Pulitzer Prize for editorial cartoons, an Academy Award for animation, a Reuben for graphic novels, and an Obie for his play, Little Murders.

Preface

We were sitting around the table top at Major Goolsby's, a pub tucked under one corner of the *Milwaukee Journal* building, talking about a new movie based on *Up the Down Staircase*, the best-selling book by Bel Kaufman. The main character is an English teacher at a New York inner-city high school who is frustrated by the petty bureaucracy that fosters indifference in her students and incompetence in some of her peers. The title springs from an incident when one of her students is punished for going up the "down" staircase as a shortcut to class, rather than walking to the other end of the hall and using the "up" staircase.

During a beer-stained debate over the movie, one of my colleagues was waxing eloquent on the virtues of conformity when he looked at me and said, "You wouldn't know about that, 'up the down staircase' is the story of your life!"

Reflectively, it was one of those moments of truth. Introspection has never been my long suit, and often what seemed logical to me was at odds with the rest of my immediate world. I guess I came by it honestly. For my parents, to be in Springfield, Tennessee, in the 1930s was much like inhabiting Grover's Corners in Thornton Wilder's *Our Town*. The flow and patterns of life were predictable and comfortable. It was not surprising, then, that the good towns-people thought it scandalous when my mother rode her Indian motorcycle around the town square with her toddler—me—strapped to her back.

As for myself, I never thought about my "place" and apparently had a fuzzy view of the demarcation line for what some thought was inappropriate behavior. When I disguised myself as a homely, mute kid and successfully enrolled as a new student in my own class, the powers that be didn't think it was funny. I figured the principal just didn't have a sense of humor. Also, I didn't understand the moral indignation over the after-school "Love Club" meetings at my house to play spin-the-bottle.

As I grew up, I came to understand that my family was dysfunctional. We

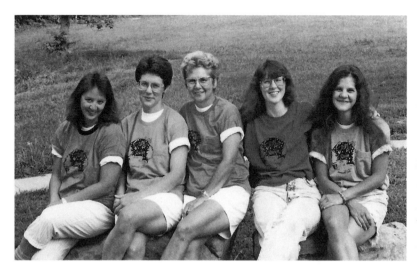

The women and support team I could not have done without: Vicky, Cathy, Joyce, Cheryl, and Denese.

moved from Springfield to Dothan, Alabama, and on to Pompano Beach, Florida, in search of normalcy and livelihood. Having to constantly relate to new and different peers was a learning curve for my youth, but what I lost in "Our Town" stability, I gained in the ability to cope with new and often different relationships.

Satchel Paige, the legendary black baseball pitcher, had it right when he called the game a metaphor of life, saying, "You win a few, you lose a few. Some get rained out. But you got to dress for all of them." Getting dressed for "all of them" is how one arrives at one's destiny in life. The daily ritual of showing up will sometimes tweak the path that is taking you to the future.

In my case, four elements have defined my life—athletics, art, music, and fate.

Athletics kept me in high school and gave me an opportunity for a full university scholarship. As a result of that scholarship, I met the woman who would be my soul mate and give me four of the most wonderful daughters one could hope for.

Art gave me a path to earning a living. I use the word "art" loosely, because it is not a term generally associated with cartooning. More importantly, it gave me a voice in what was going on in the world and access to decision-makers who affect our lives.

Music is more difficult to articulate. It is a grotto that beckons my soul and nourishes a secular-spiritual sense that keeps me from languishing in daily practicality.

Fate continually stepped in with extraordinary timing to effect a change or confirm a direction in my life—for which I am eternally grateful. I should explain that I do not mean fate in a religious-spiritual sense, because that implies that man has no control over his direction in life. I certainly do not

subscribe to that notion. To me fate is an unplanned intersection of events and circumstances that may have a variety of effects on one's life—for better or for worse.

One of those intersections called me to political cartooning. Another provided my first employment as a political cartoonist. And the latest has resulted in the writing of this book.

Herblock, the great *Washington Post* cartoonist, was once asked what he expected from the tough opinions he expressed in his cartoons. He allowed as how he hoped to deposit an occasional "pearl of wisdom" with his readers, then added, "and where would the pearl industry be without an irritant?"

Did I get into political cartooning to change the world? Yes!

Has the world listened and changed? No!

What then was the point? Maybe the point was best articulated in a single line of a one-paragraph letter written to the *Milwaukee Journal* when I retired.

Laura Chmieslewski, of Kewaskum, Wisconsin, wrote: "I will miss Bill Sanders very much! Whether I agreed with a particular cartoon or not, he usually prodded me, none too gently, into making a decision as to where I stood."

I don't know how other political cartoonists go about their work. I can only speak for myself. As a general rule the cartoon should be a vehicle for opinion and it should be polemical in nature—otherwise, it is a waste of time. Certainly, humor and creative presentation are desired qualities, but above all a reader should have no question about where the cartoonist stands on any given issue.

While the cartoon is a simple communication, it should have as its roots a deeper knowledge of the subject at hand rather than a shoot-from-the-hip, light-bulb-over-the-head genesis. My daily routine at the newspaper was about three hours of reading and research, and about three hours of drawing.

While there may be—to varying degrees—two sides to *some* issues, don't bother looking for that posture on the following pages.

AGAINST THE GRAIN

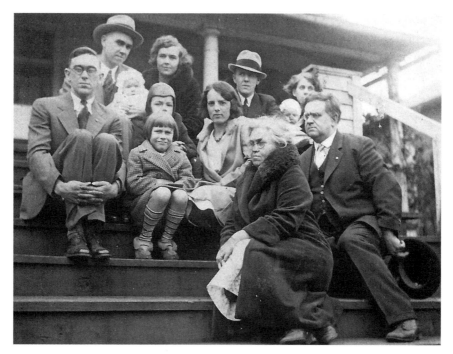

The Tomerlin side of my family, posing on the steps of the East Fifth Avenue "Pulltight" house in Springfield, about 1931. At the right front are my grandparents, William J. and Lucy Tomerlin. At the left on the top row, my parents, Romie and Catherine Sanders, are holding me.

1

Springfield, Tennessee

"All right, class, I want you to take this sheet of paper and draw something you see in this room that looks interesting to you," said Mrs. Owens, as she passed out crisp pieces of drawing paper.

I stared at the vast white sheet lying on my desk. In my fifth-grade mind, she might as well have said to write Einstein's theory of relativity. Draw? Didn't she know I was going to be a football player? Football players don't draw!

As my Main Street Elementary School classmates busily started applying pencil to paper, I looked at Mrs. Owens, who appeared to be concentrating on a sheaf of papers. No doubt she was conjuring up some other fiendish scheme to ruin my day.

Finally, I picked up my pencil and looked around the room. A vase of flowers? No way! Half the girls were drawing those. The goldfish? I didn't think so! Then I saw it—a framed picture of red fox jumping over a log. That was more like it! With tongue planted firmly between my lips, I applied pencil to paper.

To my amazement, something resembling a fox took shape under my hand. Wow! This drawing thing might not be such a waste after all. Furiously, I whipped in the log—and scribbled in the bushes and trees.

Finally, I held my finished assignment at arms' length and thought to myself, "That looks like a fox jumping over a log!"

When I went up to Mrs. Owens to turn it in, she looked at it, then looked at me, and said, "Why, Willard, that looks like a fox jumping over a log."

I WAS NAMED AFTER my two grandfathers, William Tomerlin and Willard Sanders. Why my family chose to call me by my middle name, I'll never know, but I was thankful that they did not call me by my first name, William, because that would have led to the nickname "Willie"—which would have led to misery.

For four days the fox drawing hung directly behind Mrs. Owens, in the center of other assorted pencil scratches said to be flowers and goldfish.

I was three years old when my grandfather gave me a football. It's ironic that my mother had me in a "dress" at the time.

Where else would my drawing be hung? Wasn't its placement a testament to her judgment that it was her favorite?

Finally, Mrs. Owens returned the drawings and I took mine home to show Granny Tomerlin. She looked at it and said, "Why, Willard, that looks like a fox jumping over a log."

When Aunt Lucille came by the next day, I showed it to her. She said, "That's a fox jumping over a log."

Well, that pretty much established my standing in the annals of Springfield art, so I stuffed it away and went back to polishing my skills throwing and kicking a football.

"DYSFUNCTIONAL" WAS NOT PART of my vocabulary as a ten-year-old growing up in Springfield. But it was part of my family life even if I didn't know the term, and it resulted in my spending a great deal of time with Granny Tomerlin.

She lived on a street we called "Pulltight." Technically known as East Fifth Avenue, Pulltight sloped sharply downhill from the town square, into a narrow valley occupied by "Granny" Lillian's General Store and an old red granary barn—both situated beside Black Branch, a shallow creek whose bottom was covered with black, yucky something-or-other.

Pulltight then sloped sharply upward to the hill opposite the town square. The Tomerlins lived on that "up" side, two houses past the store. We called it "Pulltight" because trying to ride a bicycle up the hill required all the pull-push pedal action you could muster.

After my grandfather died, Granny, who didn't drive, would occasionally haul me out to walk up Pulltight to the department store on the Square.

One day we ran into Leroy, one of my classmates, who lived down the valley in an area of town that today would be charitably called low-income housing. I was not feeling particularly friendly toward Leroy since he had beaten me twice

<div style="font-style: italic; text-align: right;">

Grandfather Tomerlin, wearing hat and holding a granddaughter, was fire chief when Springfield obtained its first fire engine. Its solid rubber tires and primitive springs made for very rough riding. The engine is now in a museum in California. Uncle Clark Tomerlin was at the wheel in this photo.

</div>

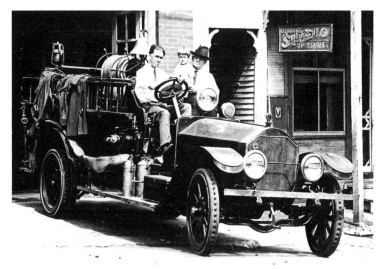

at "set back," a football-kicking game that we played on the school playground.

Leroy asked if I wanted to go catch frogs around Black Branch. I said no, and he asked "Why?" Then, words spilled over my lips as if I had no control of them: "I don't go with white trash!"

Granny Tomerlin jerked me by the arm and briskly walked back to the house whacking me on the rear end with every step. "Don't you ever let me hear you calling people names like that! You aren't so high and mighty you can look down on anybody!"

There were two ironies here. First, social or economic status had not formed in my young mind as a measure of one's worth. I didn't really know what "white trash" meant. I had heard the mother of another of my friends saying to her son, "I don't want you running around with that white trash!" Second, neither the Sanderses nor the Tomerlins enjoyed an economic status that entitled them to an upper-crust pecking order. Granny set me straight on that with a brief but pointed lecture.

Later, I was to learn a more visceral lesson. Granny sent me to school with a corned beef sandwich and an apple. I didn't like corned beef so I swapped with Leroy for five of what I thought were peanut butter and crackers. They turned out to be crackers smeared with lard from fried meat. Not knowing exactly how to handle the situation, I ate two and tucked the others away, along with the taste of Leroy's world.

RACE WAS NEVER AN issue around my parents or around my grandparents. I never heard the "N"-word from their lips. "Aunt" Mattie Stamper, who helped with spring cleaning, was a "colored" person, as was John, who changed tires at our Western Auto Store. This is not to proclaim my parents and grandmother devoid of prejudice—I just never heard it verbalized.

I remember my father taking me to the funeral when John's wife died. Ours were the only white faces there, but because I had only been to one other funeral in my life, that of my Grandfather Tomerlin, I didn't analyze the event.

What did motivate my thoughts about "colored" people was our local movie house, and that was because of brief summer adventures with Curtis Stamper. Curtis lived in a shanty on the hill behind the old red granary with, as my young eyes perceived it, a whole bunch of other "colored "people. He was "Aunt" Mattie's nephew.

Right: Grandfather Tomerlin, center, in his early twenties as manager of the Springfield Telephone Company, with some of his employees. Below: A phone company car parked in front of the 5th Avenue house. The Springfield granary is on the left in the background, and in the right background is "Granny" Lillian Duncan's home and general store.

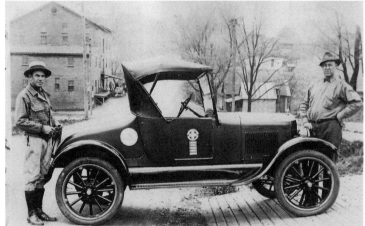

As I took the shortcut behind the granary to town one day, he was standing by the dirt road straddling a long stick. The air always smelled like rotten eggs when I went by that house, so I asked him, "What's that smell?"

"Hit's our well," Curtis replied.

"What kind of well stinks like that?" (Tact was not my long suit, either.)

Curtis took the stick from between his legs and said, "Hit's sulphur water."

"I never heard of that," I said, walking over to a big round pipe sticking out of the ground, more a cistern than a well.

Curtis picked up a beat-up tin dipper that was hanging on a post, saying, "You want a drink?"

"No, sir-ree!" I smirked.

Curtis laughed and said, "Momma says it is good for what ails you."

Curiosity got the better of me when Curtis lowered the dipper and brought it up overflowing with water. I poured a little on my hand. It looked clear enough, but it smelled awful. Finally, I took a quick sip from the dipper. Though some slipped down my throat, the smell was powerful so I spit out the rest. It never occurred to me that I had just violated Southern social norms by putting my white lips to a dipper that had been used by "colored" people.

Then Curtis said, "I know where there's some real good water." He pointed to the hills opposite town square, where small frame houses gave way to giant oaks and willowy elm trees. "I'll show you."

As we set out to cross Black Branch, I asked Curtis what he was doing with that stick he was dragging by his side. He grinned and allowed as how, sometimes, it was his horse—kind of like the one Hopalong Cassidy rode. I knew exactly what he meant, since I had a sawed-off broom handle hitched to the latch on our coal bin.

Curtis took me that day to Watermelon Springs, nestled in the woods on the side of a hill. Crisp clear water bubbled out of the rocks onto a giant flat slab, then fell over the edge, forming two small streams that flowed down the hill.

Slightly off-center in the slab was a small pool, perfectly shaped like a watermelon that had been cut neatly in half, lengthwise. I learned later that the pool was indeed occasionally used to chill a melon.

For the next few weeks, Curtis and I had occasional "cowboy" adventures chasing bad guys and Indians with our stick horses in and around Black Branch and Watermelon Springs. When we talked about Hopalong Cassidy, I learned that Curtis had seen only one movie, *Hopalong Cassidy Rides Again*. "Momma don't let me go much," he explained. However, his uncle had given him a Hopalong Cassidy comic book for Christmas.

That set me thinking about "colored folks" and Mr. Hancock's Capitol Theater. I had only been to the movie once in the evening, to see *Charlie Chan at the Circus*. As I entered, there was a line of "colored folks" buying tickets and, for the first time, I noticed that they went upstairs through an outside door located just behind the ticket booth. It was just an observation; I did not decipher it beyond that, other than the brief thought of Curtis watching Hopalong Cassidy from the balcony.

That summer, my parents took me on a trip to Florida. When I returned,

Grandfather Tomerlin signing (by lamplight) the contract that brought Tennessee Valley Authority electricity to Robertson County after a lengthy political battle with a private two-state utility company.

Curtis and his momma had moved to Shelbyville, Tennessee, and I never saw him again. I soon put my broomstick out to pasture and went back to my old leather football.

BY THE TIME I entered the sixth grade we had moved into a modest brick house directly across the street from the end zone of the Springfield High School football field. On Friday nights our front yard basked in the peripheral illumination of the football lights—and in the afterglow of a game, I would take advantage of the final minutes of lighting to elude imaginary tacklers and throw lofted spirals to imaginary receivers in our yard.

Saturdays were the best. After a brisk morning of playing "tackle" with friends at Tony's lot, I would hurry home and get cleaned up for the Saturday matinee, again at the Capitol Theater.

For ten cents I could marvel at the adventures of Gene Autry, Hopalong Cassidy, and Bob Steele, then shudder at the fate that might befall Flash Gordon. Flash always faced death or disaster as each chapter of the serial ended, leaving us not knowing if he would be dead or alive the following Saturday. However, the icing on the cake for me was the *Movietone News*, which on the really good Saturdays was bound to include clips of "Slingin' Sammy" Baugh of the Washington Redskins.

It was magical watching Baugh drop back with the ball cocked at his ear and fire it downfield. This was the imagery that became embedded in my mind along with a vow that someday I would be doing that. To that end, I roped an old tire to a tree limb and spent endless hours swinging it like a pendulum, then dropping back—ball cocked to my ear—and attempting to rifle the ball through the center of the swinging tire. After what seemed a hundred thou-

sand failures, I eventually learned the knack of "leading" the tire in a way that resulted in moderate success.

IN 1942, THERE WAS no such thing as middle school. Seventh and eighth grades were located in one wing of the new Springfield High School, which was right beside the football field and the gymnasium. In the seventh grade, you could "come out" for basketball and football.

In football, we seventh and eighth graders served mostly as blocking dummies for the upperclassmen, and in basketball we mostly hung around the fringes of the floor and were occasionally called to scrimmage against second- or third-team players. We practiced every day and whooped it up every game night as spectators in the stands. For me, basketball was just something to do between football seasons. I could never master the one-handed jump shot but was reasonably adequate at the two-handed set shot from outside the keyhole.

One cold February night, classmate Howard Cook and I were sitting in the stands with our friends rooting for the Yellow Jackets as they were trouncing the Coopertown Eagles. Shortly after the second half began, Coach Boyce Smith rose from the bench, turned and looked up into the stands. Spotting Howard and me, he motioned for us to come down to the floor.

Us? What did we do now? Hesitantly, we wove our way down through the crowd to Coach Smith, expecting the worst. Smith had black bushy eyebrows hanging over dark piercing eyes, which didn't exactly give him the look of a happy camper. As we stood like deer caught in the headlights, he uttered five words that anointed us with the Walter Mitty experience of a lifetime: "Go down and get dressed!"

We scurried down into the locker room and were issued the most magnificent raiment known to man—a Springfield Yellow Jackets varsity basketball uniform.

We played the last five minutes of the game. I can't speak for Howard, but it was like a blur to me. *Am I really doing this? Lord, don't let me screw up! What's this in my hands—oh, a basketball!!!* The only thing I remember is taking the ball down court, charging towards the basket, and passing off to Howard, who coolly tossed it in for two points.

While that was a wonderful experience, everyone knew that football was the game! Springfield was known for its dark-fired tobacco and its winning

football teams that regularly beat the big-city schools like Father Ryan and Montgomery Bell Academy over in Nashville.

Coach Smith allowed no prima donnas—if you didn't master blocking and tackling, you didn't play for the Yellow Jackets. His fiercely fundamental approach revered the old single-wing offense even in an age when the T formation was gaining wide popularity. Smith was already a legend to us and he deserved it; by the close of his career he was ranked among the nation's greatest prep football coaches of all time.

By the end of my eighth-grade year, I began to suspect that I would never be the Yellow Jacket star I had imagined myself in my backyard passing practices. I was not a speedy runner and my future appeared to be as a blocking back in Coach Smith's single-wing offense. However, I could pass the football and could mimic all the moves of a T-formation quarterback, so Coach Smith used me to run pass plays in practice to let the defensive unit get a feel for combating a T formation. The practices also gave me a tantalizing taste of what I wanted for my future.

OTHERWISE, LIFE WENT ON and other diversions arose. One came to me in our unfinished upstairs room. Every home has a junk drawer. Ours was at the bottom of an old chest of drawers stuck in the attic. From time to time I would make a pilgrimage up there to see what treasures I might behold. On this occasion, it was my dad's first upper dentures. He had always had problems with his teeth, and when his second dentures suited him better he tossed the old ones in the junk drawer. What adventure could this old horseshoe-shaped device provide? I hurried downstairs to the bathroom and stood in front of the mirror.

Placing the denture in my mouth over my upper teeth, I was astonished at the change in my face. I looked at the protruding upper lip, pulled tight over the buckteeth protrusion of the dentures. The other effect was to give me balloon-like humps just under my cheekbones. I could be Frankenstein if I had black hair. *Yes, black hair. That's it!! A piece of cake!* I went to the desk in the living room and rummaged for a sheet of black carbon paper (young readers, ask someone born before 1970 to explain carbon paper to you). Returning to the bathroom, I rubbed the carbon paper vigorously over my blond hair. Voila, black and shiny hair.

I studied my reflection. I didn't recognize myself—and if I didn't recognize myself, nobody else would. *Now, what could I do with this? Surely such creativity should not go to waste.*

I hid the denture, washed my hair and headed downtown to the Saturday movie, all the while feeling this tiny light bulb struggling to life over my head. It suddenly glowed full force when I ran into Bobby Boyles outside the theater. Bobby was a transfer student from Nashville and had shown us the ID card that his old school had issued for his transfer. I talked him out of it and hurried home after the movie.

Using ink eradicator and the typewriter, I updated Bobby's ID (no photo on it), changed the name to Homer Smith (there was a limit to my creativity), and typed on the back, "vocal impediment, limited speech."

Mrs. Padfield was our second-period English teacher. She was a tall, stately woman, with graying hair and a warm smiling face. I chose her to play out my adventure.

After stopping in the boys' bathroom to apply my new character, I entered Mrs. Padfield's room and presented my transfer card and a typed note from my "mother" that pointed out that I was shy about speaking because of my vocal handicap. True to her nature, Mrs. Padfield smiled and ushered me to a seat in front of my friend Harold Fuqua, who apparently didn't have a clue that "Homer" was me.

After taking the roll and adding Homer Smith to the list, Mrs. Padfield instructed Harold to take me to the office to make sure that Homer was properly registered. In the hallway, Harold distanced himself from me as if I had the plague, until I finally extracted the denture and revealed the gag. "Homer" successfully completed the English class before disappearing for the rest of the day.

It never occurred to me that Willard Sanders would be counted absent or that the principal would take a really dim view of the incident. My penance was to confess to Mrs. Padfield, to apologize to the class, and to clean the chalkboard for a week. Moreover, my moment of truth was that pretending to be handicapped was not as cool as I thought. When I confessed to Mrs. Padfield, her cheeks reddened and I would have sworn I saw the faintest traces of a tear in her eye.

I didn't feel like such a fun guy at that moment.

2

Odyssey

Whoever said a great journey begins with a single step had never been in shoes like mine! My odyssey away from familiar Springfield, Tennessee, seemingly began when my mother beaned my father over the head with a high-heeled shoe, sending him staggering out of their bedroom in the middle of the night with blood running down his face.

In the middle of another night some weeks later, my mother pulled me out of my bed and told me to get dressed, that we had to go look for my "no-good" father. With me huddled on the passenger side of our old Pontiac, she drove directly to the Colonial Hotel, located on one corner of the town square. Pulling me along, she stormed into the lobby, up to the sleepy desk clerk, and demanded to know the room number for Romie Sanders.

The befuddled clerk, taken aback by the aggressive tone of this confrontation, fumbled through the registration book as if he didn't know my father from having worked briefly at our Western Auto Store. After a testy but fruitless exchange, my mother stormed out of the hotel and deposited me at Granny Tomerlin's while she continued her search.

The details I didn't know about "the birds and the bees" would have filled a thick book, but I was attentive enough to street talk to get the general idea about "whoring around." My mother was obsessed with the idea that my father was sneaking solace with Christine, a young waitress at the Corner Grill.

After Pearl Harbor, when the country was mobilizing to fight World War II, my mother felt that the call to do her patriotic duty included camping on the doorstep of the Robertson County Draft Board, demanding that they draft her philandering husband and send him as far away from that "harlot" as was within their power.

The truth of all this was obscure, even if the underlying reality of my parents' dysfunctional relationship was not. So our odyssey began.

After selling our interest in the Springfield Western Auto Store, we moved

to Dothan, Alabama, where my father was a traveling representative of the company for a year. Then we moved to Pompano Beach, Florida, where he opened another Western Auto and where I was again the new kid in town.

No longer did I have friends that I had known since childhood. No longer did the town fathers know me—and no longer was I destined to be a Springfield Yellow Jacket. Now, I was living in the land of palm trees and sandspurs, destined to play football for a team called the Beanpickers.

Pompano was not the vision of a beach town that one might imagine. One, the town part was not on the beach, and two, the town had no square. Rather, it had an "L" shape. The "downtown" was about four miles west of U.S. Highway A1A which ran along the beach, and the main road heading west was Atlantic Boulevard, which made a right turn at the old Dixie railroad tracks where most of the stores were located.

Where Springfield had been known for dark-fired tobacco, Pompano was

Below, with my parents, Catherine and Romie Sanders, in front of a "Kester" cottage on Pompano Beach in 1948.

known for green beans. By 1947, Pompano was billed as the largest winter vegetable market in the United States. While that claim may have been debatable, it was a fact that the market provided pocket money for high school kids willing to spend several hours a night tossing hampers of beans onto trucks for shipping north.

The town's name was said to have come from a map notation made by surveyor Frank Sheen, who was allegedly fed pompano (the fish) by natives at the Hillsboro

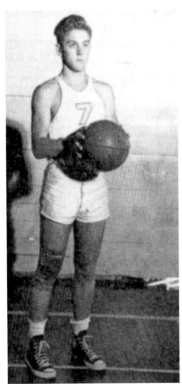

inlet around the start of the twentieth century. However, when it came to naming the high school athletic teams, the farmers held sway, and thus were born the Pompano Beach Beanpickers.

In my day Pompano High was a small school with about three hundred students in grades K–12; there were twenty-eight in my graduating class. The gymnasium looked like it had been converted from a barn, but in 1948, my junior year, Pompano was competitive with the larger schools in basketball and we made it to the state tournament in Daytona Beach.

As part of the state tournament showcase, the boosters constructed large hoops with paper stretched over them. Each of the competing high schools had its emblem painted on the paper of one of the hoops. As your team was announced, you would take to the floor by breaking through the center of the paper hoop and dashing out before the crowd.

Now this was awesome if you were the Delray Seahawks or the Marianna Bulldogs—but we were the Beanpickers! Our emblem was a bean hamper with a fish lying on top and a palm tree apparently growing out of the back.

The announcer proclaimed in a deep baritone voice, ". . . and from Pompano Beach, the Pompano Beach Beanpickers!" The nine of us ballplayers broke through the paper hoop and onto the floor to the rippling laughter of some 1,200 spectators.

We lost in the finals to Daytona's Seabreeze High (which went on to win four consecutive state championships). But at the end of the tournament, I was flabbergasted to hear my name, along with that of my teammate Franklin Harry, announced as members of the Florida All-State Basketball team. But as the old saying goes, "That won't get you any credit at the A&P"—no university scouts were beating a path to my door with a scholarship in the offing.

I played guard on the Pompano Beach high school basketball team and was named to the Florida All-State team in 1948.

Willard Sanders Makes Florida All-Star Team

Willard Sanders, son of Mr. and Mrs. Rommie Sanders, has been named on the Florida All-State High School Basketball team following the recent State Tournament held at Daytona Beach, Fla.

Sanders is a member of the Pampano Beach High School cage quintet which was the runner-up at the State Tourney.

Young Sanders is a former resident of Springfield and attended the Springfield High School at one time. His parents are well known here both being native Robertson Countians.

Sanders is the grandson of Mrs. Will Tomerlin, who recently moved to Nashville.

SPRINGFIELD HERALD

POMPANO WAS ONE OF the few Florida schools that did not play football at night, for the simple reason that we did not have a lighted field. In the summer of 1949, my good friend Reid Hardin and I decided to take the bull by the horns and we petitioned the city fathers to install lights on the football field. Tactically, we decided to start the petition by seeking the signature of the biggest fish in Pompano's economic barrel. William L. Kester had moved to Pompano in 1923 and bought considerable property on the beach and in town. He constructed a row of beach cottages between Atlantic Boulevard and the Hillsboro Inlet and became a major force in the economic development of Pompano. Once we got his name on the petition, others followed suit and we had lights on our field by the beginning of the football season.

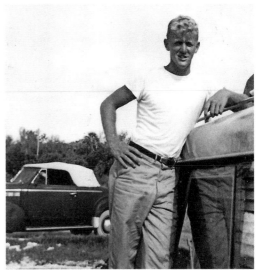

My spending money was earned cleaning and servicing small private boats around Hillsboro Inlet in the summer season.

Now that we were in the big time with night football games, another drawback became obvious. We didn't have a school band. We barely had a few rows of bleachers for spectators. Other schools had bleachers and the players dashed onto the football field to the tune of their school song.

Not to be deterred, our school set up a sound system on the back of a flatbed truck to play music from a record as we charged out onto the field.

However, the only record available at the first night football game was the theme song from an old Bob Hope movie, *The Paleface*. So, the Beanpickers charged out onto the football field as Dinah Shore sang:

> *East is east and west is west*
> *And the wrong one I have chose*
> *Let's go where I'll keep on wearin'*
> *Those frills and flowers and buttons and bows*
> *Rings and things and buttons and bows*

IN MY SENIOR YEAR, almost every student seemed to be involved in one or more school clubs. Since grades were not high on my list of goals, I figured I could be on the *Beanpicker* yearbook staff and draw some cartoons.

That summer, I had acquired a couple of sable brushes and a bottle of

My first published cartoons were for the Pompano Beach High School annual, The Beanpicker, in 1949.

India ink and, with a little practice, had become moderately proficient. Drawing for the yearbook gave me some sense of identity aside from athletics. Beside, girls seemed to find the drawing thing amusing and I made a mental note to remember that for the future. It was a good gig. However, as football season went on, my interest in drawing fell by the wayside after I finished the yearbook illustrations.

We were headed for a good year in football despite being such a small school that we were almost off the statewide radar. We were so small that no one kept statistics on us. However, we did have a good team and our successful season included upsets of a couple of larger schools. I threw twelve touchdown passes during the season and a Fort Lauderdale sports writer opined that, "In Bill Sanders, a veteran back, the Beanpickers boast one of the finest small-school prospects along the lower East Coast." Once again, however, no one was knocking at my door to offer either A&P credit or a scholarship.

BY THE TIME I graduated, my dad's business had gone down the tubes. We moved to a one-bedroom apartment in South Miami, where he looked for a job. I slept on a cot in a long narrow closet without folding doors and a sheet pinned over the doorway for privacy. It was not the best of times.

My dad finally found employment as an appliance salesman for Jefferson Stores. Meanwhile, Billy McClellan, an older friend from Pompano, persuaded me to try out as a walk-on at the University of Miami. Billy had played basketball there and had connections with the athletic staff. One afternoon in August he took me over to the University and talked Dave Wike, the football team trainer, into issuing me a practice uniform.

About the fourth day of practice, the freshmen were running passing drills

and I was having a good day. I loved the Spalding J5V football. It was the easiest-passing ball I had ever had in my hands.

After a few minutes of throwing, I saw in my peripheral vision that head coach Andy Gustafson was standing nearby watching. He motioned me to him and asked where I had played. Pompano Beach, I replied. There was an awkward moment of silence between us and I felt compelled to say something, so I explained, "It's a small school." Gustafson grinned and in a quiet voice said, "I like the way you throw the ball." Then he turned and walked away.

As I walked off the practice field at the end of the day, line coach Walt Kichefski came walking beside me and said, "We're going to put you on scholarship. Dave will take you over and get you checked into the dorm." Kichefski then peeled away without saying another word—and I was officially a member of the University of Miami Hurricanes football team.

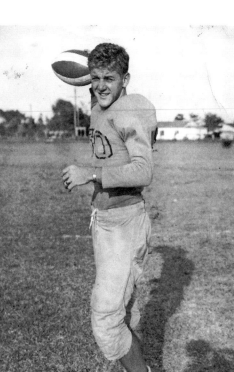

In 1948–49, I played quarterback for Pompano Beach High School.

ANOTHER OLD SPORTS CLICHÉ is that "close only counts in horseshoes." That turned out to be my case at the University of Miami. Back then freshmen were ineligible to play on the varsity, but we had a five-game schedule playing other freshmen teams.

As it turned out, the Hurricanes' offense operated from the T formation but its bread-and-butter strategy was running the option play, in which the quarterback could run or toss a lateral to a running back. The Hurricanes had a heavily recruited freshman quarterback from Pennsylvania whose talent was running the option play but whose passing ability was limited. His play-calling and reading of defenses were nothing to write home about, either.

As a result, I was never a starter in our five games, but I logged considerable playing time because the passing offense was often sorely needed. Nonetheless, after the freshman season and much soul-searching, I decided there had to be a better niche for me somewhere else.

3

WKU: Football, Art, Music & Brotherhood

Thomas Wolfe wrote that you can't go home again, but the fact is that you can find a new home if you are diligent and lucky.

After the University of Miami season, I went back to visit relatives and friends in Tennessee, including my old high school coach, Boyce Smith. He suggested I take a look at Western Kentucky State College (now Western Kentucky University), just thirty miles up the road from Springfield. Coach Smith felt that the Hilltopper offense would be well-suited for me.

Perched atop a hill in Bowling Green, the Western Kentucky campus was laid out in concentric circles downward from its crest. Its compactly spaced buildings were planted between large towering oaks and elms. WKSC embodied the physical elements of what I envisioned as a college environment, and there were positive vibes at first glance.

As I drove up over the crest of the campus, the football stadium was carved out of the south face of the hill, topped by a row of Greek-style columns. Beyond the east end zone was the gray stone basketball gymnasium and athletic complex. I parked and entered the gym, looking for the football office.

As I stood in the hallway surveying a series of doors, I heard a resonant voice say, "What can we do for you, Whitey?" I looked around to see a large, square-jawed, wavy-haired man leaning out of a doorway.

It took a second to realize he was talking to me and that "Whitey" was just a friendly generic term because my hair was sun-bleached and very blond. "I'm looking for the football coach's office," I replied.

"Well, you found it," he said, stepping back and ushering me into a modest and cluttered office. "This is Coach Clayton," he added, gesturing to a middle-aged man in a red baseball cap, hunched behind the desk at the far end of the room. Then the wavy-haired man—I would learn later he was Frank Griffin,

Western's line coach—turned and left the room, saying over his shoulder, "I'll get things started this afternoon, Jack."

"What can I do for you, son?" Coach Clayton inquired.

"I'd like to try out for football," I replied.

Clayton studied me for a moment, then said, "Where are you from . . ."—leaving the sentence dangling, then adding, "Whitey—is that your—what they call you?"

Now, I had not thought about this part at all! It suddenly dawned on me, not being particularly bright, that having played a season at the University of Miami, eligibility might be a problem. In a stunning moment of naiveté, I said, "Yes, sir. Whitey Sanders," thinking that would render me incognito.

I extemporaneously concocted a brief story of having looked at the Miami set-up and decided it was not for me. I explained that I came back to Tennessee seeking the advice of Coach Boyce Smith, who directed me to Western. How much Coach Clayton bought into that tale, I'll never know, but he sent me to the equipment manager in the basement locker room to check out a practice uniform.

My experience that day was much like the one I had at the University of Miami and by the end of the day I had been put on scholarship and assigned a dorm room.

POTTER HALL WAS ONE of the main buildings atop the hill right across the street from the football stadium. My roommate was Bill Ploumis, a six-foot four-inch, 230-pound end from Pittsburgh, affectionately known as The Greek.

I learned that I had taken the place of his best friend, Jimmy Sacca, who had been kicked off scholarship. Apparently Sacca had a more casual relationship with team rules than was tolerated. He loved music and the nightlife in which it flourished, and on a road trip in Atlanta, he ignored curfew to check out a nearby club that was featuring Gene Krupa's band.

After losing his scholarship, Sacca stayed in school, where he played clarinet in the school band and sang at a Bowling Green nightclub called Boots and Saddles. There he met an older sax player and part-time barber, Billy Vaughn, who was an aspiring songwriter. Vaughn had written a song, "Trying," that he had marketed, without success, as a country & western tune.

In 1952, the popularity of close, four-part vocal harmony was edging into

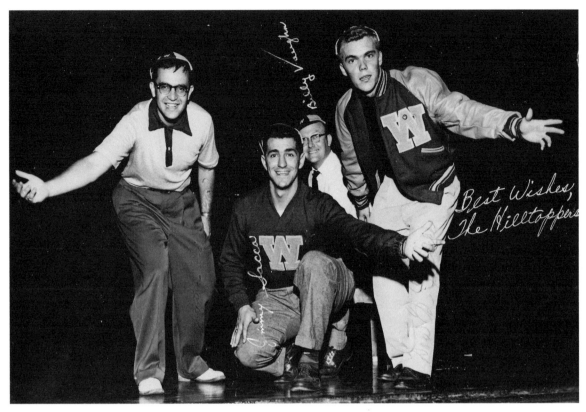

Four WKU students formed a quartet called the Hilltoppers that made the national charts with hits like "Trying," "Only You," and "P.S. I Love You", which sold a million records. Jimmy Sacca, center, was the lead vocalist—shown here with, left, Seymour Spiegelman; back, Billy Vaughn; and, right, Don McGuire.

the popular music market. This style was later to be tagged as doo-wop. Vaughn taught Sacca the song as a pop ballad. Then Vaughn and Sacca got together with two other Western students, Don McGuire, a basketball player, and Seymour Spiegelman, a music major, to form a close-harmony quartet. They made a tape of "Trying" and a local disc jockey sent it to Randy Wood, owner of Randy's Record Shop and Dot Records in Gallatin, Tennessee.

Wood surreptitiously recorded the quartet's song one night in Van Meter Auditorium on the hill at Western. His release of "Trying" launched the national career of the Hilltoppers vocal group and a hit record that eventually moved up to seventh on the Billboard music chart.

Meanwhile, I set out to enhance The Greek's understanding of the principles of Southern-style dormitory housekeeping—mainly never disturb discarded clothing, shoes, socks, etc., unless necessary when

searching for something of importance. The Greek was a quick learner and soon divided the room in half—his side being the crisp, orderly side and mine the genteel tradition of slovenliness.

On the football field, Ploumis was equally as precise in blocking, tackling, and pass-catching but infinitely less tolerant of errant passes than he was of a sloppy room. After Western Kentucky, he was called up by the Los Angeles Rams and made the cut of their summer camp, but he was also accepted into dental school and chose that career. He became a highly successful and respected orthodontist in Larchmont, New York.

ACADEMICALLY, I HAD NO idea what I wanted. I thought about being a physical education major but the thought of taking Comparative Anatomy squelched that idea. I settled on English because I liked literature.

After looking for a three-credit-hour course that would not require homework, I signed up for a freshman art class under professor Ivan Wilson. That decision would have a lasting effect on my life.

Wilson was a thin, diminutive, bespectacled man in his sixties, approximately five feet seven inches tall, who possessed the kindest heart that nature could bestow on a man. He joined the Western art faculty in 1920 and remained until his retirement in 1958.

Somewhat shy and soft-spoken, he glided under the radar of the more aggressive world of art, yet his mastery of watercolors was unrivaled. His loyalty was to the purity of colors. He strove never to paint one color over another. For example, he would never do a light blue wash for the sky and then paint the trees and foliage over it. As a result, the rural scenes that were his specialty leapt from his paper in crisp, bright colors that pleasured viewers no matter their level of art appreciation.

I passed his course, but my most valuable accomplishment was getting to know this little giant of a man and siphoning from that experience fuel that would ignite my soul to express itself. Ivan Wilson saw something in me that I did not recognize but that he chose to cultivate in the subtlest fashion.

The first day in Wilson's class, he caught me doodling some cartoon characters. As he peered over my shoulder he said, "Now that's interesting. What do you intend to do with it?" Before I could answer, a department staff member interrupted us and the class period was over shortly after that. It would be

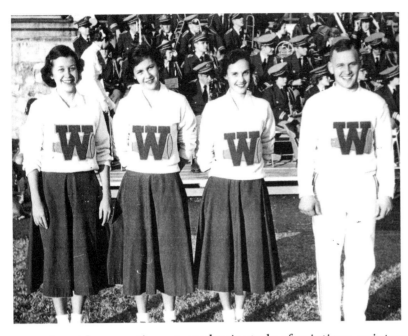

I met Joyce Wallace and her twin sister Joan when they came to Western Kentucky University and were elected cheerleaders. From left, Joan Graybruck, Joyce Wallace, Joan Wallace, and Bobby Hensley.

five years before I discovered the answer within myself.

During that freshman year, I was fortunate to be invited to visit with Wilson in the small studio in his home on the edge of the hill from time to time, watching him deftly apply colors with the most delicate of strokes. Each visit was a revelation both in techniques and philosophy. Fortunately, it was a seed-planting time—because I only took one other art course.

That was Art Appreciation, an academic study of paintings, painters, sculpture, trends, and architectural art. I was not too sharp when it came to flying buttresses and abstract sculptures, not to mention splashes of color that appeared to be tossed onto a canvas from a pitcher's mound. I failed the course miserably.

SOCIALLY, ONE OF THE September rituals on the hill was sitting on the retaining wall along the sidewalk that led into the student union cafeteria, watching for the new crop of freshman girls. In the fall of 1953, I was seated with Marvin Satterly, a guard on the football team who was called "Tank" because he was built like one.

We spotted two cute girls and followed them into the cafeteria and instructed a couple of freshman football players to go carry the young ladies' trays and bring them over and introduce them to us.

The freshman who struck my fancy turned out to be Joyce Wallace, from Munfordville, Kentucky, a small town and widely known speed trap between Bowling Green and Louisville.

Joyce and her sister Joan were twins recruited by Western's legendary basketball coach, Ed Diddle. In earlier years, Diddle, ever the promoter, had parlayed his trademark red towels and another set of Western cheerleader

twins, the Cook sisters, into gallons of ink from the Eastern press. He looked on the Wallace twins as another publicity opportunity.

Little did I know that meeting Joyce Wallace that day in the cafeteria would begin a relationship that would last the rest of our lives. While our courtship went through the usual hormonal dating rituals, I became aware of a growing comfort zone that transcended the sexual attraction and demanded attention to a deepening commitment.

Joyce had a favorite aunt, Martha Graham, who lived in Nashville with her journalist husband, Gene, an editorial writer and columnist for the *Nashville Tennessean*. He also happened to be a talented cartoonist who often illustrated his folksy, Will Rogers-style political columns with slick, insightful caricatures of his subjects.

On visits to Nashville I was transfixed by the magic of brush and India ink in the hands of this reddish-haired, freckled man with a ready wit and keen intelligence. Moreover, it was a revelation that one might earn a living this way.

Gene Graham went on to win the 1962 Pulitzer Prize for National Reporting and wrote the definitive book on reapportionment reform, *One Man, One Vote*. He would be my confidant and mentor until he died of a brain tumor in 1982.

BACK AT WESTERN, I began drawing and contributing cartoons to the *Herald*, the student newspaper. Mostly they dealt with the vagaries of student life. Also, inspired by Walt Kelly's *Pogo*, I attempted to work up a comic strip based on a Florida "swamp" youth. Neither effort was of

One of my cartoons for the WKU student newspaper.

THE COLLEGE HEIGHTS HERALD

Welcome Back

the highest quality, and I soon became distracted by the regular demands of football and a growing fascination with music.

In the early 1950s, songs such as "Wheel of Fortune," "Jambalaya," and "Anytime" had the nation's ear, but in Bowling Green the jukeboxes filled the nights with the soulful and rocking sounds of Lloyd Price, Ruth Brown, and Rusty Bryant on tunes like "Lawdy Miss Clawdie," "Night Train," and "Teardrops from My Eyes." It was as if Bowling Green was a small enclave of soul music.

Down the hill from Western, at the intersection of State Street and the 31-W Bypass, a late-night hamburger joint occupied the front section of an old Quonset hut; the back section was rented for parties and dances. I stopped by one night before heading up the hill and discovered the back room was rocking to some great R&B music. I peeked through the door to see a roomful of black adults dancing to a seven-piece band.

The restaurant manager tapped me on the shoulder and said, "If you want, you can go up in the loft and listen." Directly above the restaurant was a storage loft that was open to the back room, separated by only a metal railing across the edge of the floor.

I sat on the floor with my feet dangling between the railings, mesmerized by the whining guitar riffs and the shuffling bass rhythm. The tall skinny young singer raised his face towards the ceiling, with his eyes closed as he laid guitar licks behind his vocals. I learned later that young man was named B. B. King and that a black entrepreneur had booked the band as a "one-nighter" between Memphis and Detroit.

On another occasion at the Quonset hut, I discovered an old upright bass amid the neglected junk in the loft. It appeared to have been there for ages. I had been having some fun with a homemade washtub bass, consisting of a washtub turned upside down with a cord attached to the center of the tub and the other end attached to a broom handle that stood vertically on the bottom rim of the tub. The old upright bass I had found beckoned to me as an opportunity, and I convinced myself it was being wrongfully neglected and would never be missed from the loft.

One night I took my friend Bobby Hensley on a mission to liberate the upright bass. I went up into the loft, ostensibly to hear the music, while my friends waited outside beneath the loft's window. I had brought a length of rope and had started to lower the bass out the window when I realized that

directly beneath the loft window was the restaurant window—and any customer, not to mention the manager, would see a hulking bass fiddle as it was lowered past the window.

Not to be deterred, I started swinging the instrument right and left like a pendulum in the idea that once it cleared the restaurant window I would suddenly lower it to the ground. Of course, the metal siding of the Quonset hut had ridges like a washboard and the resulting noise could be heard for blocks. Fortunately, the music inside and the crowd noise drowned out the scraping sounds, and we soon drove away with an old but very real bass fiddle.

In my ignorance, I painted the bass white and drew cartoon eyes on either side of the extended fretboard, dulling what resonance the old instrument had left in it.

Then I started to get a band together.

Warren County was "dry" and one could not buy a mixed drink except in a private club, so a number of the football players had joined the Moose Club where you could get a rail drink for twenty-five cents. That is where I came to know Eddie Jackson, the black bartender who in his youth had played alto sax with Coleman Hawkins and had married a Bowling Green woman.

He was now in his sixties and played a bit locally to supplement his income. I had solicited two friends to join me in the band. Music major Charlie Black was our drummer, and Harry Spires, who was not a music major but had an amazing ear for traditional jazz, played trumpet. We talked Eddie into joining us because I had lined up a gig at a local dinner club and a little bit of money was to be made.

We needed a piano player and Eddie lined up Sam, a gray-haired black man we guessed to be pushing eighty. He looked like a grizzled version of the Uncle Remus character in the movie, *Song of the South.*

Sam lived in Bowling Green's black whorehouse, where he pushed a broom and did odd jobs. If he had ever articulated the reason for his hard times, it might have sounded like a line from the song, "Mr. Bojangles"—"'cause I drinks a bit." However, I was convinced Sam knew almost every blues, jazz, and traditional song, at least when he was reasonably sober.

The Manhattan Towers was a classy bring-your-own-bottle dinner club just across the river north of Bowling Green. We played there on Friday nights with another Western student, Donna Hansen, as our vocalist. Our style was

mostly "New Orleans" traditional jazz and blues.

The gig was a good one and lasted until a fight broke out one night and one of the brawlers was knocked into my bass, breaking the neck. Anyway, the Western coaches were already taking a dim view of my playing in a joint where flowing booze was a major attraction.

My pass completion rate at Western Kentucky was an NCAA record at the time.

THE 1952 FOOTBALL SEASON produced Western's first bowl team. Led by senior quarterback Jimmy Feix and a sprinkling of major college transfers, the Hilltoppers defeated Arkansas State in the Refrigerator Bowl (sponsored by Servel Corporation) in Evansville, Indiana.

This was early in the era of unlimited-substitution football when quarterbacks called most of the plays. Feix was a brilliant strategist who made the most of a pro-T offense and was one of the leading passers in the nation, completing 63.1 percent of his attempts. He went on to become head coach of the Hilltoppers from 1968 to 1983 and remains the most successful head coach in Western history.

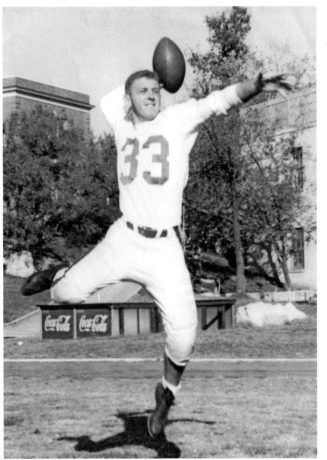

When I took over the starting quarterback position in 1953, the NCAA had rescinded the "two platoon" (unlimited substitution) rule in an aberrational year most people don't even recall. There was no longer an "offensive unit" and a "defensive unit." Under very limited substitution rules, there was no longer the luxury of a pipeline of fresh running backs or pass receivers from the bench. There was just the starting team that played both offense and defense.

This resulted in a less wide-open, less run-and-gun style of play, but I was fortunate enough to generate a 66.7 percent pass completion rate, which was an NCAA single-season record at the time. After the

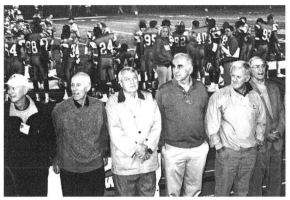

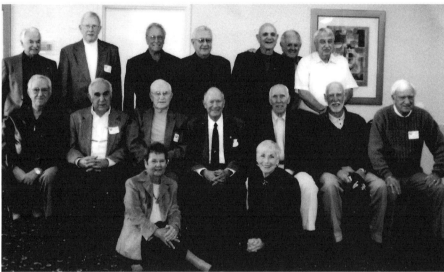

Left: Members of the 1952–53 WKU bowl team were honored at Homecoming during their 60th reunion. From left, fullback Willie Watson, tackle Willard Price, tackle Ed Worley, end Bill Ploumis, QB Bill "Whitey" Sanders, QB Jimmy Feix. Below: Another photo from the 60th reunion shows additional members of the team. Top row, from left—Bo Cully, Tom Patterson, Max Stevens, Jerry Passafiume, Arnie Oaken, Bill "Whitey" Sanders, and Ed Worley. Bottom row— Jimmy Sacca, Bill Ploumis, Guy Newcome, Willie Watson, Willard Price, Dave Patton, and George Saur. Seated, bottom— cheerleaders Joyce Wallace Sanders and Emmie Smith Patterson.

season, I experienced a Walter Mitty moment when I received a notice from the Cleveland Browns wanting to know about my eligibility status.

Well, not only had my athletic eligibility expired but my draft-exempt status was also about to expire if I did not fulfill my ROTC contract with the U.S. Army. So I finished my last semester in January 1954 and pestered Joyce Wallace until she agreed to marry me.

An old Turkish proverb says, "No road is long with good company." A core group of the 1952–53 football team and our future wives were forming "good company" without really being aware of it. We were in a bonding process that would link us for the next fifty years or so—through homecomings, armed services' life, Derby parties, births, and deaths.

Korea and the Herblock Epiphany

I n 1954 I put down fifty dollars on an engagement ring and fifty dollars more on a 1949 Chevrolet. The second investment lasted about two years; the first has been good for six decades.

Joyce Mary Wallace and I were married on the afternoon of February 12, 1955. The roads were covered with ice and I was covered—much to the dismay of my bride—with a charcoal and pink zoot suit. It was the first suit I had owned since I was in the eighth grade and had to attend a cousin's wedding.

Joyce and I were married in her hometown on February 12, 1955.

You have to understand that at the time, the "in" colors were charcoal and pink. Narrow ties, those of the one-inch wide variety, were also the coolest

guys' fashion accessory. So what could be better than a wool charcoal suit with pink flecks, a two-button roll, double split coattail, and a pink tie? I was to learn after the fact that almost any costume in the known universe would have been better for a traditional wedding in a traditional Methodist Church in the traditional village of Munfordville, Kentucky.

Joe Goodman, one of my best friends and a fellow teammate, had married Joyce's friend, Pat Lemon. The four of us, plus another teammate, Arnie Oaken, and his new bride, Mary Rae, were all headed for Fort Benning, Georgia. Joe, Arnie, and I were commissioned as U.S. Army second lieutenants and were to report for active duty in May.

During the four months of Officer Training School, the big question was about our next assignments. Some of us would go to Korea;

the others to Germany. All of us were preoccupied with devising a strategy to stay out of Korea.

Joe, Arnie, and I had a simple plan. We would play football for the Fort Benning team, thus giving us more time to work on a permanent diversion. The ploy worked for Joe and Arnie but not for me.

AS SOON AS FOOTBALL season was over in November, I received orders for Korea. I was scheduled to fly to Seattle on Christmas Eve and then board a troop ship to Korea.

During the interim, I took flying lessons, soloed, and did a little recreational flying. Then one afternoon I decided to shoot some baskets at the base gym. A man who turned out to be a captain and coach of the Benning basketball team was watching me hotdog it around the court. He finally came out of his office and wanted to know where I had played ball. I told him Western Kentucky. It was not exactly a lie, just a deceptive truth.

I played football at Fort Benning, Georgia, in an unsuccessful attempt to avoid being assigned to Korea.

Would I be interested playing basketball for Benning? Absolutely, but there was the little matter of being sent to Korea. The captain thought he could get me another extension.

The captain was wrong, and I spent Christmas Eve eating in a rundown cafeteria on the sad side of Seattle, Washington.

My final attempt to stay out of Korea came aboard the Navy ship taking me there. I was one of a dozen Army officers, two hundred Army troops, and a handful of Army dependents. The dependents were headed for Japan and the rest of us were going on to Korea.

The troops were packed like sardines in the bowels of the ship, while the civilian dependents and we officers were in the upper-deck quarters.

One crisp foggy morning, while on duty on the lower deck, I spotted PFC Ralph Beard, the three-time All-American who had played on the 1947–48 "Fabulous Five" basketball team at the University of Kentucky. His younger brother, Mony Beard, had played for the Hilltoppers while I was there.

Ralph was headed for Japan, thanks to his athletic reputation, to play basketball for the Far East Command Headquarters.

I had never met Ralph but our connection under the circumstances was immediate and, as recreation officer, I made him my assistant, which got him

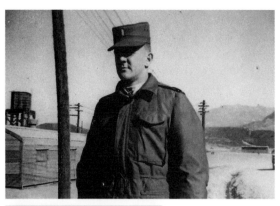

Top: I was sent to Korea in December 1955 and assigned as a mortar platoon leader. Bottom: At an orphanage Christmas party outside Camp Casey, 1956.

out of the sardine-like accommodations in the belly of the ship and onto the upper deck with me.

In the course of our conversations I told him I had played basketball at Pompano Beach High School against a mutual friend, C. M. Newton, who played at Fort Lauderdale and later went to the University of Kentucky. Newton and I had been Florida High School All-State players.

When Ralph heard I was going to Korea, he said, "Hey, maybe I can get you diverted to play basketball with us in Japan. When we dock in Yokohama, I'll check it out."

It was a great idea, but sadly destined to be an exercise in futility. Even with his reputation, Ralph didn't have enough juice to get my orders changed.

AFTER SIX MONTHS AS a mortar platoon leader in the 17th Infantry Regiment at Camp Casey, near the DMZ, I managed to get a leave back to Seoul. The day before I was to return to Casey, fate placed me at a mess table with the civilian counterpart of the Commander of Special Services.

This was a man with the pecking-order rank of a full colonel. He spent a good part of our conversation lamenting the fact that he needed a junior officer to take command of the small *Stars and Stripes* unit in Seoul, consisting of a printing press crew of five and three reporters, plus half a dozen young Korean civilians.

Had I had any experience on a newspaper? Absolutely, I lied! Would I be interested? You bet!

He told me to meet him at General Sands's office at 0800 the next morning for an interview before I departed for Camp Casey. At 0700 the next morning, I was at the front door of the base library hoping against hope that someone would open it up before 0800.

Finally at 0745 someone let me inside and in three minutes I was scribbling notes from an Army manual titled *Journalism AR100*. By 0815 I was whipping those notes off the tongue in a fantasy "experience" tale for the 8th Army Headquarters Commanding General.

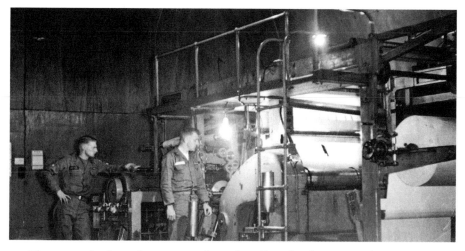

Left: Somehow, I was put in charge of the Pacific Stars & Stripes *unit. The Korea edition of the tabloid was printed on an old Goss press and then distributed throughout South Korea. Below: My* Ed Feck *comic strip was drawn for the local Seoul Area Command newspaper. "Ed Feck" was an acronym for "Effective Date of Departure Far East Command."*

Three weeks later I was transferred to Seoul, where I took command of the *Stars and Stripes* unit.

This was heaven compared to slogging around the mountains of Camp Casey. I had a private room, with a shower, at one end of our large Quonset hut and a jeep and driver at my disposal.

Moreover, printing, distributing the newspaper, and supervising the gathering of news was stimulating—something that was worthwhile. In my spare time I set up a drawing board and started doodling about Army life.

One afternoon a captain and friend who ran the 8th Army base newspaper saw the comic strip I was drawing and persuaded me to produce it on a regular basis for his paper. I agreed and for three weeks my cartoon character Ed Feck (an acronym for Effective Date of Departure Far East Command), played out his misadventures on the pages of the base newspaper.

ED FECK BY BILL SANDERS

In the third week's edition, Ed was the driver for General Sands. He was shown driving away from the general's house on the hill—where the general's wife visited occasionally from their home in Tokyo. In the back seat, being chauffeured by Ed Feck, was an attractive "Moose," the nickname for a Korean female companion of the carnal knowledge variety. She was saying to Ed, "Itaewon, Jamesy!"

Itaewon was, at the time, a neighborhood on a hillside in Seoul where prostitutes and mistresses lived.

After that publication, General Sands sent troops to confiscate as many of the newspapers as they could find and threatened the captain with Article 15 (a nonjudicial punishment) if he didn't "get rid of that cartoonist!" Thus ended my career as an Army comic strip artist.

Meanwhile some colonel convinced the general that the 8th Army Headquarters Command should field a football team that fall. He then went into the personnel 201 files and flagged anyone with football in their background.

Shortly thereafter, I was given an invitation I could not refuse. So I ended up reporting for practice. As it turned out, there were only two other players with college experience. There were a few guys who *may* have played a little high school ball—and a raft of guys who would do anything to get out of regular duty. The coach was a major and a wannabe who had never played nor coached a game in his life.

If anyone reading this envisions us playing and practicing on a green grass field such as in the one in the movie *M*A*S*H*, forget it! Our field was a tan dust bowl, sprinkled liberally with walnut-sized pebbles. After two games and getting the tip of one finger severely bitten, I turned in my uniform and dared them to send me back to Camp Casey.

They didn't, of course, and I stayed on as the commanding officer of the *Stars and Stripes* unit.

UP TO THIS POINT, the currents of life had swept me along without much thought on my part as to where I was headed or what the future might or might not hold.

The outside world had not really intruded on my consciousness until I was seated in that shopworn cafeteria eating a solitary Christmas Eve meal and awaiting shipment to Korea the next morning.

Now, I was reading a newspaper every day and facilitating the coverage of news in Korea. My world was rapidly expanding thanks to the goading and mentoring of one of our reporters, Corporal Rod Hohl.

Then one fateful evening I headed for the Officer's Club and took a shortcut through the base library—a nondescript Quonset hut with rows of tables and a few stacks of books. I entered in one end and hurried through the tables towards the exit at the other end. In my haste, I knocked a book off one of the tables.

I picked it up to place it back on the table when I took notice of the cover. The title was *Herblock's Here and Now*. The jacket had a drawing of a huge atomic bomb with long, ape-like arms and the visage of a thug. The anthropomorphic creature was staring down at a small, bespectacled man looking up aghast at the monster in front of him.

Curious, I sat and thumbed through the book. It was filled with pithy, hard-hitting cartoons about politics, civil liberties, the bloated military, and governmental incompetence. The accompanying essays were brilliant pieces of satire and opinion, laced with tongue-in-cheek syntax that could only flow from deeply held convictions.

I never made it to the Officer's Club. I read about half the book while sitting there, then took it back with me to my Army unit. It was a true epiphany.

I had never heard of Herblock (Herbert Block) and, frankly, had never paid much attention to newspaper editorial pages. But his cartoons were so powerful and the opinion essays so compelling that I felt a groundswell of desire to be a participant in that world—to become involved in and perhaps contribute to changing that world.

Suddenly, I saw journalism as a pathway to my future . . . if I could find the means to pursue it and could catch up on the requisite knowledge to become competent at it.

At Panmunjom, on the border between North and South Korea, I covered a meeting for Stars and Stripes. *No cameras were allowed beyond the entrance to the conference building. This is a quick sketch, done surreptitiously (and not very well) on paper secreted inside an army hat.*

5

Sayonara, Korea

In 1957, the hottest Hollywood film was *Sayonara*, starring Marlon Brando as an Air Force fighter pilot who falls in love with a Japanese female performer working in a traditional Takarazuka-style theater. The movie plot confronts the racism and prejudice that sprang from such relationships as they became frequent in Korea and Japan.

In war-torn Korea there was little future for budding romantic involvements. However, the brass had no problems with temporary sexual relationships, as they themselves often had such liaisons.

But in Japan the ravages of World War II had mostly disappeared by the late 1950s, and rising in their place was a restructured relatively modern country with all the amenities of cross-cultural lifestyles.

About the time I was cultivating my desire for journalism near the end of my tour in Korea, I managed an R&R (rest and recuperation) leave to Tokyo. It was like visiting another planet.

Tokyo was metamorphosing into a modern metropolis. Contemporary high-rises punctuated its profile. Western-style bars, coffee shops, and boutiques sprouted in cramped spaces between department stores and office structures. Acres of neon signs gave Tokyo a glow of excitement and enticement.

The day I walked into the *Stars and Stripes* city room in the paper's headquarters in Tokyo, I knew that this was the atmosphere for me. I immediately began campaigning for a job there.

Pacific Stars and Stripes was a hybrid of Army personnel and civilians. The managing editor was a civilian *Chicago Tribune* veteran, but the commanding officer was a lieutenant colonel whose role was that of a benign editor.

I managed to talk my way into a job as a general assignment reporter, if I would agree to take my separation from the Army in Tokyo—which was a no-brainer, given my appetite for getting a foothold in the journalism profession.

Since I had only thirty days left on my tour in the Army and had not taken

any leaves while in Korea, Colonel Whitt arranged for me to forfeit my leave time and take my separation from the Army without returning to Korea.

The fly in that ointment was that the government would only pay to transport my wife and daughter to Japan after I had been employed as a civilian for eight months, which to me would have been like a lifetime. So, I paid for them to fly commercially as soon as they could obtain the necessary paperwork.

JOYCE AND I SPENT a magical two years in Tokyo, enjoying Japan's culture and history. We lived in a small one-bedroom apartment in a modern high-rise complex near the Daikanyama station in the Shibuya Ward.

Our apartment neighbors were multicultural. Our daughter Cathy was three years old and most of her playmates were Japanese, so she readily picked up the language and more than once was our interpreter at the small shops around the neighborhood.

Meanwhile I was on an intense learning curve at *Stripes*, working as a general assignment reporter, doing some feature writing with illustrations, covering sports, and finally working on the copy desk, reading copy and writing headlines.

Expressing my opinions through drawing remained a growing compulsion, but *Stripes* had no spot for cartooning. However, when Russia launched *Sputnik*, the first orbiting satellite, I went back to the drawing board.

I was separated from the Army in Tokyo and was hired by Pacific Stars and Stripes as a civilian. I worked as a reporter, copy editor, and finally as feature writer/ illustrator/ cartoonist. I interviewed Masters and PGA champion Jackie Burke at the Canada Cup (international) Golf Tournament outside of Tokyo.

The launch took place on October 4, 1957, as part of the International Geophysical Year. *Sputnik*—which in Russian translates to "companion"—gave dramatic evidence of American lethargy in space and science.

I felt compelled to point out in a cartoon that the U.S. had been asleep at the switch and offered the drawing to the managing editor, who agreed to run it. However, when the proof page was pulled and Colonel Whitt saw the cartoon, he vetoed it.

Incensed, I took the drawing to the

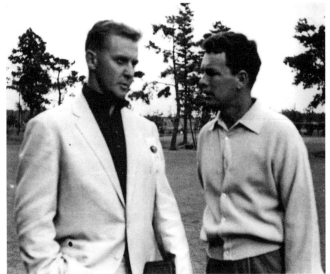

It's awfully hard to score on this course, Harold!!

Under my middle name (Willard), I drew political cartoons for the Japan Times, *after having one turned down by the* Stripes *editor.*

Japan Times, a Japanese-run English-language newspaper in Tokyo. They not only agreed to use the cartoon but offered me an opportunity to freelance on a regular basis for ten dollars per cartoon.

However, civilian employees at *Stripes* were forbidden to work for the Japanese media. I agreed to draw for the *Japan Times* but did so under my middle name, Willard, since that name never appeared on my contract with the government.

This experience motivated me to contemplate returning to the United States. Even besides the ambition of becoming a professional cartoonist, the novelty of living in an exotic land was wearing thin. As Tokyo took on more western characteristics, the United States was beginning to downsize its physical occupation by returning facilities and property back to the Japanese.

Our second daughter, Vicky, was the last American child born in Tokyo Army Hospital—on June 22, 1958—before it was turned over to the Japanese government. The growing family was an added incentive for returning to the States.

With the help of a creative friend, I put together a brochure of cartoons, written articles, and a biography. I printed twenty copies and mailed them to

CINCY GUNNER **BY SANDERS**

After Stripes' censorship of my political cartoon ideas, I drew mostly sports cartoons for them.

IN ANCIENT LATIN, SOPHOMORE MEANS "WISE FOOL"

WEBSTER SAYS IT MEANS "A SECOND YEAR STUDENT"...

BUT AROUND CINCINNATI IT MEANS

CINCINNATI 29

OSCAR ROBERTSON

A 6-5 SOPH WHO SCORED **56** POINTS TO SET A MADISON SQUARE GARDEN SCORING RECORD !

ALREADY ORIENTED **BY SANDERS**

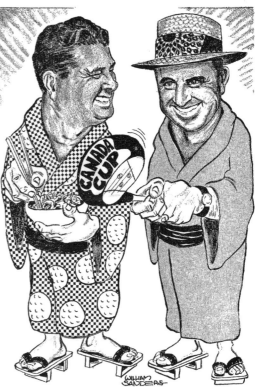

CANADA CUP

stateside newspapers I had selected at random (except two) from the *Editor & Publisher Yearbook*.

The two exceptions were the *Louisville Courier-Journal*, with which I was familiar because of my time at Western Kentucky, and a paper in a town with the word "green" in its name. I remembered passing through it on the way to Tennessee and thought to myself at the time that it was an interesting little city.

As one might expect, I received multiple rejections. However, one morning I walked over to my desk and had two pieces of mail. One was from the *Louisville Courier-Journal* and the other was from Greensboro, North Carolina.

I immediately took the *Louisville Courier-Journal* letter to the coffee shop to read while having breakfast. Editor Barry Bingham complimented my work but said he had just hired a promising young cartoonist and would not have an opening in the foreseeable future.

Dejected, I returned to my desk and looked at the letter from Greensboro, North Carolina. It dawned on me that the city that had struck my fancy was in South Carolina. I suddenly remembered its name. It was Greenville. I had sent the brochure to the wrong city.

I opened the Greensboro letter. It was from editor Henry Kendall, who informed me that their cartoonist, Hugh Haynie, had just been hired by the *Louisville Courier-Journal*. Kendall wanted to know when I contemplated returning to the United States because the *Greensboro Daily News* would be interested in interviewing me for the position.

Needless to say, I responded that my family and I would be taking the next available ship back to the States and gave them an estimated time of arrival in Greensboro for a job interview.

Sayonara, Tokyo.

6

The Buffalo's Nose

When I started drawing for the *Greensboro Daily News* in January 1959, I knew squat about North Carolina politics. I assumed that its political character was somewhat akin to that of its sister Southern states. However, I found it to be a strange mix of parochial attitudes, segregationist and Bible-thumping tendencies, with a substantial population of well-educated elites.

My first day on the job, I was to realize my good fortune. The editorial page editor was a beanpole of a graciousness, Henry W. Kendall, whom everyone called "Slim." His nature was as gentle and outgoing as it was progressive and thoughtful. He nourished no illusions about Southern social attitudes and charged me to "draw what you feel."

"You are going to make mistakes, but don't let that inhibit you. I'll let you know when we have a problem," he added. He was true to his word and our working relationship turned out to be a model for a political cartoonist and editor.

As I studied to find out who were the good guys, the bad guys, and the facilitators, I was drawing at a less aggressive level then I might have under more knowledgeable circumstances. Ironically, it was one of those early cartoons that helped me establish a foothold in the state.

Luther H. Hodges was governor. In 1952, he had retired from his executive position at a woolen mill owned by Marshall Field and was elected lieutenant governor. He succeeded Governor William B. Umstead after Umstead's death and was later reelected to a full term.

Hodges's image was that of a Southern, white-haired gentleman, soft-spoken, with a gentle nature. He was not burdened by the truncated vision of his peers in other Southern states like South Carolina, Georgia, and Alabama. In his final years in office, his focus was to bring North Carolina into the mainstream of commerce and industry. He was convinced that success

in this effort should trump all other demands and issues in the state. He was the captain of "Hodge's Raiders" who successfully whisked businesses from their northern confines and even made a raid on Europe.

His twilight tenure did not offer a particularly high-profile target for political cartooning—only an occasional critique. He was, however, good for tweaking at a lesser level.

Whatever shortcomings Hodges may have had, he was keenly aware of stroking the press when need be. Prior to the 1959 legislative session, the press worked in a crowded and cramped room in the east wing of the state capitol and were given to considerable grousing about their circumstances. Redressing reporters' grievances became a bone of some contention between some of the lawmakers and the governor because the structure of the capitol meant that building a pressroom would be an exorbitant cost to the state budget.

Fiscal penny-pinchers in the General Assembly mounted a campaign to use the construction proposal for the press corps as an ax to go after trimming the general budget. Aside from the cost of the project, critics also complained about what it would do to the historical integrity of the old building.

However, a plan was devised to glass-in the second-floor portico of the east wing for the press. As the work began, the modified structure became the brunt of ridicule from a number of quarters. Secretary of State Thad Eure allowed as how it would be like putting a nose on a buffalo.

When I noticed that comment buried in a lengthy news story, I decided to salvage a slow day by having some fun with it. I drew a buffalo head mounted on a wooden trophy plaque with a human-looking nose strapped to its face. A metal plate under the head read "Buffalo Porticotus, of species East Portico-

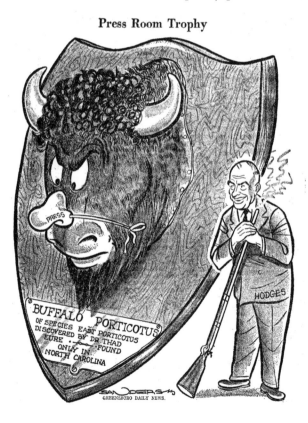

Press Room Trophy

tus—discovered by Dr. Thad Eure—found only in North Carolina." Next to the trophy stood Governor Hodges, with smoking shotgun.

It was what I called a space-filler cartoon—not of any import. However, in the trivia of discourse at the state capitol, Governor Hodges took the cartoon and had it printed on a fancy certificate that proclaimed the owner to be a member in good standing of the Royal Order of the Buffalo's Nose. He then distributed the certificates to the General Assembly and other parties throughout the state.

The resulting statewide humorous buzz defused the embryonic fiscal revolt. The entire press box affair was a tempest in a teapot.

Hodges's national reputation as a creative thinker in restructuring Southern rural economies caught the attention of President John F. Kennedy. At the end of Hodges's term as governor, the president appointed him as U.S. Secretary of Commerce.

Dot Smith and Abraham Lincoln

In April 2005, a four-paragraph news story caught my eye and reminded me how fickle is the finger of fate.

It was datelined Louisiana and concerned one George St. Pierre, who claimed to have purchased for ten dollars a postage stamp-sized swatch of cloth that was supposedly snipped from the coat President Abraham Lincoln was wearing when he was assassinated.

The story said St. Pierre was planning to put the framed swatch up for sale on GoAntiques.com with a minimum bid of $1 million. The story also went on to say that Lincoln collectors were skeptical. This interested me because I knew that, theoretically, St. Pierre's claim could possibly be true. Whether it was worth $1 million was another question.

The *Daily News* editorial page secretary while I was in Greensboro was Mrs. J. Marvin Smith. "Dot," as she was fondly called, was a wonderfully warm and efficient lady I guessed to be past her mid-sixties. She took my wife and me under her wing and we became good friends.

Over dinner and drinks one evening she told us a remarkable story.

Her grandfather, Alphonse Donn, worked as a personal guard in the White House and was a favorite of President Abraham Lincoln.

After Lincoln was shot, Donn asked Mrs. Lincoln what he should do with the suit the president was wearing when he was killed. It was unsightly and soaked with blood. Mrs. Lincoln was repulsed and told Donn she didn't care what he did with it. She just wanted it out of her sight. He took it home and kept it.

In 1875, P. T. Barnum tried to buy the suit, offering Donn $25,000, but he would not sell. In 1915, the 64th Congress introduced a bill to buy the suit for the Lincoln Memorial for $7,000, but Donn also turned down that offer. He kept the suit in his home and often showed it to friends and visitors, but that proved to be an unfortunate practice because Donn discovered that

Lincoln's suit on display at the Ford's Theater National Historic Site.

when he was distracted or would leave the room, some people would snip souvenirs from the coat.

At one point during his ownership, Dot's grandfather was persuaded to let the suit go out of his house for the purpose of historical display. It was another unwise decision, as the cloth was further mutilated.

The coat and pants had been carefully authenticated. The clothing was made by Brooks Brothers for Lincoln's second inaugural and was alleged to have been made of wool finer than cashmere.

The lining was what made the long-tailed frock coat unique. The hand-stitched silk featured an intricate pattern, in color, of an American eagle, with its wings spread, holding in its beak a ribbon bearing the inscription, "One Country, One Destiny." In 1918, the seamstress who as a young woman had sewn the lining in the frock coat testified that it was, indeed, the one she had worked on. The *New York Times* called it "the most expensive Brooks Brothers suit of all time."

That is how the frock coat and pants came to be owned by Dot Smith. It was passed down to her after Donn's death and was, at the time of our conversation, stored in a vault in Greensboro along with papers, letters, and documentation, including letters written by Mrs. Lincoln to Donn.

By 1968, I had moved from the *Greensboro Daily News*, via the *Kansas City Star*, to the *Milwaukee Journal*. Dot Smith was then a widow living in Georgia on a meager retirement income.

She was still trying to find a buyer willing to purchase the suit and donate it to the Lincoln Museum in the renovated Ford's Theater. The U.S. Interior Department wanted the suit for display but the department could not get authorization to buy the historic apparel nor find a private patron to sponsor the purchase.

Other potential buyers were turned off by the shabby, crusted appearance

of the outfit and were disinclined to pay Dot the $50,000 she felt it was worth. In some desperation, Dot called me at the *Milwaukee Journal* to ask if I had any connections in Washington or if I had any other ideas that might help. I decided that before I tried to lobby a senator or congressman, it might be wise to have a feature story as a foundation for the effort. A columnist friend, Jerry Kloss, interviewed Dot by phone and wrote a nice feature article in the *Milwaukee Journal*'s "Green Sheet" section.

As a result of that story, a Milwaukee-based company ultimately purchased the suit, reportedly for $10,000, and donated it to the Museum.

I often wondered what the appraisal figure might have been for that donation. My guess is that it was a whale of a lot more than Dot Smith ended up with.

Hot Roast Beef and Civil Wrongs

While drawing political cartoons for a paper like the *Greensboro Daily News* was near nirvana for me, it did not place the Sanders family in the lap of luxury.

I was making $100 per week with a take-home largesse of about $85. Our third daughter, Cheryl, was born in November 1959 and I had not been on the *Daily News* payroll long enough for company insurance to cover the medical expense. As a result, we had to pay the full cost.

I went to the publisher and asked for a raise. It was the first and only time I ever asked for a salary increase during my career. He allowed as how he could give me $5 more a week, which didn't put a dent in our economic burden.

Therefore, I was a brown-bagger at lunchtime except on rare occasions when I would splurge for a barbecue sandwich at a hole-in-the-wall joint or, on rarer occasions, for a hot roast beef sandwich with gravy and mashed potatoes at Woolworth's.

Mondays were always slow days for the mental process of political cartooning—at least for me. Weekends were family time, when I abandoned the perpetual hunt for issues that needed comment, and when I processed no more information than was necessary for getting the girls to the park or the mountains or the backyard for playtime.

As a result I had to catch up on events or issues on Monday, which involved "lag" time, unlike today's instant 24/7 communication technology. On Mondays, I would have to squeeze my creative juices to the core to extract a comment on a less-than-timely issue in hope of constructing a useful and pithy metaphor in time to complete a drawing before the deadline for the next morning's paper. Mondays were the pits.

Monday, February 1, 1960, was destined to be one of those long days when I just could not get in gear. I had been mentally coasting the latter part of the previous week and had not been diligent in keeping up with my reading.

On the state level, gubernatorial candidates were coming out of the woodwork, and public school integration was about to become central to the campaign. On the international scene, French military leaders in Algeria were in revolt against Charles de Gaulle's self-determination policy for the territory. Algeria's Home Guard took up arms against the French, resulting in rioting and the deaths of nineteen people in one day. As America was building bomb shelters, France was building atomic bombs. After spending the morning reading, I opted for an effort to say something about the French-Algerian crisis and its effect on NATO and the upcoming Western Summit talks.

As the afternoon wore on and discarded sketches piled up, I finally put together a reasonably acceptable idea and penciled it onto my drawing paper. By the time I was ready to "ink" the drawing, it was after 3:30 p.m., I had missed lunch, and was feeling burned out. So I decided to take a break and splurge for a hot roast beef sandwich at Woolworth's, then return and ink the cartoon.

France developed a nuclear weapon in 1960. While De Gaulle used testing to bully Western powers, Algeria exploded in a violent revolt against French occupation.

LITTLE DID I KNOW as I strolled over to Elm Street it would be to witness an event that would change the social fabric of America and my personal social conscience.

As I was finishing my meal, four African American students from North Carolina Agricultural and Technical State University (A&T), walked in and took seats near the other end of the lunch counter from where I was seated. I was peripherally aware of African Americans shopping and getting food at the "stand-up" take-out counter during my infrequent visits to Woolworth's, but I didn't invest any thoughts about it one way or the other.

Here I was back in the United States, fresh out of eighteen months in Korea and two years in Tokyo, and I am ashamed to say that the idea that a big chain like Woolworth's would have "whites only" seats at their lunch counter wasn't even a flicker along my brain's neural pathways.

When the U.S. Supreme Court handed down

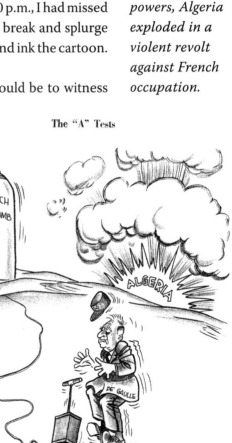

The "A" Tests

FRENCH A-BOMB

ALGERIA

DE GAULLE

SANDERS
GREENSBORO DAILY NEWS

its *Brown v. Board of Education* decision in 1954, I was just out of college, in the Army, married and starting a family in Fort Benning, Georgia—blissfully unaware of the outside world. The Army was integrated and race was not an issue to me.

By the time Little Rock's Central High School was being integrated in 1957, I was a world away in Tokyo working as a civilian journalist for *Pacific Stars and Stripes* and very definitely a member of a racial minority in that world. Living in Tokyo as a *Gaijin*—meaning "not Japanese" or "outside person"—I was not aware of any racial animus.

When I returned to the States and went to work at Greensboro, all of my energy and focus went into the learning curve of a totally new profession and getting reacquainted with my family. If I thought of segregation at all, other than in public schools, it was as a relic of a time gone by and a concept that was only embraced by people whose minds were also relics.

However, until that moment at Woolworth's, I wasn't aware that my civil rights view was an exercise in tunnel vision. Also, I was heavily engrossed in the political campaign between John Kennedy and Richard Nixon—my first as a political cartoonist.

People have often asked me, "How did you come to your attitude on civil rights?" To this day, I cannot answer that question. My guess is that such things are not traced through DNA—otherwise, I might readily give tribute to my grandfather, a bear of a creative man who took up the cause of the common people most of his adult life. And was instrumental in bringing TVA power into middle Tennessee.

THAT DAY IN FEBRUARY 1960 I wasn't immediately aware that the four black students had taken stools at the lunch counter. When I did look up, the four were quietly seated and the waitresses seemed to be ignoring them.

There was no dramatic response from shoppers or lunch counter customers. However, the four were the targets of second looks and outright stares. A couple of nearby teenagers mouthing racial clichés momentarily distracted me.

Finally, there was some exchange of words, which I could not make out, between a waitress and the four students. One of the waitresses left from behind the counter.

After several minutes, a man I presumed to be a manager came over and said

something to the students. Several customers were standing nearby watching the scene. A waitress listening from behind the counter looked bewildered. I could not hear the conversation, but it was apparent the four were not about to be served. The man then turned and left.

Years later the manager would claim, in a chronology he wrote about the event, that he strictly ignored the students and instructed the waitresses to do the same. A 1985 feature story on the four sit-in participants contradicts his claim, saying that the manager, "after failing in his attempts to get the students to leave, headed for the police station to see Chief Paul Calhoun."

Meanwhile a waitress came and retrieved my empty plate. She stopped in front of an old man seated next to me and urged him to finish his meal as the lunch counter was about to be closed. He appeared to be a "street" person, rather shabbily dressed, with a large paper bag at his feet.

Apparently, he was hard of hearing and did not look up. When he finally did, he announced in a loud voice, "I ain't finished eatin'!!" The waitress scurried away.

The scene was surreal. The four black men quietly remained seated and the waitress continued to ignore them.

Then it dawned on me that as I sat there time was running out on my deadline for engraving a cartoon that I had not even inked yet. As much as I wanted to stay and see how this tableau would play out, I reluctantly scooted out the side door and headed back to the paper.

I FINISHED INKING MY cartoon, turned it in to the engraving department, and went home to contemplate the events of that afternoon.

In the days that followed, more students from A&T plus a scattering of students from the Woman's College of Greensboro "sat in" and occupied all of the straight-line lunch counter seats. While there were a couple of instances of bigoted reactions, by and large the tensions were tolerable and the students were dignified but firm in their passive resistance.

Meanwhile, community leaders who took pride in Greensboro's acceptance of the *Brown* school integration decision were urging negotiations and cool heads—warning all to keep in mind the "economic damage" that would be collateral to continued confrontation.

As for me, I was trying to reconcile moral responsibility with the dichotomy

of a private business not legally obligated to serve anyone but customers of their choice. I made the mistake of letting the so-called "dilemma" argument cloud what had generally been my clear vision where race relations were concerned. As the story developed, I tried to conceive of a cartoon that would take into account the dilemma while maintaining my supportive view of civil rights.

Drawing about the sit-ins from this posture resulted in the worst cartoon I have ever put on paper. I tried to point out management's moral responsibility and stupidly used an empty lunch counter seat as metaphor. When I saw the cartoon in print the next day, I literally felt sick and vowed that I would never again let ancillary debate detract from my gut feeling as a social critic. Also, I would never again use inanimate objects as metaphors.

The ripple effect of that February day was to spread across North Carolina and the nation and would follow me to my next job at the *Kansas City Star*.

THE SIT-INS AND THE subsequent demonstrations in Greensboro had further offshoots that occupied less newspaper space. One was the "threat" of integration of white churches.

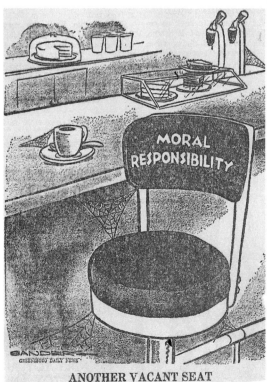

ANOTHER VACANT SEAT

My interest in religion has always been intellectual as opposed to rooted in faith and doctrine. My concession to traditional custom while in Greensboro was to attend Grace Methodist Church, and before that February I had somewhat reluctantly agreed to be on the church board.

Sometime following the turmoil of the sit-ins, several African Americans showed up at one of the white churches for a Sunday service. Thereupon, Grace Methodist Church called a board meeting to discuss what its response should be if confronted with that situation.

After some contentious discussion, there appeared to be common ground forming along the idea that two members of the board should be at the front door of the church to determine if any such visitors really wanted to worship or if they were there to foment trouble.

At that point, my bemusement at the intellectual contortions faded; I asked the minister and the board if we, indeed, had two board members who were mind readers. It was my last board meeting.

During the following two years of turmoil, I met and was inspired by John Ehle, a professor and author at the University of North Carolina. He was a man of great integrity and courage who challenged me to use my platform vigorously.

THE GREENSBORO SIT-INS CAST the civil rights conflict on a new battlefield. It was no longer the moral correctness of equal opportunity versus bigoted government institutions, i.e., school and universities. It was now cast (by many editorial writers in the South) as moral responsibility versus the "vital" economic interests of businesses and communities. It was not rocket science to visit the shallowness of that assessment.

Woolworth's headquarters in New York had issued a statement that it was their policy to follow "local customs." As the sit-in movement spread to other cities in the South, the business mantra was the same, that government could not dictate whom private businesses should serve, and that integrated businesses would suffer economically, causing a negative ripple effect on the entire community.

Meanwhile in Washington, legislative minds that were less encumbered by moral timidity, and whose legislative rear ends were less cushioned by special interest bucks, finally figured out that on the economic freeways of the nation there were many federal regulations that helped facilitate businesses, not the least of which was the Interstate Commerce Clause.

This would ultimately mean that discrimination against blacks was not an option for a hotel in Atlanta that served interstate travelers. It meant that Ollie's Barbecue in Birmingham, Alabama, which had mostly local patrons, but served food that was shipped across state lines, could no longer refuse to serve blacks, or that the mom-and-pop recreational park in Florida could no longer keep black families out of the swimming pool because three out of four items sold in their snack bar and gift shop crossed state lines.

One of the managers of the S&W Cafeteria in Greensboro predicted that if it had to seat blacks, the cafeteria would lose a significant amount of customers. A few years later, after moving to the *Kansas City Star*, I had occasion

to return to Greensboro and walked across to the S&W at lunchtime. It was filled with customers, both black and white.

The debate over desegregation expanded to include speculation over other venues. I found myself in a late afternoon debate with my associate editor about the goals and nature of desegregation. He was on the right side of the civil rights issue by the "moderate" standards that held sway over those considered progressives in the South. I confess I did not see the virtue in editorial moderation. How could one talk about balancing the community's "economic" interests with the fundamental possession of equal rights?

As our discussion grew heated about where integration was headed, he said with some exasperation, "Do you want them swimming in the pools?" I said, "As long as they don't pee in it the way whites do."

For the record, Greensboro closed its swimming pools rather than integrate them.

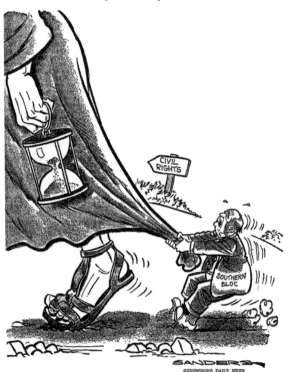

"Can't We Talk This Over, Awhile ... Say Thirty Or Forty Years?"

"No tellin' what kind of riff-raff will come in here if we can't be discriminating in who we serve!"

North Carolina and Terry Sanford

On an overcast afternoon in the summer of 1960, I sat in my car watching I. Beverly Lake standing under a tree on the grounds of a building in Smithville, North Carolina. The grounds were planted with hand-painted signs announcing "Lake for Governor."

He appeared to be looking at something on the ground and would intermittently lean slightly forward and spit on the object. The visual image of the man reminded me of "Digger" O'Dell, the friendly undertaker on the old television series *The Life of Riley*. Clad in a black three-piece suit, he was balding and thin, with a sharp face and a deadpan expression.

Shortly, two men came out and escorted Lake into the building where a political rally was getting underway. As I exited my car to follow the men, I took notice of the target of the man's saliva bombs—an ant hill.

Beverly Lake was a Harvard Law School graduate, a professor of law at Wake Forest University, and a former assistant attorney general of the state, who amused himself by spitting on ants in the manner of Tom Sawyer or Huck Finn. The dichotomy was striking.

As assistant attorney general, Lake had argued the *amicus curiae* (friend of the court) case for the state of North Carolina and its segregated school system in *Brown II* of *Brown v. Board of Education*.

He basically argued that separate did not mean "unequal"—even though the state's own statistics gave lie to that assertion. He also argued that black students were intellectually inferior to whites, citing statistics that there were more blacks who were older than normal for their grade in school.

He later gave up his job as assistant attorney general when he was not appointed as attorney general, and his segregationist expressions became more strident, even advocating converting public schools to private institutions.

After the Greensboro sit-ins, Lake decided to run for governor. A three-way race produced no clear majority and the runoff pitted Lake against Terry Sanford.

Sanford was a lawyer, long-time activist in the Democratic Party, and a former state senator who had a reputation as an articulate, progressive thinker who believed quality education was the key to curing North Carolina's social-infrastructure tunnel vision.

Sanford's philosophical idol was Frank Porter Graham, a former president of the University of North Carolina and civil rights moderate who was appointed as a U.S. senator by Governor W. Kerr Scott. When Graham ran for reelection, he was soundly defeated by a segregationist, Willie Smith.

Sanford absorbed this lesson and crafted a campaign to carefully avoid any direct reference to racial issues unless asked. When the subject came up, he would dance around the question, saying, for example, that he was giving it "prayerful consideration."

There was little honor to found on the path to school integration anywhere in the South, and North Carolina was no exception. The Southern model for responding to the U.S. Supreme Court was to design loopholes through

"THESE LIL' OL' AMENDMENTS ARE JUST WHAT YOU NEED, SON!"

"Now, Will The Real Terry Sanford Please Stand?"

which states might avoid integration altogether or at least delay it for as long as possible.

As he avoided the racial issue, Sanford articulated a campaign to dramatically fund education and raise teachers' pay. He advocated increased funding for special education and proposed a system of community colleges to bring educational opportunities closer to the population.

However, the Beverly Lake campaign became more aggressive and accused Sanford of being for "mixing the races."

Sanford's response was completely disingenuous and counter to the image he was so carefully cultivating for the campaign. He said in a radio broadcast, "Professor Lake tried to set up a storm to run against. He is injecting a false issue on integration and it is false because I am and he knows I am opposed to integration. The difference is, that I know how to handle it and he doesn't."

I must confess here that I never heard those words nor read them in print prior to his becoming governor. In retrospect, I was embarrassed when I

"Remember Me, Dearie? I Won In 1928!"

Above right: The Al Smith presidential candidacy of 1928 exposed the fears of Southern Protestants, who believed the Pope would dictate his policies. John Kennedy's candidacy of 1960 evoked the same response.

confronted my naiveté in letting that get by me. There was no comfort in the knowledge that most of the editorial writers also missed that boat or chose to ignore it.

Therefore, the question was never asked of Sanford, if he was not for racial integration, how would his "going about it" be different in implementing the U.S. Supreme Court's decision that required integrating the schools?

Sanford continued his campaign rejecting Lake's segregationist hard-line rhetoric while appealing to moderate yearnings to keep the schools open and integration policies in the hands of local government.

At some point during the campaign, U.S. Senator John Kennedy sent brother Bobby to North Carolina to persuade Sanford to support JFK rather than Lyndon Johnson for president. Reluctant at first, Terry Sanford became the first major Bible Belt political figure to endorse Kennedy, which took considerable political courage in the face of the region's anti-Catholic bias.

The irony was that Sanford's political tactics and nature were more like those of Johnson than Kennedy, but he admired Kennedy's energetic and

articulate leadership, comparing him to Franklin D. Roosevelt.

SANFORD DEFEATED LAKE BY eighty thousand votes and his election as governor was hailed as a rare victory of a moderate over a segregationist in a Southern state during that era.

The real Terry Sanford was then revealed in the unfolding of his term as governor when he said at a press conference, "The time has come for American citizens to quit unfair discrimination and to give the Negro a full chance to earn a decent living for his family, and to contribute to higher standards for himself and for all men."

Governor Sanford was destined to become an icon of white Southern liberal leadership. He went on to fight for desegregation, banned discrimination in state employment practices, and established the North Carolina Fund to battle poverty among the state's youngest citizens. This latter effort would become the model for President Lyndon Johnson's Head Start program.

"We Can't Afford Bread—How About A Pack Of Cigarettes!"

To fund his education programs, Sanford maneuvered a tax bill though the legislature that included a controversial sales tax on food. His taxing courage did not, however, extend to the Tar Heel state's sacred cow, the tobacco industry.

On that issue, I drew a father and son at a grocery store checkout counter with the father saying to the son, "We can't afford bread. How about a pack of cigarettes?"

Several days later, I followed Governor Sanford's entourage to a school in Fayetteville that was impacted by students whose parents were stationed at Fort Bragg. I had made arrangements through the governor's office to do some sketches for a feature article.

As Sanford strolled from a student body assembly to an administrative office, he spotted

"There! I Knew You Could Do It!" "Here's That Apple I Promised You, Teacher!"

me among a group of bystanders and came over and extended his hand for a shake. With a sly grin he took my right wrist with his left hand and placed the palm of his right hand into my right palm, saying, "I hope you're getting some better ideas here than you had last week."

As he walked away grinning, I looked down in my palm to see a package of Camel cigarettes. That was pure Terry Sanford: a shrewd politician with a down-home manner and sense of humor.

AS FATE WOULD HAVE it, my wife and I would discover that the state's first lady, Margaret Rose Sanford, shared Sanford's "down-home" manner.

We were invited to a reception at the executive mansion in Raleigh and after some consideration decided that it would be an excellent opportunity for me to observe some of the state's political pushers and movers outside of their normal habitat.

A very thin line separates personal relationships with public figures and conflicts of interest for journalists who write or draw about them. While I

recognize that pitfall, I also believe that some personal contact gives a dimension to a subject that you can't obtain through distance and media. The real danger is getting caught up in the celebrity of it—which, sadly, is a virulent infection in today's so-called television "journalism."

Since we never frequented such high company, I had to rent a tuxedo and Joyce had to make a dress for the occasion. I had never worn a tuxedo and felt like a penguin, walking very upright to keep the button studs from popping out of the stiff front of the shirt.

As it turned out, Margaret Rose was a gracious and friendly host with a soft Southern accent. She and my wife spoke the same language.

Joyce had learned prior to our trip to Raleigh that Margaret Rose Sanford was from Hopkinsville, Kentucky. On the edge of Hopkinsville was the small rural crossroads of Herndon, where Joyce and her twin sister spent time in the summers with her grandmother and visited with her twin uncles.

When Joyce mentioned this in her conversation with the First Lady, Margaret Rose replied that she not only knew the twin uncles but had dated one of them briefly when she was a girl.

As we drove back to Greensboro, we contemplated the small-world aspect of the Hopkinsville, Kentucky, connection and the role that fate was still playing in our lives.

10

Hollywood and Jayne Mansfield

One of the perks of political cartooning is belonging to the Association of American Editorial Cartoonists and attending an annual convention.

Fortunately, the *Greensboro Daily News* viewed that as a professional plus; either that or they felt I needed all the help I could get and that such help might be forthcoming if I mingled with veterans in the business. So in May 1961, Joyce and I boarded a plane for a meeting in Los Angeles.

There was the usual scheduled mix of social activities and business meetings, plus Walt Disney invited us to be his guest at Disneyland.

Getting a bunch of opinionated cartoonists together to discuss "business" is somewhat like putting cats and dogs in a tow sack. Our main session was devoted to whether we should pursue a cartoonist exchange with Russia that had been worked out through the U.S. State Department. The problem was that the Soviet Union did not tolerate political cartoonists in the same sense that we did.

Krokodil was a Russian satire magazine in which three cartoonists collaborated to produce social satire cartoons. The State Department approved their visit to the U.S. and, potentially, our visit to Russia at a later date. The three *Krokodil* cartoonists came to the United States, and two promptly defected—which didn't do a lot for American-Soviet relations.

So here we were in Los Angeles debating whether to pursue getting State Department approval for our cartoonists to go to Russia. It quickly degenerated into a verbal slugfest between the reactionary, anti-communist majority and the liberals (i.e., "socialist, communist sympathizers").

The *Chicago Tribune*'s Cary Orr was something of a crusty "Dean" of old-school political cartooning and a staunch conservative—slightly to the right of Attila the Hun. He was about to retire and he had never condescended to come to an AAEC meeting until this one. He only came this time because he

was to be featured on the television show *This Is Your Life*.

He vociferously led the opposition to sending anyone to Russia, finally rising to his feet and saying if he came face to face with "communists and I had a gun I'd shoot 'em!" His sentiment carried the day and the exchange notion was turned down.

While this was going on, the cartoonists' wives, including Joyce, were bused to Twentieth Century Fox studios where they were given a tour and saw Celeste Holm filming *Bachelor Apartment*.

Their tour host turned out to be Jayne Mansfield, Hollywood's new blonde sex symbol who was touted as a rival to Marilyn Monroe. While she had some success in the Broadway and Hollywood versions of *Will Success Spoil Rock Hunter*, Mansfield's popular celebrity was in large part due to her voluptuous figure—a 40D bust and 22-inch waist.

In an extemporaneous gesture, Jayne invited the wives to visit her home—which they readily accepted. At the time, Mansfield was married to Miklos (Mickey) Hargitay. They had two children, Miklos Jeffrey Palmer (Mickey Jr.) and Zoltan Anthony. Jayne had a ten-year-old daughter, Jayne, by a previous marriage.

Hargitay was a plumber and carpenter before getting into bodybuilding and gaining the Mr. Universe title. They had purchased a Sunset Boulevard forty-room Mediterranean-style mansion that was formerly owned by Rudy Vallee. Jayne and Mickey had painted the house pink with pink cupids surrounded by fluorescent lights, pink furs in the bathrooms, and a heart-shaped bathtub. Mickey had also built a heart-shaped pool, and the place was quickly dubbed "the pink palace."

Jayne proved to be a gracious host, allowing the wives to make themselves at home looking around. Her ten-year-old daughter took over the hosting when her mother had to opt out, briefly, for an interview.

While the wives were impressed by the plush living quarters—they were asked to observe the family custom of removing their shoes for the sake of the white carpeting—the real coup de grâce was the master bedroom and bathroom, with pink carpeting, heart-shaped bed, and gold-tiled heart-shaped bathtub.

The bus driver who was following the wives around asked Jayne if he could use the telephone to call his wife. When his wife answered the phone,

Mickey Hargitay, (holding Miklos), Zoltan, Jayne Mansfield, and Jayne Marie (Jayne's oldest child from previous marriage). Miklos, often called Mickey Jr., is the one we babysat for—he was five at the time.

he exclaimed, "Guess what? I'm in Jayne Mansfield's bedroom with my shoes off!"

More than a few disgruntled cartoonists questioned the convention planning wisdom that scheduled men to debate communism while their wives were visiting a blonde sex symbol.

BY 1962 MANSFIELD'S FILM career was flagging and Fox did not renew her contract, though she remained a popular high-profile celebrity, successfully doing public appearances and performing in night clubs. Her celebrity enjoyed a particular boost in 1963 when she was the first mainstream star to appear nude in a movie (*Promises, Promises*).

In March 1963, I received a phone call in my office at the *Daily News* from the owner of the Plantation Supper Club on High Point Road. He had booked Mansfield, who was coming to the area for public appearances. He had read the *Daily News* account of Joyce's visit with Mansfield when we were in Los Angeles, and he invited us out to the Club to have dinner, visit with Jayne and Mickey, and watch the show.

It was a pleasant, low-key evening. While Jayne remembered the cartoonist wives' visit, her conversation with Joyce turned to a more mundane nature involving children and common interests. We had four daughters. Jayne had left two of her children in Los Angeles but had Mickey Jr. with her on this tour.

Mansfield also had made several trips to Tokyo, where we had lived for two years, and it turned out we had a mutual friend in Al Ricketts, an entertainment columnist for *Pacific Stars and Stripes* who had lived in our Toyko apartment complex.

To understand what ultimately transpired during this visit, you must know that my wife is a guileless earth mother whose warmth and openness nourishes positive responses from almost everyone she meets. At some point during the conversation, Jayne spoke with some concern about Mickey Jr. being im-

mersed in the hectic crowds of shopping center appearances such as the one she was scheduled to make the next afternoon, but she was also conflicted with anxiety at the thought of "agency" babysitters.

I suggested that they might let Mickey Jr. spend the afternoon at our house, since we had four daughters, two of whom were within Mickey's age range and would be delighted to have him for an afternoon playmate. The Hargitays seemed genuinely pleased at the offer and made arrangements for me to pick up their son at their motel.

Mickey was a well-mannered, handsome little boy of five, with a tousled shock of long blond hair, who immediately fell into the boisterous rhythm of cowboys and Indians in our backyard, though he wasn't quite sure what to make of a broomstick horse.

Our girls were not used to seeing a boy their age with such long hair and occasionally slipped and referred to him as "she."

At "supper time," Joyce placed a glass of milk at each of the kid's plates. When asked if he liked milk, Mickey shyly said he liked chocolate milk. Joyce whipped out a can of Hershey's Chocolate Syrup, poured it into his milk, and stirred it vigorously. With wide-eyed fascination, he picked up the glass and drank. He allowed as how it tasted "different"—but in a neutral, not hostile tone. In most ways, Mickey was just like any other five-year-old kid who was well-parented.

It was dark when I returned him to the Hargitays' motel. Without prompting, Mickey thanked me and said he had a good time. Jayne expressed her appreciation for giving Mickey some time away from the tour routine.

As I was walking away, I was amused to hear Mickey telling his mother, ". . . and she made chocolate milk, right there on top of the table!"

11

Lyndon Johnson to the Rescue

During my time at the *Greensboro Daily News*, the North Carolina General Assembly was never a hotbed of geniuses.

The Tar Heel State had lost a congressional seat after the 1960 census, and redistricting became a major priority in 1961. The Democratic-controlled General Assembly decided to use the opportunity to dump Representative Charles R. Jonas, the only Republican in the state's congressional delegation.

Doing this required considerable creativity in redrawing district lines—which, of course, would be guided by the partisan gerrymandering instinct that lurks in the breast of every legislator.

In their efforts to shift Republican-leaning areas from under Jonas, one district ended up being shaped like a thin jagged snake that slithered from Charlotte north to Winston-Salem and High Point.

The results placed Democratic U.S. Representative Paul Kitchin in Jonas's Mecklenburg lair and also diluted Democratic Representative Hugh Alexander's base in his district.

In October 1962, when the Democrats stepped back to view their handiwork and calculate the possibilities, the error of their ways became apparent—and they sent for Vice President Lyndon Johnson to help salvage the seats that could be in jeopardy.

The previous month, I had been in Washington on a background junket and was in the Capitol around lunchtime. After I left the Senate press gallery, I passed a small dining alcove off the Senate dining room and ducked in to have lunch. At one of two long tables I found a seat next to a big bear of a man with a bushy head of prematurely graying hair. He wore rather thick glasses that were propped over a pair of chubby jowls. I introduced myself. My lunch companion turned out to be George Reedy, Vice President Johnson's administrative assistant.

We had a most amiable lunch. Reedy waxed eloquent on a range of topics other than politics and seemed to be a storehouse of trivial and not so trivial facts. He in turn was intrigued that a political cartoonist would seek depth beyond the surface situations reported in the media and was interested in how we went about finding just the right metaphor for any given political or social issue.

This was the beginning of a friendship that would extend through the years and facilitate valuable contacts and experiences for me professionally.

That October, I wrote Reedy asking if I could join the vice president's entourage in Charlotte and do some sketching and feature writing on his campaign efforts to bolster the two Democratic congressmen. Reedy phoned to say that Johnson was agreeable and that I would be riding in one of the caravan limousines.

"If it moves, salute it!" goes an old motto for young Army recruits. Lyndon Johnson's motto for campaigning was "if it moves, shake hands with it." Sporting a ten-gallon smile and a Texas drawl, the kingfish of Southern Democrats did exactly that during his whirlwind probe into the lower Piedmont area of North Carolina.

Using his patented, homespun vernacular, he preached the party gospel in Salisbury, Statesville, and Charlotte. It was pure hominy and black-eyed peas—and the faithful ate it up.

In Salisbury, Governor Terry Sanford joined the party for lunch and was seated next to Johnson. In between the telling of tales and laughter, Sanford and Johnson would lapse into what appeared to be serious conversation in the language of political soul brothers.

At the end of this whirlwind campaign, the caravan returned to the Charlotte airport on a route that took us down a four-lane road divided by a

JOHNSON PAUSES to chat with Gov. Terry Sanford at Salisbury.

lush green median strip. At one point we passed a golf course with a fairway that ran right beside the road. As we approached, I saw a golfer had climbed over the small fence and was in the median with a golf club, poking around in the tall grass for his ball.

Our caravan consisted of five motorcycle policemen leading the way, a Secret Service limousine, the vice president's limousine—official flags flying—another Secret Service limousine, and four trailing limousines occupied by various officials and the press.

As this rolling menagerie roared past, the wayward golfer never looked up.

This little vignette of the golfer ignoring the ostentatious caravan turned out to be a perfect metaphor for the voters of the two gerrymandered districts. Despite Lyndon Johnson's whirlwind efforts, Republican Charles R. Jonas defeated Democrat Paul Kitchin and Democrat Hugh Alexander was edged by Republican James Broyhill.

12

John Kennedy

In January 1963, the winter in Washington had a crisp, electric quality that was a metaphor for the political climate surrounding the Kennedy administration.

Kennedy had won the presidency in 1960 by one of the closest electoral margins in U.S. political history. To many, and especially to white Southerners, he was suspect as the first "Catholic" president and for his presumed civil rights sympathies. Others were concerned about his youth and fortitude on foreign affairs.

However, many in America and Europe were charmed by Kennedy's charisma, humor, and intelligence. After supporting an ill-fated Bay of Pigs invasion by Cuban expatriates, he demonstrated his foreign affairs backbone by going eyeball to eyeball with Nikita Khrushchev, pressuring the Soviet Union into removing its missiles from Cuban soil.

I had made the trip to Washington from Greensboro to attend a White House news briefing, engage in some battery recharging on the Hill, and listen to the State of the Union speech. I contemplated how fortunate I was that the whims of fate had placed me in the path of a job opportunity of a lifetime, at a quality newspaper that enjoyed an excellent reputation among its peers.

By the time Kennedy defeated Richard Nixon in 1960, I had a fair amount of exposure by means of reprints in national publications.

As a senator campaigning for president, Kennedy had requested several of my originals

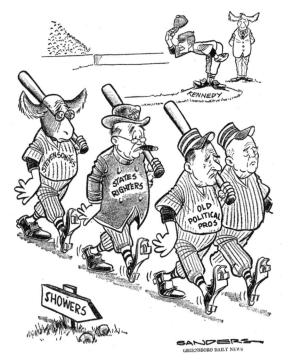

No Hits, No Runs, No Errors

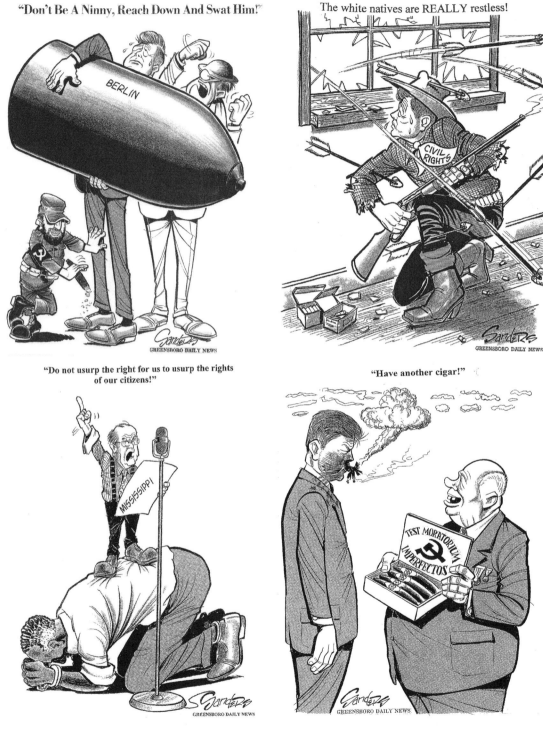

"Don't Be A Ninny, Reach Down And Swat Him!"

The white natives are REALLY restless!

"Do not usurp the right for us to usurp the rights of our citizens!"

"Have another cigar!"

through his personal secretary, Evelyn Lincoln. One of the first was a cartoon critical of the anti-Catholic bias that was rampant in the South. Then after he was president, Lincoln continued to write occasionally to ask for particular drawings.

The day after that 1963 State of the Union speech, I walked from the Willard Hotel down the street to the White House gate. The president's press secretary, Pierre Salinger—who had extended my invitation to the briefing—had arranged my entrance to the West Wing.

While there existed a briefing room in the White House in 1963, Salinger often had reporters simply crowd into his office for a more informal session, which was my experience that morning.

I learned over the years that the ambience of the working wing of the White House often shed light on the fundamental nature of an administration. The atmosphere under John F. Kennedy was one of youth and button-down collars. The working areas were neat, but not stuffy, with a definite sense of high energy.

Salinger's office was the exception to the neatness. I took comfort in observing that he was, like me, something of a slob.

After the briefing, we chatted a bit about politics in North Carolina and Kennedy's selection of former North Carolina Governor Luther Hodges as Secretary of Commerce—a perfect choice that gave Kennedy brownie points from Southern moderates.

I was about to leave the White House and head for Capitol Hill but Salinger said to stick around, the president was busy at the moment but wanted to meet me. He was grinning so broadly that I grinned back and said, "Yeah, right." I thought Salinger was joking, but he was not, and shortly after 5:30 he escorted me down the hall and into Evelyn Lincoln's office.

Kennedy's erudition was well known. He was a reader, a student of history, and one of the most articulate presidents to inhabit the White House.

I learned he was also a man with an intense interest in artists and the arts. One of the first paintings he chose to hang in the West Wing was an abstract impressionist piece by Willem de Kooning. It was in stark contrast to the traditionalist style of most of the other art in the White House.

Salinger introduced me to Lincoln, a thin, soft-spoken, gracious woman in her early fifties with her black hair done in the same style as Jackie Kennedy's.

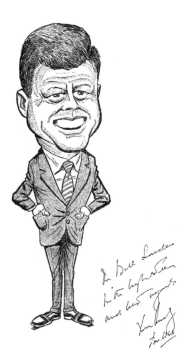

Kennedy signed this caricature I had drawn of him, but Press Secretary Pierre Salinger had to decipher the inscription: "To Bill Sanders. With high esteem and best regards. John Kennedy, Jan. 1963."

After brief pleasantries, Salinger ushered me into the Oval Office. Hanging to the right of the doorway was the original of one of my cartoons.

Salinger introduced me to the president, who smiled broadly, shook my hand, and was encouragingly casual. He asked about the ownership of the *Greensboro Daily News* and seemed somewhat familiar with its progressive reputation in North Carolina.

He asked about the routine of producing a daily cartoon and wondered how it was for me as a Southerner supporting civil rights. I told him about my experience with the sit-in movement that started at Woolworth's lunch counter in Greensboro and about the public marches and demonstrations that followed that event. While our conversation was only a little over fifteen minutes, I sensed nothing casual about his interest in grievances due to segregation.

Little did I know at the time that his interest in North Carolina was deeper than it seemed. He had been musing over dumping Lyndon Johnson and getting Governor Terry Sanford as a vice presidential running mate in his 1964 reelection bid.

When Salinger indicated it was time to move on, I asked the president if he would mind autographing a drawing I had brought with me. He agreed. When he looked at it, he laughed and said, "Well, one of us has to lose some weight in these cheeks and I think it would be easier if you did it with your pencil."

As we were leaving, the president called me back saying there were a couple of people he wanted me to meet. He then introduced me to Secretary of State Dean Rusk and Secretary of Defense Robert McNamara. Earlier in the year, McNamara had requested a couple of originals. We shook hands, spoke briefly, and Rusk joked about politicians growing to look like their caricatures by political cartoonists.

As we walked back to Salinger's office a younger man called out, "Wait up," as he hurried towards us. It was Ted Sorenson, the president's speechwriter, who had seen in the *Washington Post* Sunday section a particular cartoon he liked.

During the flight back to Greensboro, I reflected on the visit and the brief conversation and concluded that the torch had indeed passed to a new generation and truly a new vision was inhabiting the White House.

13

Detour to Kansas City

In the latter part of 1962, Bill Mauldin had a negotiating rift with the powers that be at the *St. Louis Post-Dispatch* and moved to the *Chicago Sun-Times*, leaving a plum position open at one of the nation's iconic liberal newspapers.

I really wanted that job and, as often is the case with rookies in any chosen profession, I thought I stood a good chance of getting it. In a fog of ambitious hubris, I quickly wrote a letter asking for consideration and packaged samples of work to go with it.

In response I was asked to send more samples, which further fed the old ego. As time passed without a summons, the old ego slowly deflated and the fog of hubris dissipated. Both completely disappeared when I read that the *Post-Dispatch* had hired another rookie, Tom Engelhardt.

As it turned out Tom was a fine thinker and drew in a style similar to Daniel Fitzpatrick, one of the old, great political cartoonists. Ironically, Tom and I became good friends and our families often enjoyed meeting and camping together at Alley Springs, Missouri.

My motivation to move to a larger newspaper was never primarily about money. Though more money was pleasant to contemplate, I could never entertain the idea, even with a growing family, of trading the freedom to express my own opinion for a bigger paycheck.

However, I encountered that possible dilemma in early 1963 when I received a letter from a colleague, Charles "Chuck" Werner of the *Indianapolis Star*. He informed me that the political cartoonist for the *Star's* afternoon "sister" paper was retiring and asked me to send some samples of my work.

Chuck was some fifteen years older than me and was considered one of the better "conservative" cartoonists. My description of his politics would place him far to the right in our profession—but we enjoyed a mutual addiction to golf. Why he suggested me for the opening, I'll never know.

Bill Vaughan, columnist for the Kansas City Star, *who was responsible for my move to the newspaper.*

I knew that if Chuck recommended me and I sent some politically middle-of-the-road material—not that I had a lot of middle-of-the-road drawings, but one could always cherry-pick from a body of work—there was a good chance I might get the job, and a fair salary increase to boot. In the end, I sent a small package of recent and strongly opinionated cartoons that would not contribute to any ambiguity about my political leanings. That was the end of that and Chuck never spoke of it again.

SHORTLY THEREAFTER I RECEIVED a letter from Bill Vaughan, author, humorist, and syndicated columnist for the *Kansas City Star*. He said the *Star* was looking for a political cartoonist to replace S. J. Ray, who was retiring.

It was obvious that Vaughan had typed his own letter. I liked that—and I liked the laid-back, down-to-earth feel of its succinct narrative. I responded positively, if for no other reason than to see where it might lead.

In his second letter, he admitted, "I was probably not very truthful in my first letter. I have been touting you for the cartoonist's job for several weeks because I liked your stuff and subscribed to the Greensboro paper so our thinkers could get better acquainted with you. I am a mere columnist but I am trying to lead the management out of the darkness in picking a cartoonist. I want a good one!"

Bill Vaughan was not "a mere columnist," as he described himself. He was an icon at the *Star* and with his "Senator Soaper" column enjoyed a national reputation as a Will Rogers-type commentator.

His popular aphorisms published under the title "Starbeams" in the *Star* were widely quoted. For example, his take on urban development: "Suburbia is where the developer bulldozes out trees, then names the streets after them." His evaluation of our allegiance to democracy: "A citizen of America will cross the ocean to fight for democracy, but won't cross the street to vote in a national election."

Bill Vaughan was the nation's first tweeter!!

At the editors' invitation, I was flown out to Kansas City for an interview.

While all this was very flattering, I had done some homework and learned that while the *Star* was one of the ranking U.S. newspapers, it also had a "staid" and "conservative" reputation both in its makeup and in its politics.

The Kansas City Star building on Grand Avenue was as pedestrian as its newspaper typography—a nondescript two-story brick structure resembling a warehouse.

Walking into its second-floor city room was like stepping back in time. There were no offices. Just a vast array of desks, each equipped with an old typewriter and a bronze spittoon. Roy Roberts, the legendary publisher, had more floor space around his desk than anyone else. Editor Dick Fowler was second in the floor-space pecking order. In descending order was the editorial page editor, Bill Vaughan, the editorial writers, and a spot that was apparently reserved for me.

Roy Roberts, iconic president and publisher of the Star.

I was assured that a desk, drawing board, and filing cabinet along editorial row—as opposed to S. J. Ray's spot back in the art department—was a sure sign that the *Star* was catching up with the twentieth century.

Moreover, I was assured that Roy Roberts liked President John F. Kennedy and the *Star* was inclined toward supporting him and was thus straying from the Republican reservation.

Fate had played such a major role in the course of my life, I contemplated long and hard if this was its fickle finger pushing me past my misgivings towards this move. Of course, more than doubling my salary was no small influence.

Ultimately, I really liked Vaughan. He was a journalist's journalist and he was to become a dear friend and mentor. If Bill could live with this newspaper, I decided that I should give it a try.

One of the type of cartoons I drew early on that resulted in speculation by other Kansas newspapers.

After the story of my joining the *Kansas City Star* appeared in *Editor & Publisher* magazine and the *Star* did a promotion piece, the *Wellington* (Kansas) *Daily News* wrote this editorial:

The *Star*'s Cartoonist

The *Kansas City Star* has a new editorial page cartoonist, young fellow name of Sanders. His early efforts show him to be an excellent artist and draftsman whose pictures and ideas have impact. Also it would seem that he has been given the freedom to express his convictions without either dictation or censorship by the editors of the newspaper. Sanders' productions have already marked him as a liberal of decidedly positive views. It will be interesting to watch the response from the *Star*'s readers, most of whom have been satisfied with the generally conservative or moderate tone of the newspaper.

Little did the Wellington editor know how prescient his observation would prove.

14

Harry Truman

In 1959 the No. 1 song on *Billboard* was "Kansas City," written by Wilbert Harrison and made famous by Fats Domino. In his lyrics, Harrison wrote nostalgically about "Standing on the corner of 12th Street and Vine with my Kansas City baby and a bottle of Kansas City wine."

Obviously, Harrison was writing about Kansas City, Missouri, not Kansas City, Kansas, where in the 1960s one could not buy a bottle of wine no matter on which street corner one might stand.

The huge metropolitan area was sprawled across the state line that separates Kansas from Missouri, but if you drove out into the suburban residential areas, you would never know when you passed from Missouri into Kansas and vice versa.

One of the obligations for me as a new member of the *Kansas City Star* staff (the first "outsider" in a decade) was to become familiar with the area and its pushers and movers. Part of the duty to show me around fell on the shoulders of Ray Morgan, who covered Kansas politics for the *Star*.

After touring downtown Kansas City, Kansas, and its political habitats, Ray suggested we go for drink, which sounded fine with me. We drove up a side street past nondescript structures and parked in front of a narrow brick building with no neon lights or signs to indicate its role in the Kansas City economy.

We walked up the stone steps to a concrete stoop, where Ray rang the doorbell. To my amazement, the small square decorative panel in the upper half of the door slid open, revealing an intense pair of eyes topped by thick, black, bushy eyebrows. After a brief pause, there was a glimmer of recognition and the door opened. We were shown into a regular-looking cocktail lounge.

I marveled that here in Kansas City, in 1963, was a speakeasy right out of the 1920s. Not only Kansas City but the entire state was "dry." I was told that until recent years commercial airlines could not serve liquor while flying

over Kansas air space. I never found out if that story was true but it certainly could have been.

THE STATE LINE WAS a demarcation for the social and political schizophrenia that was evident in the character of the metropolitan area.

Missouri was a more or less Democratic state whose urban area, Kansas City, produced somewhat less than stellar candidates for political offices.

On the Missouri side, the obligatory tour included the city and county political habitat but also its cultural icon, the Nelson Museum. The other absolute "must" in the orientation was a visit with former president Harry Truman at his Truman Library.

So one afternoon I was taken to the Truman Library and given a tour that ended with meeting Mr. Truman in his office. It was a casual affair that was generally cordial in tone. It was explained to Mr. Truman that I was taking S. J. Ray's place as political cartoonist for the *Star*.

Ray had spent his professional life at the *Star*, first as an illustrator and then as its editorial cartoonist from 1931 to 1963.

"There! That Makes You A Dark Horse Instead Of A Missouri Mule!"

Truman's response was strikingly neutral. He did remark on Ray's long service and wished me success. He allowed as how he read the *Star* every day, even though it was not overly friendly to Democrats.

While Harry and Bess Truman were always open to communications from the *Star* staff—often accepting phone calls seeking their reactions to events—it was widely suspected that Truman never really forgave the *Star* for its opposition to his early political career. I sensed that he suspected I would follow the same drumbeat that he found annoying.

Truman was never the subject of a straight political comment from me. I did draw a cartoon—which he requested for the Truman Library—that peripherally involved him. I also learned that he had kept track of my frequent

criticisms of the Republican opposition to President Johnson's social programs.

On a subsequent visit to the Library and Mr. Truman, I sensed that he had concluded that I marched to a different drummer than he first expected.

Toward the end of April 1964, a prominent Kansas City businessman along with Truman friend Jack Benny were planning a big eightieth birthday party for the former president. Benny was to be the main speaker. Truman had apparently made some favorable comments about my cartoons and the planners phoned to ask if I would draw a cartoon to be printed on the program for the dinner.

I was invited along with some three hundred other guests and was seated right in front of the long head table and speakers' podium.

As the crowd began to settle into their seats, Mr. and Mrs. Truman were escorted to their places just to the right of the podium, almost in front of our table.

KANSAS CITY STAR, FRIDAY, JUNE 25, 1965

"Things Haven't Changed So Much Since You Left, Harry"

THE KANSAS CITY STAR

It occurred to me that if I were ever to get a signature from the former president for my autograph collection, now was the time. I took the program with my cartoon on the back page and walked around behind the head table.

Upon seeing me, Truman turned and extended his hand, which I shook and wished him a happy birthday. He chuckled, said he had gotten "a kick" out of the cartoon, and thanked me for contributing it for the program and the original for the Library.

He readily agreed to autograph my copy of the program. With a twinkle in his eye, he handed it back to me and whispered, "There was a time when this might have gotten you fired at the *Star*."

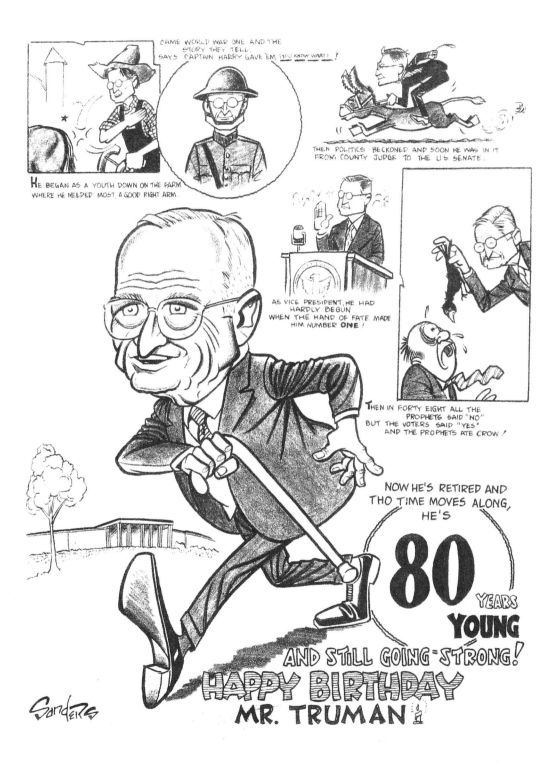

15

Extremism in Defense of . . .

If one quote had to best articulate the early 1960s, I would nominate this one by Barry Goldwater: ". . . extremism in defense of liberty is no vice . . . and moderation in pursuit of justice is no virtue."

When the Sanders family settled into their new home in Kansas City in July 1963, the subculture of extremism had swept across the Midwest in quest of various lost "liberties" as seen in the eyes of its beholders.

For some it was extremism in the defense of segregation. For others it was extremism in defense against "socialist government." For some, it was extremism in defense against communist subversion. For most, the paranoia was a package of all of the above.

George Wallace rode the crest of a "segregation forever" landslide into the governorship of Alabama in January 1963 using rhetoric that was red meat to prejudiced tendencies across the country. Later that summer, his "stand in the schoolhouse door" at the University of Alabama, plus his bigoted bombast, crackled across the synapses of those on the border of paranoia—and those ready and willing to exploit that border for personal and political gain.

The continuing reverberations from the Greensboro sit-ins and the path President Kennedy laid out in his civil rights proposals fed into those circuits.

The reality of school desegregation for equality played out within institutions that were isolated from most daily social intercourse—not many adults spent time in schools before or after the *Brown* decision.

However, most adults did exercise their social habits in public accommodations from time to time—and when the impending equality in restaurants, bars, motels, and such loomed large in the national consciousness, then suddenly, it was up close and personal.

Public equal rights was not only an affront to segregationists, but it was a coalescing force among those with strong anti-government sentiments, particularly those who embraced the outer edges of a libertarian view.

The John Birch Society, an ultra-conservative "Patriot" group founded in 1958 by candy manufacturer Robert Welch Jr., claimed a 1961 membership of more than 100,000 and up to a million (perhaps grossly exaggerated) "sympathizers."

The bible of the Birchers was Welch's *Blue Book*, a transcript of a two-day-long lecture in which he equated the U.S. and Soviet governments as being controlled by "cabal of internationalists" bent on a "New World Order." He considered liberals to be "secret communist traitors." He called President Dwight D. Eisenhower a possible "conscious, dedicated agent of the Communist Conspiracy."

And of course the John Birch Society opposed the civil rights movement because Welch believed it to be rife with communists.

The battle over civil rights in public accommodations was in full swing when I started drawing for the *Kansas City Star* in 1963. Those rights were delineated in Title II of the Civil Rights Bill proposed by President Kennedy,

"WELCOME TO TH' MAINSTREAM, BARRY!"

THE KANSAS CITY STAR

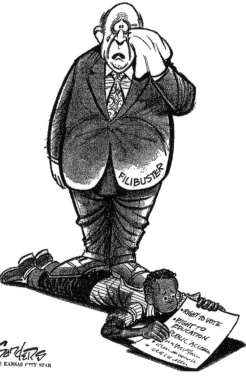

"THOSE TERRIBLE OLE SENATORS ARE TRYING TO SUPPRESS MY RIGHT OF EXTENDED SPEECH!"

THE KANSAS CITY STAR

and as it was an ongoing issue, I started drawing about its critics from day one.

It was not a Johnny-One-Note crusade. I was also drawing cartoons about the growing U.S. involvement in Vietnam, the U.S.-Soviet Union talks on a nuclear test ban treaty, and Barry Goldwater's maneuvering for the Republican presidential nomination.

It just so happened that each of those issues touched some nerve in the subterranean paleoconservative culture of the Kansas City area.

Also active in this fringe milieu was Robert Bolivar DePugh, a financially successful veterinary medicine entrepreneur who founded Biolab Corporation in the small town of Norborne, Missouri, in the late 1950s. By the early 1960s DePugh had organized and recruited a militant militia group called the Minutemen. They believed a communist invasion was coming and their mission was to amass a cache of weapons and train in guerilla warfare.

Taking a page from the John Birch Society's book, the Minutemen were dedicated to eradicating communist spies they "knew" infested our government. DePugh published *On Target*, a monthly magazine with a logo image of a telescopic rifle sight with the mantra, "Traitors beware, the crosshairs are on the back of your neck." My name was superimposed under the crosshairs for some time.

While some media regurgitated DePugh's exorbitant claims about his followers and influence, Harry Jones, a great reporter for the *Star*, put DePugh's paranoia in perspective: ". . . his ideas were so out of whack . . . the great majority of people laughed him off as a kook."

THE EDITOR OF THE "Public Pulse" section of the

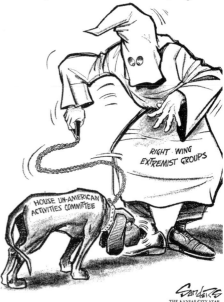

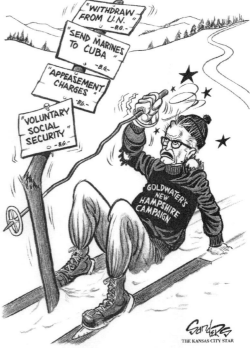

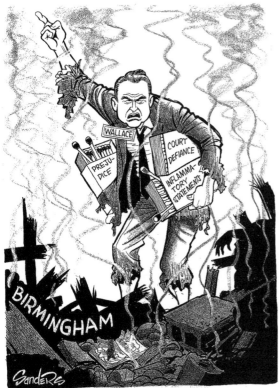

"Damned outside agitators!"

paper came to me after a few weeks on the job and said, "We've had more letters to the editor in a month over your cartoons than we've had total in the last five years."

I began to get anonymous letters at the *Star* addressed to "Nigger Lover Sanders" and dripping with what in most cases was illiterate venom. Other letters, more literate but no less enraged, began to pile up from local bar owners.

At home, we began to get the phone treatment. The phone would ring sometime before 8 a.m. and a fairly calm voice would inquire "are those cartoons you put in the paper your ideas or your editors'?" I would inform the caller that they were my ideas—to which he (or she) would announce in an aggravated tone, "Well, you're both nigger lovers!"

Five or ten minutes later the phone would ring and a different voice would ask if I knew that "thousands of people are being killed and tortured over in Africa every day and that the nigger agitators over here are communist-inspired?"

The next caller would want to know, "Why don't you go back to Russia with the rest of the communists?"

One caller warned, "We don't like communists and pinkos out here and if you keep putting those drawings in the paper you'll find out how we treat 'em!"

My wife had learned to handle the phone treatment with aplomb—like the time she answered the phone from an irate caller who raged, "Is this where that son-of-a-bitch lives?" She responded in a calm Southern accent, "Why, yes, it is. Would you like to speak to him?"

I had to give one of my critics an "A" for creativity. He placed an ad using my phone number in the *Star* classified section that read, "1960 Chevrolet hardtop, stick shift, clean, top condition, must sacrifice at $200." The ad ran on a Sunday and the phone started ringing at 6 a.m.

The first caller was a car dealer from Springfield, Missouri, wanting to

come up and buy the car that day. The phone rang frequently all day. We recognized one repeat caller, who finally chuckled, "Isn't this driving you crazy?" My wife and I had an engagement that night, so we took the phone off the hook, wrapped it in a towel and told the baby sitter to ignore it.

ONE OCTOBER AFTERNOON I was seated at my drawing board in a corner of the large room that housed the editorial staff. As I previously indicated, there were no individual offices at the *Star*, just rows of desks. My space, consisting of a drawing board, small desk, and a filing cabinet, was across the room opposite the stairwell entrance from the first floor.

As I sat making some preliminary sketches, I heard a commotion and the loud clatter of something crashing to the floor. Looking up I saw a uniformed postman wading past reporter's desks, knocking off papers and in-boxes.

He had his mail bag over one shoulder and was shoving objects and people out of his path as he headed directly towards me with a fixed glare in his eyes. Chasing several feet behind him was our security guard.

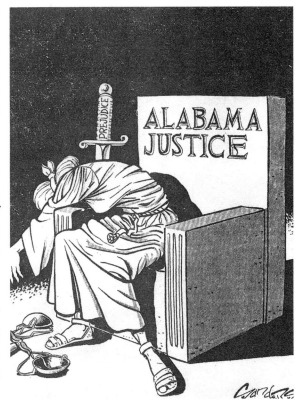

About halfway through his charge, the man reached into his mailbag. My first thought was that he had a gun. My second thought was "this drawing board is not going to stop a bullet." My third thought was "get behind the filing cabinet, you dummy"—which I did.

The security guard caught the man a few feet from me. As the guard yanked him by his neck to a stop, the man's hand pulled a sheaf of papers from his bag and threw them in my direction, yelling, "Put these in the paper, you son-of-a-bitch!"

The papers scattered into the air then fluttered to the floor like large snowflakes. They turned out to be copies of white supremacist cartoons. I picked up one to examine it. It depicted a large black man leering as he choked a little white girl.

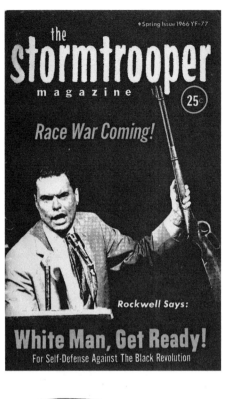

Top: Stormtrooper *magazine, published by neo-Nazi George Lincoln Rockwell, featured propaganda articles and crude, bigoted cartoons. Bottom: "Whiteman" was a racist comic strip drawn by John Patler.*

A number of the cartoons were signed, "Patler." It was a name that would resonate in the media a few years later and take me back to that city room episode.

Patler's real name was Yanacki Christos Patsalos, the only son of poor Greek immigrants living in New York. The father murdered the mother because she left him. Yanacki was a dysfunctional adolescent and a gang member who at age sixteen was suspected of murdering a friend but was never arrested. When he became old enough he joined the Marines.

After serving in the Marines, he became enamored with George Lincoln Rockwell's American Nazi Party. He changed his name to John Patler because he thought "Patler" sounded like "Hitler."

He became the editor and cartoonist for Rockwell's magazine, *The Stormtrooper*, in which he drew a comic strip titled "Whiteman." The main character was drawn like Superman but with a swastika on his chest instead of an "S." Whiteman spent his time battling "the Jew from Outer Space" and "Supercoon."

On August 25, 1967, Rockwell was shot to death while leaving the Econowash laundromat at the Dominion Hills Shopping Center in Arlington, Virginia. Patler was arrested, tried, and convicted for the murder. His motive was never revealed.

MEANWHILE, SENATOR BARRY GOLDWATER'S 1964 run for the GOP presidential nomination dovetailed with the coalition of far-right agitation and, theoretically, gave some credibility to the idea of a "conservative resurgence." It also ratcheted up a notch the extremists' anti-government animosity and agenda.

The local John Birch Society began a campaign to get 10,000 *Star* subscribers to cancel their subscriptions because of my cartoons.

The national media began to take note of the various extremist activities and found themselves on the receiving end of residual ire from right-wing zealots. About this time, Rick Friedman, a reporter for *Editor & Publisher*, wrote a feature piece for the magazine about the extremists' campaign against me.

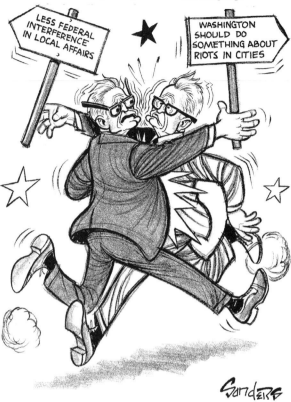

"Hey! Why don't you watch where I'm going!"

As Goldwater closed in on the Republican nomination, his rhetoric and ultra-conservative proposals made him a frequent target of my cartoons—much to the dismay of Kansas City's silk-stocking business elite. I began to feel pressure to tone down my criticism of Goldwater and his far-right supporters.

There was no direct effort at restriction, just a steady expression of discomfort with the tone of my cartoons that was enough to diminish my professional comfort at the newspaper. Frankly, I was coming to the conclusion that I would have to leave the paper.

Some months after the *Editor & Publisher* article, I received a phone call from Norman Cousins of *Saturday Review*, a national magazine of considerable stature at the time, asking about the extremists' pressure on the *Star* and me. He indicated that they were putting together a piece on extremists and the press. I referred him to the *Editor & Publisher* story.

Shortly thereafter, I was in Jefferson City observing a session of the state House of Representatives when I received a phone call from James F. "Jim" Fixx, a reporter at that time for *Saturday Review* with the assignment of writing the article about extremism and the press. Years later, Fixx became the author of the 1977 bestseller, *The Complete Book of Running*, and was credited for helping start America's fitness revolution.

As it turned out, *Saturday Review* had decided to use my experiences at the *Star* as the focus for the entire story. Fixx, while interviewing me, explained that he had already spoken with my editor, Richard Fowler.

He quoted Fowler as saying, "Sanders got under a lot of people's hides" and added, "We had letters from as far away as Florida, California, Ohio, Indiana, and Mississippi."

Fixx indicated Fowler waxed eloquent on how these extremists had to be "identified, diagrammed and diagnosed," which I found amusing in view of the palpable in-house discomfort at our editorial conferences.

The publicity of the *Saturday Review* article seemed to give the *Star*'s hierarchy some backbone and somewhat abated the growing tension that I perceived. It allowed me a more comfortable zone for another year, after which I did move on to the *Milwaukee Journal*.

Ironically, the Barry Goldwater embraced by Republicans in 1964, and the darling of the right-wing extremists, said in 1989 that the Republican Party had been taken over by a "bunch of kooks." This turned out to be an appropriate forecast for what would be happening to the GOP by 2010.

16

The Ultimate Extremist Act

On November 22, 1963, the largely inattentive American conscience was finally impacted by the assassin's bullet that took the life of President John F. Kennedy. I write about it here only in the context of the extremist subtext that was being played out across the country.

A bubbling caldron of fanaticism and paranoia took the form of one Lee Harvey Oswald, who fired the fatal shot. My initial reaction to the news that fateful day was certainty that right-wing fanatics had finally succeeded in acting out their venomous feelings. That was, of course, wrong.

Oswald, it turned out, was a pathetically insecure individual who as a fourteen-year-old was described as having a "personality pattern disturbance with schizoid features and passive-aggressive tendencies."

As a young man, Oswald embraced Marxism as a means of becoming "somebody." Incongruously, he joined the U.S. Marines, where his anti-American spiel and troubling behavior earned him the nickname "Oswaldskovich." He got a "hardship" discharge from the Marines and emigrated to Russia, where he renounced his American citizenship and married a Russian.

Oswald's leftist fanaticism was eventually destined to cross paths with the far-right fanaticism of General Edwin A. Walker.

In 1961, Walker was commander of the 24th Infantry Division in Germany, where he set in motion an anti-communist indoctrination-propaganda program for troops under his command. He also distributed literature from the John Birch Society and gave an interview with the *Overseas Weekly* newspaper in which he described Harry Truman, Eleanor Roosevelt, and Dean Acheson as "definitely pink."

U.S. Secretary of Defense Robert McNamara relieved Walker of his command, and Walker resigned from the Army on November 2, 1961, vowing to continue his crusade against internal communist subversion.

In 1962, he traveled from his home in Dallas to Mississippi to stand by

Governor Ross Barnett's effort to keep the University of Mississippi from being integrated by James Meredith.

Walker declared the nation to be in "disgrace" and "dire peril" because the Kennedy administration was forcing civil rights compliance. After his involvement in the riots surrounding Meredith's enrollment, Walker returned to Dallas. Meanwhile, in Russia, Lee Harvey Oswald subscribed to *The Worker*, a Communist Party newspaper, and read its front-page story on Walker's activities. In 1962, Oswald returned to Dallas and became convinced that Walker was the leader of "a fascist organization."

In 1963, Walker continued to make news by joining forces with right-wing evangelist Billy James Hargis and called on the U.S. military to "liquidate the scourge" of the Castro regime in Cuba.

Oswald decided to assassinate Edwin Walker and purchased a mail-order Cancano rifle to carry out his plan. He took up a position outside the Walker home and fired through a window as Walker was seated at a desk working. The bullet was deflected when it grazed the windowsill and missed its target.

It was later determined by testing that the bullet fired at Walker was "extremely likely" from the same batch as the bullet manufactured by Western Cartridge Company that killed President Kennedy.

The stunning news of Kennedy's death set me to work on a cartoon comment for the next day's *Star*. However, obituary cartoons are very difficult for most of us in the profession because we are basically critics.

What is an adequate metaphor for a mourning nation?

I decided that the Statue of Liberty was, for me, the symbol of what this nation was about, so I drew the lady with her head bowed, grief-stricken. My colleague Bill Mauldin chose Abraham Lincoln as his symbol—head bowed, grief-stricken. Both cartoons found their way into hundreds of scrapbooks, along with thousands of cartoons that appeared in other newspapers around the country. None, however, could fully speak to the empty spot in our collective souls.

In Memoriam

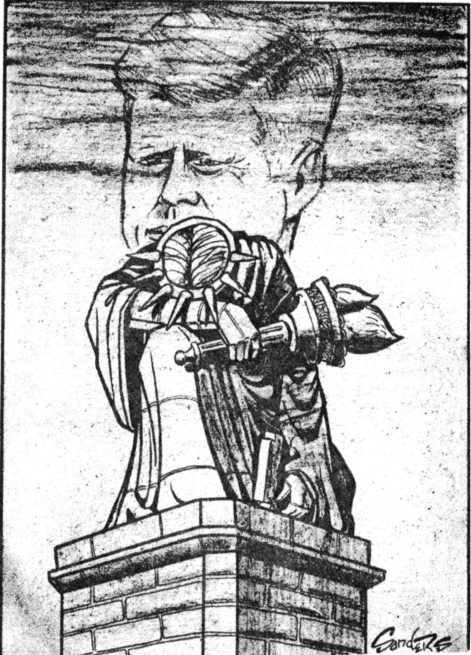

Sanders
THE KANSAS CITY STAR

17

For Whom the Bell Tolls

It has always been a mystery to me that Christian religion is beyond criticism or debate in polite society—one who dares question its behavior is at the least a heathen and probably doomed to hell. Given that, I should have known better than to do what I did in September 1964. Alas, I am a slow learner. Suing a Catholic Church is not high on the list of things to win friends and influence people, particularly if one is in high-profile conflict with people who see communism and socialism being forced on them by big government and who believe they should not have to associate with people of color.

We lived in a small house at the end of a cul-de-sac in Prairie Village, a suburb of Kansas City, Missouri, but located just across the state line in Kansas. The south side of our lot bordered a large, open, grassy field behind St. Ann's Catholic Church. In August 1964, St. Ann's installed some very large and very loud church bells, which they then began ringing for about five minutes at 6 a.m. every day—calling to worship the nuns and anyone else within a mile radius. While I was not moved to worship, I was certainly moved to wide-eyed consciousness every morning by the incessant ringing.

After a few weeks, I decided to complain to the priest-in-charge-of-disturbing-the-peace. The priest, wearing the benign smile of the truly righteous, listened patiently and gently informed me that not only were the bells important as a call to worship, they were important messengers of God's love for the community—even if I could not seem to grasp that message. He implied that if I would just meditate on God's message, I would have a change of heart.

Well, I meditated every 6 a.m. Then I decided to take my grievance to a Prairie Village City Council meeting, where I found that others had also meditated without finding enlightenment. Our complaints were to no avail: Christians 1, Heathens 0. So I moved to the next bureaucratic level, going to the police and swearing out a complaint against St. Ann's for disturbing the peace. This, of course, made the village newspaper, *The Scout*—which alerted

the community to the dangerous heathen in its midst, which resulted in the righteous circling the wagons in defense of this assault on God's bronze messengers.

Then the letters and cards began to come in, telling me I should be ashamed and should pray for God's forgiveness. One card said, "Hello Pantywaist—All of us here at the back of Westport Post Office will gladly change places with you." It went on to describe the noise made by the mail trucks but added, "There are churches of all denominations close by and the bells are music to our ears."

There was a ripple effect on our family. Occasionally our girls left their tricycles in the front yard. One morning, we found they had been stuffed into a garbage can. Ding-dong!

Having grown up being taught that our courts were the source of justice and equality, I studiously researched and found court opinions in Philadelphia and Texas that held under narrow circumstances that such bell ringing was a public nuisance. Armed with those precedents and sure that secular truth would prevail, I strode into Prairie Village Police Court to obtain justice from Judge Harry Roark. I and my fellow witnesses testified that the early morning bell ringing invaded our bedrooms at an hour normally exempt from loud and excessive noises. We cited the Prairie Village ordinance prohibiting loud and excessive noise at certain hours in residential neighborhoods.

Charles E. Wetzler, city prosecuting attorney, said the situation could be compared to a performance of an aria by an opera star outside one's window at an early hour. It would be a pleasing sound but possibly disturbing to someone trying to sleep. Talk about damning with faint praise.

Roark dismissed the case, announcing to all that "churches are the basis of all law and order, and they need every provision to call their worshipers to prayer. We owe a great deal to churches of this country. The teachings of our churches do a great deal to maintain our way of life." Before the trial, Roark had privately told a *Star* reporter, "If anyone thinks I'm going to rule against the church, they're crazy." Christians 2, Heathens 0. Plus, I learned a valuable lesson about our lower court system of justice.

Epilogue: Later, neighbors who were members of the church told us that many parishioners also disliked the early morning bells and finally expressed their feelings to the priest. The bell schedule was changed to 7 a.m.

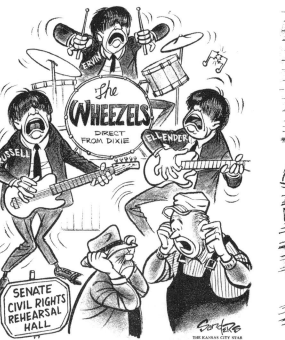

"I UNDERSTAND THEY'RE VERY POPULAR IN THEIR OWN COUNTRY!"

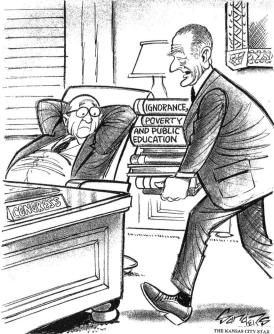

"FRIEND, YOU AND I ARE GOING TO DO A LITTLE HOMEWORK!"

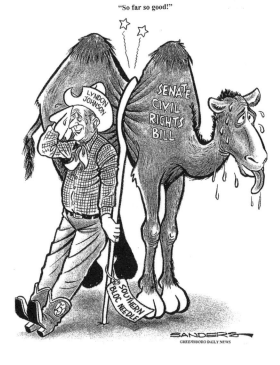

"So far so good!"

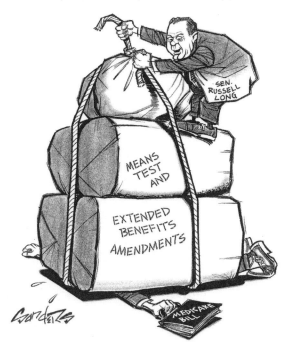

"YOU SHOULD CARRY THIS EVEN IF IT KILLS YOU!"

18

Lyndon Johnson and the Great Society

In 1964, a rock and roll quartet from Liverpool, England, landed on American soil and the U.S. music scene was instantly changed. The unlikely named Beatles and their mega-hit "I Want to Hold Your Hand" swept the country, leaving a trail of thousands of shrieking teenagers and young adults.

That same year, a cocky young Cassius Clay predicted that he would beat world heavyweight boxing champion Sonny Liston. "I will float like a butterfly and sting like a bee," Clay brashly announced—and took the title on a seventh-round TKO.

Meanwhile, in the aftermath of John Kennedy's assassination, President Lyndon Johnson presented the most ambitious legislative agenda of social programs since Franklin Roosevelt's New Deal.

On January 8, Johnson's State of the Union message outlined his "War on Poverty," which would be fleshed out with programs that would facilitate civil rights, Medicare, Medicaid, and public broadcasting and establish the Office of Economic Opportunity.

During the early part of 1964, while Johnson rallied the nation to his social agenda, U.S. involvement in Vietnam's civil conflict was not much on the radar of the major media and certainly not on the minds of most Americans.

That summer, the Goldwater campaign resonated in the press, as did the brutal, ugly nature of segregationist bigotry. The year was punctuated with racially motivated murders and Southern police brutality against civil rights demonstrators. In July 1964, LBJ signed into the law the most sweeping civil rights act since Reconstruction, giving the federal government the power to enforce desegregation.

However, as the year unfolded, the long, dark shadow of Vietnam began creeping across the American consciousness.

In August a U.S.-contrived confrontation in the Tonkin Gulf between North Vietnamese torpedo boats and the U.S. destroyer *Maddox* became the

'However, If You Survive Vietnam Don't Expect to Live Next Door to Me When You Get Back'

launching pad for air strikes against North Vietnam. On August 7, 1964, Congress passed the Tonkin Gulf Resolution that stated it "approves and supports the determination of the President, as Commander in Chief, to take all necessary measures to repel any armed attack against the forces of the United Stated and to prevent any further aggression."

Johnson was now authorized to make war without declaring war.

PRIOR TO MY ANNUAL trip to Washington in the spring of 1965, I had been drawing cartoons about the critics of social legislation, the Selma-to-Montgomery civil rights march and the Voting Rights Act proposed by the president, among other political and local issues.

Increasingly, however, second- and third-tier stories about Vietnam were edging into the news. There were stories about air strikes against Laos and North Vietnam, the commitment of U.S. combat troops to Vietnam, and anti-war demonstrations.

Working for the *Kansas City Star*, I had established a communications relationship with Missouri Senator Stuart Symington, a highly respected member of the U.S. Senate Committee on Foreign Relations, and lunch with him was part of my Washington agenda. In preparation for that opportunity to pick his brain about Vietnam, I researched the history of French Indochina, Ho Chi Minh, and the evolution of U.S. involvement in Southeast Asia.

Meanwhile, I had been receiving frequent requests for cartoon originals from Willie Day Taylor, President Johnson's longtime assistant, and I was still in contact with George Reedy, who was now LBJ's press secretary. I wrote Reedy giving him the dates of my trip and requesting a visit to the White House. He replied with a brief but gracious invitation.

In the latter part of April, I was admitted to the West Wing for a visit with Reedy and to deliver a couple of cartoon originals to Mrs. Taylor. After a brief visit with Reedy, he left for a staff meeting and turned me over to Taylor.

Willie Day Taylor turned out to be a delight. She was a short, full-figured

woman in her fifties, with gray hair framing a wonderfully warm, round face, perpetually adorned with a smile. She reminded me of Aunt Bea of the Andy Griffith Show.

She thanked me for the cartoon originals and insisted that I call her Willie Day. She said, "I hope you don't mind if we continue to bother you for our favorites when we see them." I thought, what a sweet talker—and I did not detect an iota of insincerity.

I had drawn a pencil portrait of the president and brought it with me, hoping that I could persuade George Reedy to get the president's John Henry on it for my collection. Willie Day looked at it, then smiled broadly and teased me about sucking up (not her words) by doing a somewhat flattering portrait rather than a caricature. She added, "Of course, he'll love it!"

She told me to feel free to look around, as I had indicated the wish to do some shorthand sketches of the working area for possible use as realistic background material for future cartoons. However, she gently reminded me that the other surrounding office areas were off-limits.

After about thirty minutes, Reedy came back in and escorted me to his office, where we chatted a bit about the Republican opposition to the social programs that were being put in place by the administration.

I showed him the sketch of Johnson and asked if he would try to get the president to sign it so that I could pick it up later in the week. Reedy said, "No, but you could get him to sign it when I take you in there in about fifteen minutes."

When we entered the Oval Office, President Johnson was just finishing a phone conversation. He hung up and Reedy introduced me as "the *Kansas City Star* political cartoonist whose cartoons you have been collecting." Johnson maneuvered around his desk and shook hands and motioned for me have a seat in a chair near his desk. He indicated to Reedy that we should have a few minutes to visit and George left the room.

"Would you believe guns and margarine?"

THE KANSAS CITY STAR

Almost immediately, the president asked if I had an opportunity to meet former President Truman since moving to Kansas City. He expressed his admiration for Truman and said that as soon as the Medicare bill was finalized, he would be going to Independence to visit him.

I am well aware that a healthy stream of cynicism should be in the DNA of political cartoonists and columnists, but I found it impossible to doubt President Johnson's sincerity when he spoke eloquently about redeeming the nation's obligation to care for the needy and to foster civil rights.

At the first opportunity I asked the president how he reconciled U.S. military action in Vietnam given the history of Ho Chi Minh's efforts for Vietnam independence—an effort that was crushed by the British when they supported French rule in the area.

What emerged from the resulting lecture was a view of a man much less empathetic in foreign affairs than the man who was author of sweeping social legislation in the United States. It was obvious Johnson had bought into the Dwight Eisenhower "domino" theory that a Vietnam unified under Ho Chi Minh would ultimately result in Laos, Cambodia, and Thailand falling under "communist rule."

His response was neither lengthy nor bellicose. It was brief, candid, and modulated in a mellow Texas drawl like that of a patient teacher instructing a pupil. Then he said, "I don't know about you, but I'd better get back to work." He then moved from behind his desk as if to escort me to the door.

I quickly extracted my drawing of him from its folder and asked if he

would mind signing it for my collection. He examined it, smiled, and allowed that it was a good likeness.

Then he turned, opened a desk drawer, and from it handed me a large, coin-shaped bronze medal, saying, "Take this. This fellow does a dandy job." It was a very romanticized visage of the president's face in relief sculpture.

The visit then took a bizarre turn. As Johnson led me across the Oval Office toward the secretary's office, he pulled me to a stop facing a closed door. We no sooner had faced that door than it swung open, revealing a short, Asian man aiming a camera at us. Click! Click! Click! He snapped three rapid pictures and closed the door. Then President Johnson shook my hand and turned me back over to George Reedy.

The purpose of that strange "photo op" was never revealed to me, nor did I ever see a copy of the picture. I suspect it was simply a routine that was part of Lyndon Johnson's awareness of documenting his legacy. In the coming years, I took part, in groups of journalists, in other meetings and "photo ops" with LBJ.

Ultimately, Johnson's bipolar "guns and butter" policies were unsustainable and led to his decision not to stand for reelection in 1968.

At a reception later in the year Johnson chided me about spending too much time in Washington.

19

On to Wisconsin

Late one afternoon in the spring of 1967, I was called by an old friend, Jim Lange, cartoonist for the *Daily Oklahoman.* He and his wife, Helen, had stopped at a motel in town on their way back to Oklahoma City from a trip to Wisconsin.

We made arrangements for Joyce and me to meet them after work. It turned out to be a meeting that would facilitate a huge change in our lives. Jim and Helen had visited in Wisconsin with Ross Lewis, longtime political cartoonist at the *Milwaukee Journal,* and Jim casually mentioned that Ross was about to retire, which got my attention big time!

On the first day I went to work for the *Greensboro Daily News,* I picked up a copy of the *Milwaukee Journal* from the pile of out-of-state newspapers on our editorial staff table. The *Journal* reminded me of the *New York Times* in its makeup and typeface, with one big difference—there on its front page was a crisp cartoon by R. A. Lewis.

Over the years, I came to know Ross Lewis personally and through his cartoons. We shared similar political views. He was going to retire and I was looking to leave the *Kansas City Star* for a more compatible editorial climate—it appeared to be a golden opportunity.

As a result of that visit with the Langes, I phoned Ross to wish him all the best in his retirement and to ask if he would suggest my name as a possibility for the list of candidates the *Journal* editors might be considering. Ross replied that he had already done so and the editors were wondering if I might be available.

Shortly thereafter, I received a phone call from the editorial page editor and we agreed that I would fly up for an interview the following week.

The *Milwaukee Journal* was everything I had imagined a major daily newspaper to be. It was housed in a five-story building, of relatively modern architectural design, located downtown by the river and near cultural and

government buildings, four blocks from the main shopping district. Its lobby reflected Old World classic design.

The *Journal* city room, aside from the normal journalism culture of clutter, was modern in its technology and setup. Around its perimeter were modern glass-front offices, including a row for the editorial page editor, the editorial writers, and the political cartoonist.

The interview was casual and cordial. We reached agreement on salary and details related to my moving from Kansas City in August. Importantly, the *Journal* agreed to honor my contract for national syndication, which I had recently signed with Publishers-Hall Syndicate.

THAT AUGUST, THE HOUSING market in Milwaukee proved to be very tight. Not wanting to make a precipitous commitment, Joyce and our daughters went to stay with her uncle Gene Graham, then a professor of journalism at the University of Illinois, and I checked into the downtown YMCA to live while working and looking for housing. The Milwaukee "Y" was a modern high-rise building, somewhat resembling the United Nations building in New York. I had a room on the fifth floor the first night before I was scheduled to go to work.

Around 9:30 p.m., I began to hear crowd noise wafting up from the street. Peering out the window, I saw a milling crowd of a hundred or so people, carrying signs, and chanting something I could not make out.

I went down into the lobby to investigate and found a demonstration against the

My first cartoon for the Milwaukee Journal.

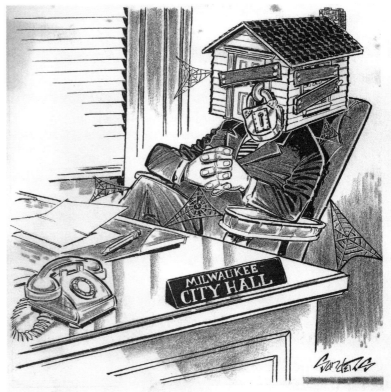

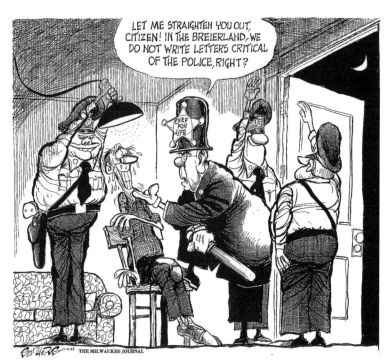

Milwaukee area's de facto housing segregation that was maintained by means of mortgage discrimination, redlining, and school district boundaries.

The demonstrators were predominantly young African Americans with a scattering of white youths. The apparent leader was a fortyish bespectacled white priest, Father James Groppi, who went on to become an icon of civil rights leadership and a habitual pain in the side of the Milwaukee area establishment.

Father Groppi and the demonstrators' push for open housing was the catalyst for my first cartoon in the *Milwaukee Journal.* I had no way of knowing that drawing would set a tone for years of contention between Mayor Henry Maier and myself.

Maier took a non-negotiable position that he would not endorse open housing legislation until the surrounding suburban communities desegregated their housing.

That first day at work, I drew a cartoon of the mayor seated behind his desk. A small house covered his head, with a front door that was padlocked. The caption read "Closed Housing." The next day, the *Journal* received three letters in response to that cartoon.

The first letter would set the tone for many such reactions to come—and would be a reminder that "Northerners" were no more immune from bigotry and prejudice than Southerners. It said, "Your man Sanders may think he's smart but he doesn't know the nigger and his ways. If he is so damn anxious to integrate, why doesn't he move into 6th and Walnut or to Vliet St."

Civil rights would remain an issue in the year to come, contributing to a bubbling cauldron of animosity that included rising anti-war sentiment over U.S. involvement in Vietnam.

WE ENDED UP BUYING a lot in the small western suburb of Elm Grove and pursuing our dream of building a house to suit our particular tastes. I designed a round, two-story house with a circular stone fireplace wall at its center. To save money, I drew the blueprints and acted as the general contractor.

As we started construction, our welcome to the neighborhood came in the form of a petition circulated by one of our future neighbors, apparently disenchanted with my cartoons, suggesting that the signatories did not want us living in Elm Grove.

As Joyce and the girls settled in anyway, I was finding Milwaukee to be a treasure trove of characters who were never-ending fodder for critiques of social and political issues.

Mayor Maier was a man of enormous ego who genuinely could not understand nor tolerate dissent from his policies. Police Chief Herald Brier was a curmudgeon from another era whose job and attitudes were heavily insulated from the normal legal restraints of discipline or removal. Unlike the mayor, the chief never publicly responded to his critics—implying that critics were unworthy of his attention.

The undisputed star of flamboyant hubris, however, was Milwaukee Circuit Judge Christ Seraphim. As part of my orientation to the area, I spent an afternoon sitting in the gallery of Seraphim's court, watching him belittle defendants, set wildly disparate bails, and ignore precedent with the declaration, "Seraphim has ruled!"

The next day I drew my first cartoon of the judge. I depicted him in a "star's" dressing room powdering his face before a brightly lit mirror. Beside him were a roulette wheel for bail amounts and a Joe Miller joke book.

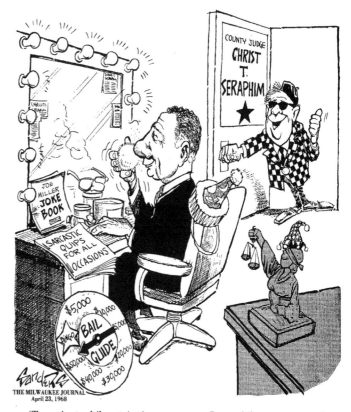

'Two minutes 'til curtain time . . . er . . . I mean 'til court convenes!'

Seraphim's belief that he was God's gift to women ultimately led to his downfall. Rumors of his peccadilloes had long floated around our reporting staff but without corroborating evidence.

The judge was prone to three-martini lunches and after-work barhopping, which allowed opportunities to put the make on female targets of opportunity. One rumor involved a well-known opera diva the judge encountered in the lobby of the Marc Plaza hotel after her performance. The judge reportedly volunteered to escort her to her suite, followed her into the bedroom, and tried to kiss and grope her. This scene was interrupted when the singer's entourage burst into the suite for an after-party.

One of Milwaukee's better-known watering holes was at Timmerman airport, a facility mainly for private and general aviation. One afternoon, Joyce and a female friend were waiting by the fence at the arrival deck to pick up a clarinet player who was flying in via his own plane to play a gig with my band. Judge Seraphim strolled out of the airport bar and spotted the two women out by the fence. Coming on to them, he strolled up and said, "And what are you lovely ladies doing out here today?"

Joyce replied that they were there to pick up someone.

Moving into their personal space, Seraphim smiled broadly and introduced himself, "I am Judge Christ Seraphim."

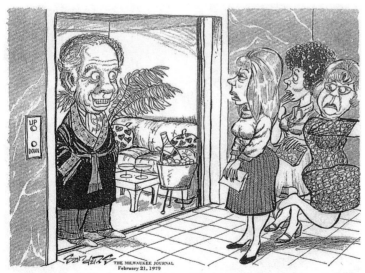

'No thanks, Judge Seraphim. We'll wait for an elevator that's less crowded!'

"I know who you are," Joyce replied, adding, "and you know my husband."

"And who might that be," asked Seraphim.

"Bill Sanders of the *Journal*," Joyce answered.

The judge mumbled something about having had "some interesting discussions with him." He then abruptly walked away.

Seraphim's Waterloo was an elevator in the Safety Building, which, among other things, housed the district attorney's office. The

judge came in from a three-martini lunch and got into the elevator with a young woman. As the elevator made its ascent, Seraphim cornered and attempted to kiss her.

His amour was interrupted when the elevator stopped to take on more passengers and the young woman fled from his grasp. She turned out to be the DA's secretary.

I drew a cartoon on the episode that appeared in the next day's paper. One of our staff reported that when the paper was delivered to the Seraphim court, he looked at it and declared an early adjournment. He checked himself into a hospital that afternoon, refusing to talk to the press.

The Wisconsin Supreme Court subsequently suspended Seraphim for three years without pay; he never returned to the courtroom.

MEANWHILE, MAYOR MAIER HAD taken to printing up and distributing flyers rebutting my cartoons about him. He referred to me as "Colonel" Sanders.

One afternoon, while driving back from a vacation with the family in Door County, I turned on the radio. It was tuned to a Milwaukee station that periodically broadcast a message from the mayor as if it was a "live" comment. It was, in fact, a pre-recorded harangue that one could get by simply dialing a telephone number that was circulated on radio and television.

On this occasion it was a lengthy complaint about "the *Milwaukee Journal*'s Colonel Sanders" and his "wildly inaccurate and misguided" drawings. This gave me an idea. The mayor had a monthly Thursday afternoon "live" press conference at City Hall. I decided to have some fun by attending the next one dressed as Colonel Sanders, complete with a white suit, Southern Colonel hat, and string bow tie—carrying a Kentucky Fried Chicken bucket containing pencils and drawing paper.

Walking over to City Hall, I paused at an intersection, waiting for the traffic light to change so I could cross the street. When it finally did, the traffic was moving slow as I stood there dressed like Colonel Sanders holding my big chicken bucket.

An old Ford cruised by with some young African American occupants who took a curious look at me, rolled down the window and said, "You a long way from home, aintcha?"

A reporter friend had saved me a front-row seat where I waited, bucket

I didn't make enemies of all the politicians I encountered in Wisconsin. U.S. Senator Gaylord Nelson, the founder of Earth Day, was a national environmental leader who eventually received the Presidential Medal of Freedom for his efforts in conservation.

in hand, for the mayor to enter the room and take the podium. Soon the door to Maier's office cracked open and two heads peeked out at me, then retracted, and the door abruptly closed.

Moments later, right at "air time," the mayor briskly came out, laid a notebook on the podium and started talking about an appropriations matter. He kept glancing at me and stumbling over his remarks. He then stopped talking, strode over to his office door, and in a minute returned to the podium with a folder.

Opening the folder, he proceeded to recite a litany of grievances and misadventures ascribed to me—including my being suspended for drawing for an "underground" newspaper, the *Journal* apologizing for one of my drawings of Police Chief Harold Brier, and the rebellion of parents during a commencement speech I made at a state university.

At the end of the press conference, he announced that costumes would not be allowed into future press conferences. Later, he abandoned the Thursday press conferences altogether and announced that he would no longer take questions from the *Milwaukee Journal*.

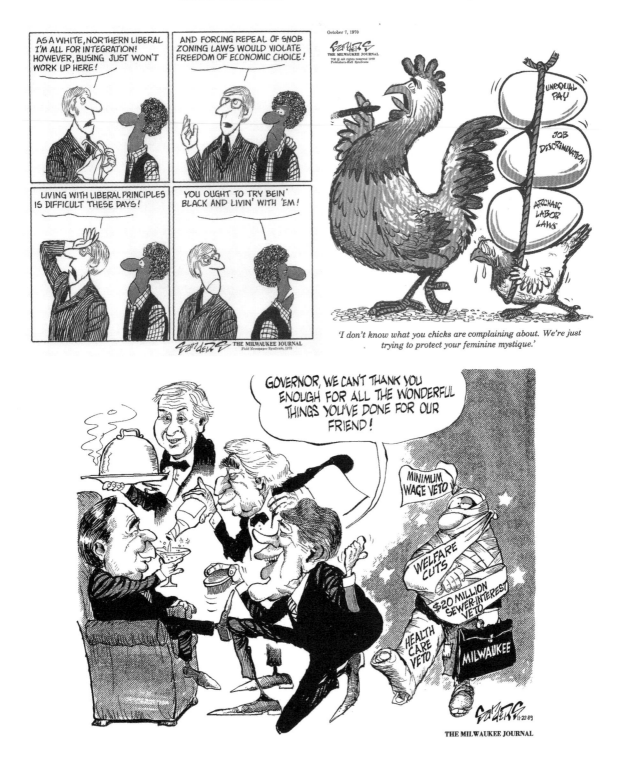

'I don't know what you chicks are complaining about. We're just trying to protect your feminine mystique.'

Vietnam

as Seen by Bill Sanders of The Journal

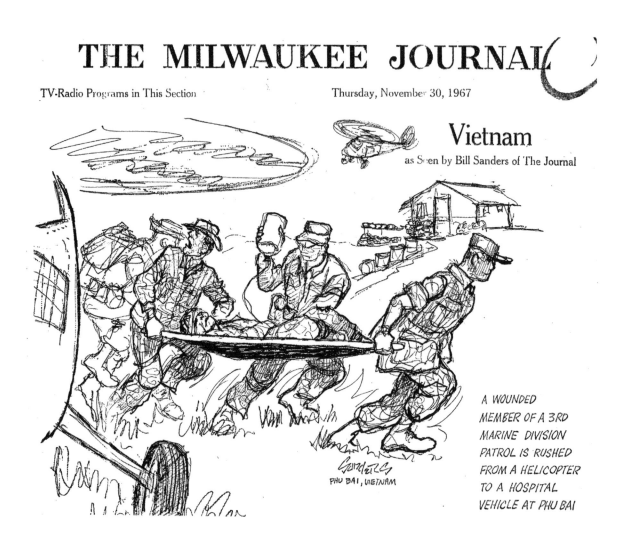

PHU BAI, VIETNAM

A WOUNDED MEMBER OF A 3RD MARINE DIVISION PATROL IS RUSHED FROM A HELICOPTER TO A HOSPITAL VEHICLE AT PHU BAI

Vietnam, Up Close and Personal

By October 1967, the profile of the war in Vietnam was expanding across the American conscience like a festering sore.

The U.S. had launched "Operation Rolling Thunder," a sustained series of bombing raids on North Vietnam by Air Force and Navy aircraft that would go on for three years. There was a rising tide of media coverage of the war—particularly television's evening news which brought the death and destruction into American living rooms, live and in color. Anti-war protesters were finding traction in their numbers and in support from "teach-ins" that sprang up in universities across the country.

Inside me there was a familiar ache to step away from the drawing board and get near the action, be it demonstrations or perhaps the war itself. I knew the *Journal* budget would not accommodate the luxury of sending a cartoonist to Vietnam, so I would settle for an occasional foray to a "war protest" activity.

However, fate placed me in the path of an opportunity to get to Vietnam by way of a USO tour. The USO tapped the National Cartoonists Society for six cartoonists who would be sent to Vietnam on a "handshake" tour.

Unlike the big-name "entertainment" tours, such as Bob Hope's, with staged elaborate shows in properly secured venues, a "handshake" tour—with no more equipment than sketch pads—could be moved in small aircraft or jeeps to remote camps and Mobile Army Surgical Hospital (MASH) units. I was fortunate enough to be included. Even though I was officially a USO entertainer, I felt no inhibitions about writing and drawing as a journalist.

The group consisted of myself; Bil Keane, creator of the comic panel, *The Family Circus*; Jack Tippit, creator of the comic panel, *Amy,* and who also drew the comic strip *Henry*; Morrie Turner, an African American, creator of the first integrated comic strip with a black main character, *Wee Pals*; Howie Schneider, creator of the comic strip *Eek & Meek*; and Willard Mullin, the great *New York World-Telegram* sports cartoonist who created the "Brooklyn

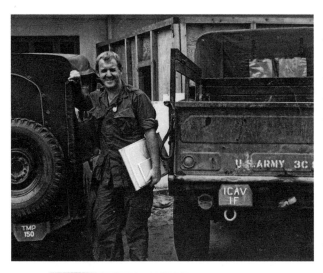

Bum" character that became synonymous with the Brooklyn Dodgers.

We were flown from our various locations to Travis Air Force Base in California, where we boarded an Air Force plane for the flight to Tan Son Nhut Air Base on the outskirts of Saigon.

This venture provided the unexpected perk of meeting and spending time with Willard Mullin. I had become a fan of his while living in Tokyo and seeing his reprints in the *Sporting News*. While in Tokyo, I wrote him a letter with samples of my work, soliciting his advice regarding my chances of a job if I returned to the states. He answered in a gently worded, hand-printed letter that finding a cartoonist's job was a "crap shoot," but encouraging me to give it a try. Mullin's talent for drawing the human figure in action reflected his classical training in anatomy. His creativity

Top, in correspondent's uniform in Vietnam. Middle, Morrie Turner. Right, with our Ranger escort (holding flag), Willard Mullin, and Howie Schneider.

in caricaturing colorful characters was superb—and to top it off, my middle name was his first name.

The other unexpected bonus was meeting and getting to know Morrie Turner. With his gentle but pointed humor, he was a pioneer in raising social consciousness. We turned out to be philosophical soul brothers and were destined to be good friends down through the years.

In Vietnam, we were split into two units of three cartoonists and transported on separate itineraries to remote camps and outposts. I went with Mullin and Howie Schneider.

We were taken to places with names like Nah Trang, Cam Ranh Bay, Qui Nhon, Phu Bai, Quang Tri and Da Nang—and to some units so remote no native names were attached to them but they were near places like Pleiku and Dak To.

Sometimes we would just move among the troops drawing sketches and fullfilling their needs to relate to something "stateside" even if it came in the form of strange guys who drew cartoons. Sometimes we would perform for a group with "illustrated" talks, hamming it up in mess hall tents or on a hillside venue.

While there were times of laughter with the troops and at ourselves—there were also dark times with bloody and maimed bodies lying in MASH units or being unloaded from helicopters. The best times were when we would see a full squad fresh from a patrol in the Delta, with no casualties.

Finally, we were shown a different perspective on the war when we were flown out to the *USS Intrepid* aircraft carrier in the Gulf of Tonkin. I had already filed some sketches and sidebar stories back to the states, but it was here that I had time to contemplate my impressions and write this narrative for the *Milwaukee Journal*:

Phu Bai, Vietnam—The young ensign stirred from an overstuffed chair in the paneled ward room of the *USS Intrepid* and said, "Sorry, I dozed off. I didn't get much sleep last night."

An Army Special Forces captain, recently out of a combat zone in Vietnam's central highlands and now temporarily aboard the carrier as our escort officer, surveyed the plush surroundings. He smiled at the young ensign and said, "Yeah. War is hell!"

In the Gulf of Tonkin while on the USO cartoonists' tour.

This brief exchange accurately circumscribes the strange nature of this much-debated war.

It is the kind of war where one can sit in a lavish French villa on the South China sea and sip a drink while listening to the crackle of automatic weapons and the thunder of 105-millimeter howitzers.

It is the kind of war where some men and machines are moving earth, pouring concrete and generating lights for cities, while other men and other machines are killing and being killed in the jungles scant miles away.

It is the kind of war where only a small body of water or a mountain range separates near-normal activities from the destruction and tragedy of conflict.

For some it is an intimate, grinding war where the enemy may emerge from the dense foliage at any minute, or death may explode from any roadbed just around the corner. For some, like the units at Dak To or Con Thien, security is a tenuous condition at best.

For others, like the men aboard the *Intrepid*, it is an impersonal war, something akin to strenuous maneuvers. It is a distant conflict of push buttons, radar and technicians. The enemy are small plots on a map and a man can relax in the evening and enjoy the Red Skelton Show over Armed Forces Television.

This is not to imply that the men of the *Intrepid* do not work hard—or that some do not risk death. They do!

For those men on the flight deck, 12-hour days are common. For those men flying bombing missions in A4 Skyhawks, there is the constant danger of North Vietnam's ground-to-air missiles.

In seven months' duty in the Gulf of Tonkin, the *Intrepid* has lost one plane. The pilot survived and is on the list of those captured by North Vietnam.

Aside from the rigorous work of the flight deck crew which launches and retrieves as many as six missions a day, a routine atmosphere prevails. The *Intrepid*'s closed-circuit TV studio keeps the men abreast of world events with its daily newscasts. The crew also enjoy boxing, smokers, USO entertainment, and excellent, plentiful food.

The men of the *Intrepid*, however, do not have a corner on the market of a near standard environment. A very large percentage of United States ground forces operates in relative normalcy.

The necessity and mission of rear echelon support troops has not changed since man began waging organized war. However, in Vietnam the scope and speed of attending to creature comforts, building permanent facilities and moving men and supplies is unprecedented in history.

For example, American forces at Cam Ranh Bay, on the northern coast of South Vietnam, are operating at near "stateside" conditions. The base bears a close resemblance to Okinawa. Troops there enjoy permanent barracks with concrete foundations, hot and cold running water, a lavishly supplied post exchange and a beautiful beach on the South China Sea. There is even a fair representation of American womanhood in the area, mostly nurses and United States aid workers.

The same is true in varying degrees at most of the major military installations in Vietnam. Only when one gets out into the field, such as the Mekong Delta or the Central Highlands, is the immediacy of war the dominant impression.

In the northern installations such as Qui Nhon and Nha Trang, the only reminders of the deadly conflict lie in the beds of service hospitals. They are incredibly young-looking men with flesh torn by rockets and mortar shrapnel—and with limbs amputated in lifesaving operations. But they are behind hospital walls.

Outside, life and activities go on. The officers' and enlisted men's clubs bustle with evening activities. A USO band rocks from an amphitheater. At the post exchange, the world's finest cameras are sold at less than half their market price.

The famous sports cartoonist Willard Mullin summed up the magnitude and scale of one side of our Vietnam operation. On a USO tour of Vietnam, he emerged from the post exchange at Cam Ranh Bay with an armful of cut-rate items including a fifth of Beefeater Gin. He said, jokingly, "This ain't a war, it's a way of life!"

For some it is. For others, it is a way of death.

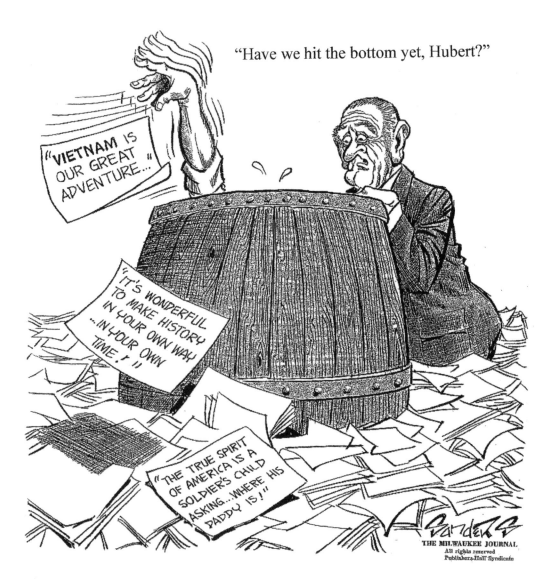

"Have we hit the bottom yet, Hubert?"

21

Ours Not to Reason Why

Ours not to reason why, ours but to do and die.

—Alfred Lord Tennyson

Vice President Hubert Humphrey, the liberal Minnesota icon, was addressing a 1967 U.S. Embassy pep rally in Saigon when he called the American war in Vietnam "our great adventure." Then he added, "It is wonderful to . . . make history in your own way and in your own time." As it turned out he was absolutely right.

About that time a book was being circulated across the U.S. titled *Why Vietnam?* It was written by Frank N. Trager and allegedly gave historical context and justification of our involvement in Vietnam. In its promotion and ballyhoo by members of the Johnson administration, there was no mention that the book was ordered and financed by the United States government at taxpayers' expense!

Its purpose? To make history in "your own way."

Reed Harris of the United States Information Agency readily admitted, "we can have books written to our own specification," and "we control the thing from the very idea to the final edited manuscript." So much for historical perspective.

Historical perspective has never been a foundation of American culture and politics. We generally take a short view of history and tend to write it like a script for a John Wayne movie.

Few Americans knew anything about the French colonization of Vietnam, Laos, and Cambodia or how it destroyed the rural peasant society, siphoned away the region's raw materials, and developed a sycophantic class of Vietnamese elite that U.S. policy would later inherit.

Fewer still were familiar with the fact that during the post–World War

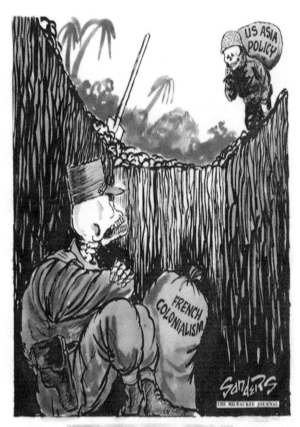

"Welcome to the slow learner's club."

I Versailles Conference, a young Vietnamese expatriate, Nguyen Ai Quoc, pleaded for independence for his people and sought American help for ending French Colonial rule. America ignored his plea and the young leader turned to the international communist movement for support.

Japan invaded Vietnam in 1940 and installed aristocrat Bao Dai as "Emperor." The French colonialist offered no resistance to orders from the traitorous French Vichy government that was cooperating with Nazi Germany. After the war, the French kept "President" Bao Dai as a puppet to use as a conduit for U.S. aid to buttress their colonial powers.

Hubert Humphrey would go on to become the 1968 Democratic presidential nominee, but his embrace of Lyndon Johnson's Vietnam policies proved fatal to his bid.

Few Americans listening to the anti-communist rants of the 1968 campaign were aware that during the latter days of World War II the U.S. was working closely in the jungles of northern Vietnam with a guerilla leader—the same man whose appeal for Vietnam independence America had spurned at the Versailles Conference, only now he was known as Ho Chi Minh.

FOR HIS PART, AFTER campaigning in 1964 on a promise that he would not send American boys to die in an Asian war, Johnson did precisely that. The greater the U.S. involvement became, the more it seemed Johnson was determined not to be humiliated by what he called a "raggedy-ass little fourth-rate power." He raised the American troop level in Vietnam from 16,000 early in 1964 to a high of over 500,000 by the end of 1968—all the while claiming he was not changing U.S. policy.

His attempts to justify the war sometimes reached comic proportions. The administration made one 1967 claim to have spotted the enemy moving 25,000

tons of arms into the south. This was based on a sighting by the military of 2,200 North Vietnamese trucks making their way south.

According to U.S. intelligence, the North Vietnamese trucks were rated at a 2.5-ton capacity. This made for interesting mathematics. At that capacity, the convoy would be carrying 5,500 tons. The remaining 19,500 tons must have been heading south on the backs of monkeys swinging down the Ho Chi Minh trail.

Lyndon Johnson's "nail the coonskin to the wall" policy became frayed with the constant abrasion of dissent and a growing awareness of the cost of the war. The burgeoning technology of the electronic media brought the war into America's living rooms every night in full color. Suddenly shorn of euphemisms, the bare bones of death and destruction were exposed.

A rising tide of dissent and disaffection ate away Johnson's public and political support. That and his health problems led to his shocking March 31, 1968, announcement: "I shall not seek, and I will not accept, the nomination of my party for another term as your president."

BEFORE I MOVED TO the *Milwaukee Journal*, the Association of American Editorial Cartoonists held its annual convention in Kansas City. John Stampone was president of the organization and had succumbed to former Vice President Richard Nixon's entreaties to let him address the meeting.

Nixon lost the presidency to John F. Kennedy in 1960, and he had been defeated in the California gubernatorial race by Democratic

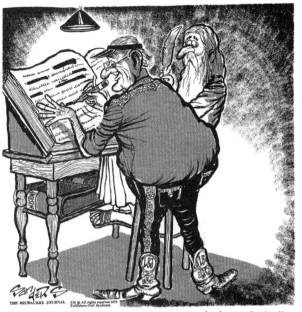

'This part about the Tet offensive being a setback . . . that's all wrong. It was a great victory. Then, this part about . . '

"Deck th' Hall With Vows of Folly . . ."

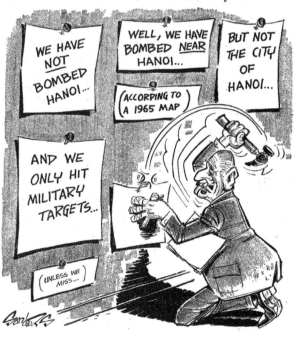

As host of the American Editorial Cartoonist meeting in Kansas City, I escorted Richard Nixon during his visit to speak to us.

incumbent Pat Brown in 1962. That was when Nixon testily told reporters, "You won't have Nixon to kick around any more, gentlemen, because this is my last press conference."

That proclamation was, as were so many in his political career, imbued with just enough sincerity to get by that particular moment.

Nixon then moved to New York in 1963 and joined the law firm of Mudge, Stern, Baldwin and Todd. It was later reorganized as Nixon, Mudge, Rose, Guthrie and Alexander and became his base for once again rehabilitating his image—in preparation for another bid to become president.

So here he was in Kansas City in May 1966, using the AAEC convention as a sounding board for his ambition. As host cartoonist, it was my role to see to the logistics of the meeting and to Nixon's needs and transportation.

On a night when a rainstorm rivaling the one that launched Noah's ark swept across the plains, I was chauffeuring the former vice president to his hotel. The torrential deluge brought traffic to a snail's pace. It was somewhat of an awkward journey because this strange and solitary man was not given to small talk—or, in fact, any talk to speak of.

Finally, I asked him to assess his chances of another GOP run for presidency. He responded with one of his pre-packaged quotes about only being defeated "when you quit." He then shifted into a third-person narrative, ending with "Nixon will still be around when the critics have gone home!"

When I told him that part of our program would be a panel on law and order as it relates to dissent by Vietnam war protesters, he launched into a monologue on the "communist" threat to Southeast Asia. His narrative on Vietnam encompassed the same view of Ho Chi Minh as those who were tolerant if not protective of the colonization of Southeast Asia by western powers.

He ended with a strange statement that anti-Vietnam war protesters were the real threat to free speech. I often reflected on this conversation as I

watched Nixon maneuver his bid for the presidency in 1968.

It was the year that Martin Luther King and Robert Kennedy were assassinated. It was a time when a confused nation was hearing Richard Nixon present himself as the voice of reason while he denounced "hippies" and promised "New leadership will end the war and win the peace."

PRESIDENT NIXON CAME INTO office with a secret plan to end the war. The plan, as it turned out, was to substitute Vietnamese bodies for American bodies. As Nixon was already saying privately in March 1968, "I've come to the conclusion that there is no way to win the war. But we can't say that, of course."

So to save face, Nixon "incurred" Laos and Cambodia. He started "protective reaction" bombing, a euphemism for dropping more bombs on Vietnam than we dropped during the entire course of World War II. The "collateral damage"—another euphemism, this time for non-combatant deaths—must have been staggering.

When I was aboard the *USS Intrepid*, in the Gulf of Tonkin, the captain took us to the bridge to show us the results of a bombing raid on North Vietnam. "This was a vital bridge we took out yesterday," he announced proudly as he ran his finger along the aerial photo taken after the bomb run. One could easily see the bridge had been destroyed. What struck me, however, was a swath of destroyed villages that seemed a mile wide on each side of the bridge.

The landscape of the Vietnam War was littered with lies, deceptions, and embarrassing quotes:

"We should declare war on North Vietnam. . . . We could

I arranged to do some sketching at the U.N. General Assembly when U.S. Ambassador Philip Goldberg was chairing the session. As I was working, Attorney General Robert Kennedy came in with three of his children and sat across from me. I had not met him personally, but we had corresponded over a cartoon original he wanted. I did a quick sketch of the kids, not for publication. Unknown to me, the U.N. had assigned a photographer to discreetly follow me around.

*pave the whole country and put parking strips on it, and still be home by
Christmas." — Ronald Reagan, 1965*

*"I see light at the end of the tunnel." — National Security Adviser Walt
W. Rostow, December 1967 (a month before the January 31, 1968, Tet of-
fensive became a turning point in the war)*

*"Let us understand: North Vietnam cannot defeat or humiliate the
United States." — Richard Nixon, 1969*

*"The Oriental doesn't put the same high price on life as the Westerner."
— General William Westmoreland, 1972*

"We believe that peace is at hand." — Henry Kissinger, 1972

While Henry Kissinger was assuring the American public that "peace is at
hand" in 1972, Nixon was secretly bombing Cambodia—all the while claim-
ing we were "respecting" Cambodian neutrality. He not only authorized the
secret bombing, but he also OK'd the official falsification of records to cover
it up. When the covert bombing war was finally exposed, Nixon defended
it, saying it would have been "ludicrous" to respect Cambodia's neutrality.

DURING THIS TIME PERIOD, another interesting development occurred in
my cartooning career—I went over to the Dark Side and worked the 1972
Democratic National Convention for CBS Television.

Simmering in my brain for some time had been the concept of creating a
workable political cartoon for television. John Chase had been drawing one
for a New Orleans TV station for some time, but the effort was similar to
what he did at the *Times-Picayune*. He would be videotaped working at his
drawing board, with occasional comments on his thought process, and the
broadcast used a time-lapse process with the punch line (caption) being the
last item added to the drawing.

My concept was to produce a cartoon with a series of scenes to be viewed
somewhat like the panels of a comic strip, but with added audio and background
music. It would be faux-animation, moving a character across a background
scene without actually animating the character. The dialogue and scenes would
lead to a punch line in about a minute and a half of television time.

Jim Peck, a good friend who then worked for WTMJ in Milwaukee, helped
me work out the sound effects and gave the political figures voices with his

talented vocal impersonations. Together, we produced three pilot cartoons, which I took to New York and showed at NBC and ABC headquarters. The viewing at ABC is particularly etched in my memory. Several executives ushered me into a small control studio filled with workers and banks of screens.

As the cartoons played across one screen the working folks chuckled and murmured to each other. Then I overheard one of the executives whisper, "We can't say that on national television!"

"Don't call us, we'll call you" was the exit line given me.

In April, Edmund Muskie brought his sagging primary campaign to Wisconsin, and I secured a spot on his small puddle-jumper plane for a quick tour of several small communities in the northern part of the state. Also on board were two white-knuckled network cameramen and Frank Reynolds, who had been demoted from an ABC co-anchor to a field correspondent. It was on this tour that I witnessed firsthand the vacuous nature of television "journalism." When Reynolds questioned candidate Muskie in the middle of a crowded dairy farmers co-op, he framed a question that revealed he didn't have a clue about dairy price supports, much less their economic impact on farmers.

Upon returning to Milwaukee, I was scheduled to appear on the CBS *Morning News* with John Hart, in a segment which was to be broadcast from Milwaukee.

My role was to draw on-the-spot caricatures of Muskie and Senator George McGovern and to display a pre-drawn cartoon that related to the primary campaign.

The Milwaukee segment of the show was directed by a young Chicago-based CBS producer who later expressed interest in my idea of a semi-animated political cartoon. After viewing the three pilots, he successfully pitched the project to the powers that be in New York and I agreed to work with him to polish the techniques and to do the cartoons for the 1972 Democratic National Convention in Miami.

One of my immediate insights was the difference between the working styles of television and print journalists—money! I was flown first class to Indianapolis for a work session in a top-shelf advertising production studio that had expertise using cartoons. The work was tedious and the day was long, but the food and accommodations were off the charts of a print journalist's budget.

Not quite satisfied with the Indianapolis effort, the producer then took me to an old warehouse in Chicago that once housed an ill-fated movie studio. It still contained an animation camera of the type that produced the early Walt Disney movies.

There we spent another extremely long and tedious day trying to produce some half measure of animation. The effort proved fruitless because it was just too labor-intensive. In the end it was decided to produce the *Morning News* cartoons at the convention with the same short-cut method used for my original pilots.

The Miami convention was a grueling experience. I had hired a Miami artist to ink the daily semi-animated cartoon that would be used on the CBS *Morning News*—but he quit after drawing one finished product. So I ended up drawing a daily cartoon for the *Milwaukee Journal* plus the semi-animated cartoon for television. I don't remember sleeping during that week.

CBS used my cartoon feature every morning on CBS, but after the mitigating brawl of nomination politics, the network went back to its usual production, and that was end of my flirtation with cartoon commentary on the boob tube.

IN MARCH 1973, I was on a second USO tour, this time to Thailand. On the 18th of the month we were flown to Nakhon Phanom, site of an Air Force base and radar installation on the northern border of Thailand right across the Mekong River from Laos.

Ironically, this base, referred to as NKP, was the forward air control center that used DV-10 Broncos to direct Nixon's secret air strikes into the two countries. Even more incongruously, one could sit in an outdoor beer joint on a hill by the river and watch the Pathet Lao moving materiel and supplies from Thailand across the water into Laos.

In the final days of his ill-fated 1972 presidential campaign, Senator George McGovern made a policy statement on Vietnam. He said that he would end American involvement in Vietnam within ninety days of taking office and would send his vice president to Hanoi to speed the return of American prisoners.

This brought shrieks and howls from the White House, and Secretary of Defense Melvin Laird accused McGovern of advocating surrender.

In January 1973, Nixon appeared on national television and told the world that he was ending American involvement in Vietnam within sixty days and

January 24, 1971

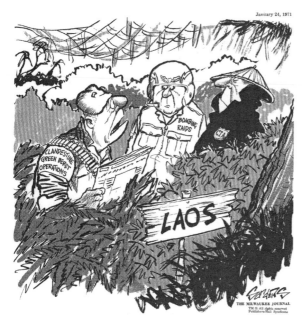

'The Senate wants to keep combat troops out of Laos. Didn't they believe the president when he said we weren't here?'

September 4, 1972

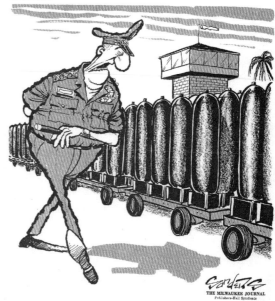

"Remember now, you're under strict orders not to hit any dikes, hospitals, schools or other civilian targets!"

September 20, 1972

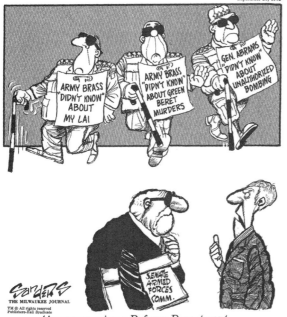

'Are we running a Defense Department or a hire-the-handicapped program?'

December 29, 1971

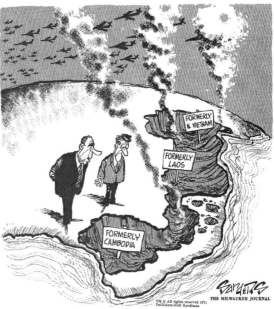

'As you can see, our withdrawal plan is working nicely!'

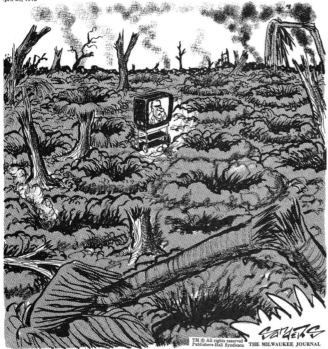

.pril 28, 1972

'We must not falter. For all that we have risked and all that we have gained over the years now hangs in the balance . . .'

Opposite page: I drew a number of cartoons related to the My Lai massacre. The case of Lt. William Calley symbolized so much of what had gone wrong in U.S. policy in Vietnam.

was sending Henry Kissinger to Hanoi to expedite the release of U.S. prisoners.

After U.S. withdrawal, after years of declaring several governments "legitimate" in South Vietnam—and claiming we were defending them from an "invading" country—Kissinger said the legitimate authority was now up to "political evolution," adding, "This is what the *civil war* has been all about."

Civil war? After 58,209 Americans dead and 128,680 Americans wounded? After being told we were fighting communism to save global freedom and democracy? In the end it was a civil war in a foreign country?

While in Vietnam, I visited an evacuation hospital in the central highlands. In the emergency room, a doctor wanted me to draw a caricature of a severely wounded soldier. Perhaps it would distract him, even if only for a moment.

He was young. They all seemed so incredibly young. His eyes peered from a heavily bandaged head and face, through puffed eyelids and the haze of sedation. The red stain of his life seeped through the bandages on his head, chest, and legs. He had been ripped with shrapnel.

Back outside, I asked the doctor if the young man would live. He replied flatly, "I doubt it."

How does one distract a doomed man? Why, the same way two presidents sought to justify a war and all those men, women, and children who died as a result of it—by handing out a caricature of the truth.

Theoretically, America's leaders learn from the past. If you believe that, I suggest you read this narrative again—and substitute *Iraq* for *Vietnam*.

April 1, 1971

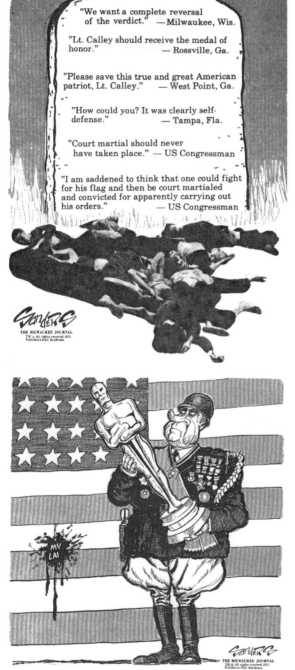

"We want a complete reversal of the verdict." — Milwaukee, Wis.

"Lt. Calley should receive the medal of honor." — Rossville, Ga.

"Please save this true and great American patriot, Lt. Calley." — West Point, Ga.

"How could you? It was clearly self-defense." — Tampa, Fla.

"Court martial should never have taken place." — US Congressman

"I am saddened to think that one could fight for his flag and then be court martialed and convicted for apparently carrying out his orders." — US Congressman

September 7, 1972

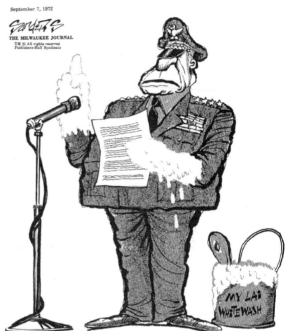

'Our final conclusion is that the blood of this tragedy is entirely on the hands of Lt. Calley.'

" . . . for his supporting role in 'Calley, The National Hero.' "

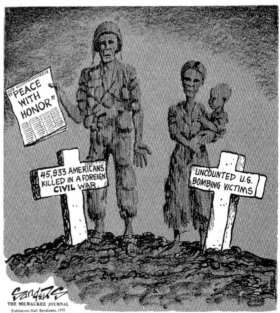

'Honor? What Honor?'

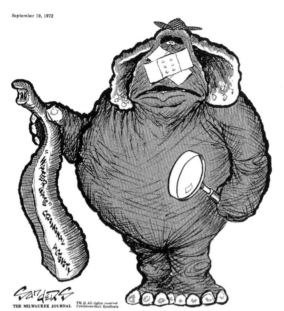

'After an exhaustive investigation I find this elephant trunk,
acting independently and of its own accord, guilty of. . . .'

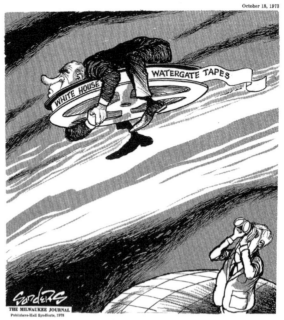

Identified Flying Object

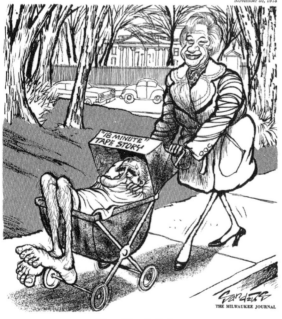

Rose Mary's Baby

'Sure I did it. What are you going to do about it?'

Watergate and Beyond

I was never one to keep a diary, but for reasons that were not even clear to me at the time, I started keeping notes on a small sketch pad in the summer of 1973. They were intermittent recordings rather than a strict daily routine.

Newspapers were then reporting that John Dean had implicated President Richard Nixon in the coverup of Watergate crimes. At the *Milwaukee Journal* editorial conference on June 27, I wrote in my sketch pad:

> Sig Gissler [editorial writer] raised the question again of Nixon speaking out on Watergate and the criminal charges by John Dean. I support that view, i.e. Nixon must speak out or remove himself from office. John Redden [editorial page editor] and Dick Leonard [editor] not ready to call for resignation yet. I still maintain that John Mitchell will be Nixon's downfall and he [Nixon] will not finish his term as president. Fred La Rue's guilty plea and willingness to turn "state's evidence" makes two [with Dean's] direct incriminating charges of OK'ing bugging. Mitchell has had it! If facing the jailhouse door, he will take Nixon with him.

On May 5, 1974, Gissler returned from a trip to Washington and reported to the *Journal* editorial staff meeting that there was some sentiment on Capitol Hill that Nixon might be forced to resign because of the force and import of a vote for impeachment that will come out of the House.

I took notes on the meeting and wrote in my sketch pad:

> I reminded the group that I predicted that would happen last March. I see a strong vote coming plus the exposure of other evidence. Nixon will not be able to hold 34 votes in the Senate and will opt to salvage his image by resigning as a martyr—hounded out by partisan politics and the press. He

would have to make a deal to foreclose later prosecution but GOP members would do that in order not to have a president of their party thrown out of office. Nixon should be out by September of '74.

Nixon resigned August 8, 1974.

While I concede that my gut told me that Nixon was ethically and morally bankrupt, I did not feel my thoughts were particularly prophetic or insightful. There were ample warning signs of impending meltdown in the wake of his career if one were willing to look at Nixon's pattern of behavior and his skewed legal views.

The Nixon "Law & Order" team had been warming up for Watergate since their minor-league days. They meticulously built a record of performance outside the generally accepted norms of behavior, beginning in 1946 when they claimed Representative H. Jerry Voorhis was not just a "New Dealer" but an enemy of the people and a subversive, unfit for public office.

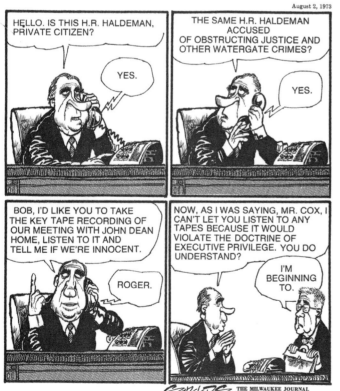

Operating from the right wing, his team scored again, describing Illinois Governor Adlai Stevenson as "Adlai the appeaser . . . who got a Ph.D. From Dean Acheson's College of Cowardly Communist Containment."

In his 1952 effort to unseat incumbent Edmund G. "Pat" Brown in the California gubernatorial election, Nixon trumpeted a 900,000-postcard "poll" that purported to show that nine out of ten Democrats flatly rejected the "ultra liberal" California Democratic Council that was backing Brown. It was a totally fraudulent poll. The man who conceived and directed the phony operation was H. R. Haldeman, later a key player on the Watergate team.

In the 1970 off-year Maryland elections, Senator Joseph Tydings was

defeated after a story in *Life* magazine said that
Tydings used his influence to obtain a $7 million
loan for a firm in which he had a financial interest.
The White House denied any involvement in con-
tributing to the story. However, it was revealed in
1971 that a White House member had supplied
"the pivotal facts" that launched the story. That
operative was Charles Colson, of later Watergate
infamy. A pivotal fact omitted from Colson's
"facts" was that a government investigation had
cleared Tydings of any irregularity.

"Let's go over that part again, Alice, where you
fell down the rabbit hole."

Nixon's main "law and order" mouthpiece
about this time was Attorney General John
Mitchell, whose first decision as the nation's top
law enforcement official was to *not* prosecute
twenty Nixon-Agnew campaign committees for
violating the Corrupt Practices Act.

However, Mitchell did orchestrate the mass
arrest of 13,400 U.S. citizens for assembling to protest the Vietnam War.
Coach Nixon declared this prosecution to be constitutional and said he "ap-
proved" of what the Justice Department did. What Mitchell "did," according
to the U.S. Court of Criminal Appeals, was to illegally arrest those citizens,
ultimately causing the District of Columbia government to fork over $37,000
in damages as a result of a lawsuit.

Meanwhile, the Nixon administration had never met a corporate lobbyist
it didn't think was downright friendly. Among those friendly folks were the
bunch over at International Telephone & Telegraph. They were always writing
memos addressed warmly to "Dear Ted" (Vice President Agnew) and "Dear
John" (Attorney General Mitchell).

Unfortunately, one of those ITT memos, written by lobbyist Dita Beard,
tying a $400,000 contribution to efforts to settle an antitrust suit, ended up in
the hands of investigative newspaper columnist Jack Anderson—who thought
it a bit too friendly.

The "Law & Order" team, anticipating what a strain Anderson's disclosure
of that memo would place on Ms. Beard, did the friendly thing and sent G.

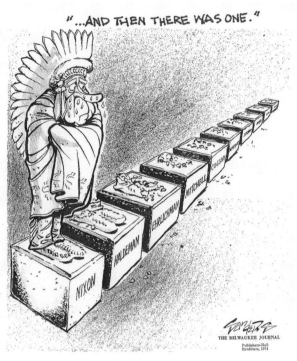

"...AND THEN THERE WAS ONE."

THE MILWAUKEE JOURNAL
Publishers-Hall
Syndicate, 1974

Gordon Liddy over to check on her. Mr. Liddy thought she appeared stressed and that it would be best to get her to a hospital. Mr. Liddy was not too familiar with the Washington area so he took her to the nearest hospital he could find—in Denver, Colorado, where, by coincidence, the media could not find her.

Nixon's warped view of breaking the law was best summed up by Nixon himself: "When the president does it, that means it's not illegal."

John Mitchell ultimately was convicted of conspiracy, obstruction of justice and perjury. The White House tapes revealed Mitchell plotting the break-in and meeting with the president three times in an effort to cover up White House involvement.

In the spring of 1974, I was invited by Chancellor Lee Dreyfus to give the mid-year commencement speech at the University of Wisconsin-Stephens Point. Even I thought it was odd to invite a political cartoonist to deliver such an address, but I was to learn that Lee Dreyfus, who was later elected governor of Wisconsin, marched to a different drummer than did most public figures.

At that time, public speaking was a product of necessity for me, as I had four daughters to put through college. I had an agent in Chicago who booked speeches that helped enormously with tuition and fees. Most of my talks were mostly light social and political commentary delivered while I stood at an easel and drew sketches.

A commencement speech was quite a different challenge. I thought of all the clichéd scenarios that unfolded at such affairs and decided that if the University at Stephens Point was willing to try something different, they should get their money's worth.

A local newspaper covered the event and wrote:

"Go out into life, support motherhood, be against sin and earn thirty thousand a year."

Having thus paid his respects to the traditional commencement address, Bill Sanders of the *Milwaukee Journal* proceeded to call for Richard M. Nixon's impeachment.

To say that this was an unusual commencement address is more than a mild understatement.

Somewhere in the middle of my speech, there was a muted commotion in the rear of the gymnasium. It turned out that a dozen or so upset parents had walked out on the speech and were in the lobby organizing to reenter to protest its continuation. Apparently, they were prohibited by security from doing that, which didn't enhance the parents' dim view of the proceedings.

I will never understand why otherwise rational people seem to feel that the office of the presidency is immune from habitation by a venal and unethical person—or, if a person is venal and unethical prior to being elected, that the presidency bestows some purification that exempts the officeholder from criticism.

Nixon was just such a venal and unethical person. When he said, "I am not a crook," he lied.

In 1971, Nixon was ordering a break-in and theft at the Brookings Institution so he could learn what information the public policy center had collected on the Vietnam War. Here is his taped exchange with H. R. Haldeman:

Nixon: Break into the place, rifle the files, and bring them out . . . I want a break-in. I want the Brookings safe cleaned out. And have it cleaned out in a way that makes somebody look bad. You go in to inspect . . . and clean it out . . . I want Brookings. Just break-in,

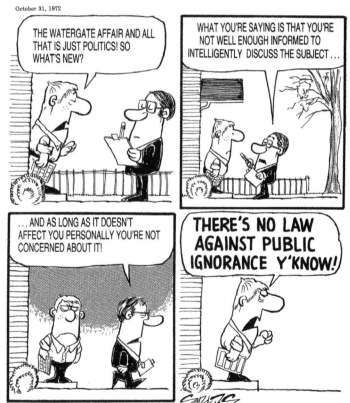

April 18, 1973

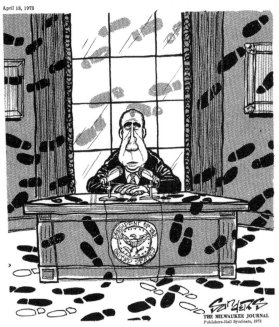

THE MILWAUKEE JOURNAL
Publishers-Hall Syndicate, 1973

'I have just discovered major new developments
in the Watergate case.'

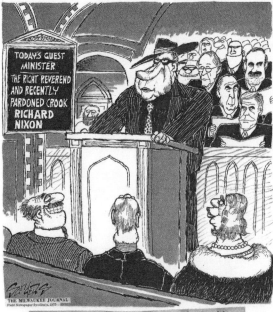

THE MILWAUKEE JOURNAL
Field Newspaper Syndicate, 1975

'My sermon for this morning is the deplorable
lack of morality in government leadership today!'

break-in and take it out. You understand?

Haldeman: I don't have any problem with breaking in.

President Richard Nixon was also an equal opportunity bigot and homophobe—convicted by his own words from the White House tapes:

"Many Jews in the communist conspiracy. . . . Chambers and Hiss were the only non-Jews. . . . Many thought that Hiss was. He could have been a half. . . . Every other one was a Jew . . ."

"The Jews are irreligious, atheistic, immoral bunch of bastards."

". . . coming back and saying that black Americans aren't as good as black Africans—most of them basically, are just out of the trees. Now, let's face it, they are."

About Italians: *"They're not like us. They smell different, they look different, they act different. The trouble is, you can't find one that's honest."*

"Do you know what happened to the Romans? The last six Roman emperors were fags . . . you know what happened to the popes? It's all right, the popes were laying the nuns."

Abraham Lincoln observed that if "you want to test a man's character, give him power." Nixon's public facade was finally stripped away when he overreached in his quest for an imperial presidency—and his true character was forever imprinted on analog tapes and court documents.

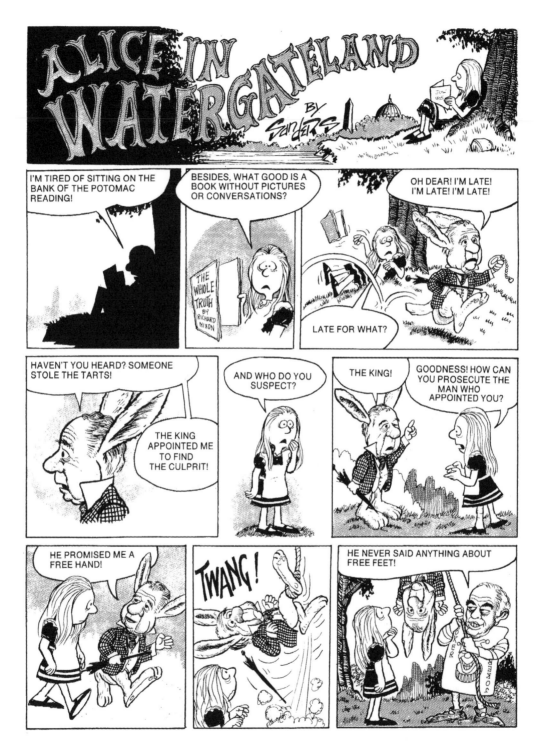

In the Eye of the Beholder

It is axiomatic that the most innocuous political cartoon may pierce the discontent of some reader, somewhere, sometime, who will then take pen or keyboard in hand to express anger or angst. This rare occasion is not to be confused with the predictable responses from cartoons that puncture the sacred tenets held dear by various segments of society.

Then, as anyone in this business knows, there are those occasional technical quirks that evoke responses, not to mention things some people see in a cartoon that no one else does.

When I was working for the *Greensboro Daily News*, I drew a mild cartoon about Eisenhower attempting to heal a rift among our European allies. The metaphor was a hospital setting with "Doctor" Eisenhower at the hospital bedside of a male figure representing the European allies.

I took the cartoon to our engraving department and laid it on a flat table next to the engraving camera. I removed a small white piece of paper I had clipped to the drawing and explained that I wanted the black printing reversed, making it white, and placed on the black doctor's bag in the cartoon. I then left work for the day.

The engraver picked up the drawing and moved it onto the large flat glass that would be locked down and raised to a vertical plane for the camera to shoot it. Apparently, he did not notice that the large paper clip was on top of the drawing. Moreover, it had fallen right on the crotch of the male patient in the hospital bed.

The result in the next morning's newspaper was the cartoon with the patient sporting what appeared to be a four-foot erection. The *Daily News* switchboard operator spent most of her day fielding irate callers.

THE CRITICAL POINT OF Milwaukee Judge Christ Seraphim's dictatorial rule coincided with the height of anti-Vietnam War protest demonstrations, and

alternative press newspapers were popping up like wild daisies in cities around the country. Milwaukee had its own version called the *Kaleidoscope*. It was a relatively benign version of an underground newspaper and was popular with university students and the "peace & love" community along East Brady Street.

On afternoon, while having coffee in a shop on East Brady Street, the *Kaleidoscope* editor was chiding me about the "establishment" press and mused, "Would you ever draw a cartoon for us?"

I replied that I would not draw a political cartoon, per se, because that is what I did for the *Milwaukee Journal*, but I would have no problem drawing a caricature for *Kaleidoscope*. The editor then asked if I would draw caricatures of three local political figures, including Judge Seraphim. I said, "Sure, but you'll have to pay me—a nickel apiece."

I drew two of the political figures as fairly straight caricatures, but I depicted Judge Seraphim as a pregnant Girl Scout. Seraphim, the local symbol of purity and old-fashioned values, was anything but.

When that edition of *Kaleidoscope* came out, a copy found its way to the judge and he hyperventilated, complaining to the *Journal* publisher of character assassination and "that you should do something about your cartoonist!" Some of Seraphim's Chamber of Commerce cronies joined in the chorus. The result was a top management meeting at the *Milwaukee Journal,* whose "policy" prohibited its journalists from moonlighting with competitive publications. Of course, the *Kaleidoscope* could be considered competition for the *Journal* only in the same way a mouse would be competition in wrestling an elephant.

Journal editor Dick Leonard, in a meeting clearly uncomfortable for him, informed me that the hierarchy had decided that I should be suspended for two weeks. He assured me that it could have been worse because there was a vice president who wanted me fired.

I already knew about that vice president. For those who might not be aware, the pecking order at most big-city newspapers consists of business corporate types at the top. Editors and such are off to the side and definitely on the lower rungs of the power ladder. Political cartoonists have never been popular at the corporate level of journalism. I was particularly out of favor with the *Journal* vice president who came into my office to solicit a pledge for a donation to the United Fund Campaign. You've seen the posters: "XYZ Company meets its 100% goal for whatever charity."

At the time, I was in the middle of building a house and trying to meet construction payments. After making his pitch, the vice president handed me a pledge card and sat back in his chair. I explained that I would take the card home and give some thought as to what we could do. He replied, "Well, actually, you have to sign it in front of me."

I said, "I really prefer to make this decision at home after discussing it with my wife," explaining that we contribute to organizations that get no funds from the United Way Campaign.

Mr. Vice President replied, "That's not the way we do it. It's a company effort, you know."

"Well, I guess if that is the case, you will just have to do without my pledge this year," I said.

"Listen, you better start thinking like a company man," he fumed.

At that point, I walked down the hall to the office of Paul Ringler, our editorial page editor. I had begun explaining about being pressured when Mr. Vice President came storming in behind me, berating Ringler to set things straight with me about how this matter was done at the *Milwaukee Journal*.

To Ringler's credit, he finally said, "I see no reason why he can't do it as he sees fit." At that, Mr. Vice President bolts out of the office saying, "Well, if you want to coddle him . . ."

It was never in my emotional core to say "Screw you!" to the *Journal* and start looking for another job. I knew I was fortunate to have a good newspaper as a base. I was fortunate to have Paul Ringler as editorial page editor. And I was convinced the *Journal* was the place for me for the long run.

There was an upside to a two-week suspension.

I had designed, drawn the blueprints, and was the general contractor for the house we were building. Winter was approaching and we were living in a summer cottage on a lake twenty-five miles out of Milwaukee. It had no central heating and we had to be out of the cottage by the first of November. I needed the two weeks to devote full time to the house.

On the other hand, two weeks without pay was a bleak outlook.

Fortunately, I had two good friends and philosophical soul mates in Jim and Gilda Shellow. Jim was a brilliant criminal defense and civil rights lawyer with a top-shelf national reputation. Gilda was the charismatic, behind-the-scenes lawyer who orchestrated the husband-wife law firm.

When the news of my suspension broke on the wire services and in the general press, Jim took possession of the original of the Seraphim cartoon, in case legal action might develop. He and Gilda then wrote a check to me for $1,000 to cover the two weeks of the suspension.

Tom Curtis, a good friend and William F. Buckley-type-conservative cartoonist for the *Milwaukee Sentinel* also chipped in a timely loan that helped me get into the not-quite-finished house before our deadline. I did pay back the loans.

YEARS LATER, MY OCCASIONAL jousting with Milwaukee Chief of Police Harold Brier, who lived in a different century than the rest of us, led to one of those "what you read into it" moments.

The Milwaukee police occasionally beat up local citizens for reasons that defy common sense. In October 1982 they beat a man so severely that he was hospitalized for a week. He was virtually unrecognizable under the bruises and abrasions on his face and head. His grievous crime was getting tipsy at a public event and urinating on a side street.

As usual in these situations, the internal investigations rendered no identity of the officers involved in the brutal beating. They just seemed to fade into anonymity under the scrutiny of Chief Brier, who repeated his mantra (which I paraphrase

here) that citizens would not have problems if they would just say "how high" when police told them to jump.

I drew a cartoon that featured a faceless police officer. In the background a citizen was pointing to the faceless man and asking another policeman, "Who is that?" The policeman replies. "That's our man who occasionally beats up a citizen—nobody knows his name."

In drawing the faceless police officer, I *penciled* in his entire face with bushy eyebrows, eyes, nose, and a smirking, downturned mouth. However, when I "inked" the drawing, I did not ink the eyebrows, eyes, or nose. I erased the penciled-in features—leaving his face "anonymously" blank, except for the downturned mouth. The day of publication I left for a few days vacation.

When I returned, I was astounded at the brouhaha that had developed in my absence.

It had become standard that there was a small segment of our readers that would take umbrage at *any* criticism of the Milwaukee police. However, this cartoon produced a run of outraged "citizens" who claimed to see a penis in the drawing where the face should have been.

Reader Contact Editor Ruth Wilson reported to *Journal* management, "In all I had eight phone calls. I had referred three to Sanders before I learned he was out of town." The theme of the calls were the same according to Wilson: the cartoon was filthy and pornographic and the paper should apologize.

When I learned the exact nature and timing of what the *Journal* hierarchy considered an "avalanche" of irate citizens, I suspected the response was not extemporaneous, particularly when I was told that Sister M. D. Kelly was leading the charge.

Sister Kelly was a nun and sort of spiritual cheerleader for the Milwaukee Police Association and editor of the *Cops* newsletter.

According to *Milwaukee Magazine*'s "Inside Milwaukee" column, "Sister Kelly stormed into the office of *Journal* Reader Contact Editor Ruth Wilson, calling Sanders 'a dirty, filthy man' and demanding to know why the *Journal* kept 'pigs' on the paper."

I knew when I drew it that the police would take a dim view of the cartoon, but I had no idea that they had the creativity to come up with the penis-face imagery that they called to the attention of Sister Kelly. I would have loved to have been a fly on the wall during *that* conversation.

The *Journal* editors decided to publish an editorial titled "We Apologize." In it they said they had "noticed nothing amiss in the artwork before publication and apologized to any readers who found it vulgar or obscene."

All of this took place before I returned from vacation. When I read the editorial, I chuckled, wondering how many readers of the editorial had gone scrambling through their old newspapers to see what they had overlooked.

What I didn't find amusing was the idea that editors would not have asked themselves, "Would Sanders really pull such an unprofessional, juvenile stunt?"—portraying the police as pricks! But, then again, I might not have liked their answer.

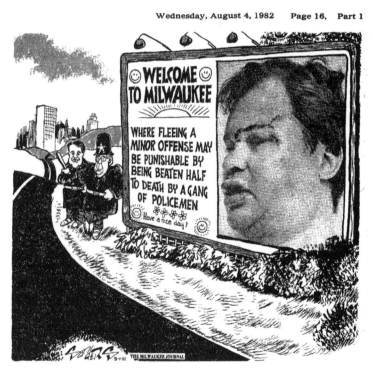
Wednesday, August 4, 1982 Page 16, Part 1

The Basin Street Saloon Band played the jazz festival circuit for ten years, including (top) at the Sacramento Jazz Festival.

24

Do You Know What *IT* Means . . .

Almost everyone who watches television has been exposed occasionally to New Orleans traditional jazz without even realizing it. If you watch commercials, you will eventually hear anonymous background music that was once on the charts, like "Jazz Me Blues," "Wabash Blues," or "Muskrat Ramble." Sadly, that is about the only venue where the general public can hear such music. Even in New Orleans, the birthplace of its roots, traditional jazz is as rare as a snowstorm in July.

Today, if one associates music with New Orleans, it is likely to be the sounds of Zydeco, the Neville Brothers, or Harry Connick Jr. That is not to denigrate *their* music. The sounds of Zydeco are delightful. The creativity and arrangements of the Neville Brothers and Harry Connick Jr. are wonderful contributions to music.

I am simply lamenting that one can no longer wander into a bar on Bourbon Street and hear a trumpet or cornet playing the lead of, say, "Tin Roof Blues," with trombone and clarinet meandering in and around the melody line.

In the mid-1960s, the Association of American Editorial Cartoonists held a meeting in New Orleans that rekindled a hunger for music simmering in my soul since my days at Western Kentucky University.

After the usual convention schedule, I wandered the streets of the French Quarter well after midnight, ducking in and out of hole-in-the-wall bars to listen to a piano player who might be joined by an after-a-gig cornet player. Or I would make it over to Mahogany Hall and catch the last set by the Dukes of Dixieland. I remember going with Joyce to Preservation Hall and listening to the pure sounds of New Orleans' musical roots while I sketched historical icons like clarinetist George Lewis and "Sweet Emma, the Bell Gal," Emma Barrett.

The AAEC had contacted clarinet virtuoso Pete Fountain, who at the time owned his own club in the French Quarter. We were hoping to reserve one evening in his establishment. Unfortunately, the timing was not good as he

Playing banjo at the Bix Beiderbecke Jazz Festival in Davenport, Iowa.

was completely booked for the times we had in mind. He made a generous counteroffer, which we readily accepted.

He proposed that he and his piano player would come to our French Quarter hotel after his last show and play a few tunes for us. We set up rows of chairs in the lobby facing a small alcove where a piano was located, and from there, in a very casual manner, Fountain began playing for us as we drew sketches.

After the second song, he abruptly stopped to examine our drawings. Smiling broadly, he then walked to the lobby front desk and said something to the clerk. In about fifteen minutes two musicians came through the front lobby door. One was carrying an upright bass, the other an abbreviated drum set.

They set up behind the piano and the Pete Fountain Trio played for an hour, to the absolute delight of his limited audience. It turned out to be a "happening," which only cost us a few sketches.

I left New Orleans with growing desire to be able to play some of that music. But what instrument could I really play—certainly not the bass, which I had "faked" as a college student. My mother had taught me to play a few chords on a ukelele when I was a teenager. But I didn't think of a ukelele as "band" instrument, and I couldn't play chords on a guitar because it has six strings instead of four.

I became infatuated with the idea of playing a banjo and on a visit to our relatives in Nashville, I wandered into Gruhn's Guitars on Broadway. There I discovered a treasure trove of vintage banjos, including a number of the plectrum, four-string variety used for traditional jazz. Unable to resist, I purchased a "bottom of the line" Vega plectrum to take home to Milwaukee.

I learned that I could accompany some recorded vintage jazz songs with

the several chords I knew—simple songs like "Ain't She Sweet" and "Five Foot Two." My playing was strictly "by ear," meaning if I could hear the melody, I could find the chords that sounded right with it. And, frankly, I was feeling pretty good about my progress.

However, my self-satisfaction was on a collision course with reality.

One Friday night I went to a Milwaukee tavern called the Red Mill to listen to Don Nedobeck's North Water Street Tavern Band. Nedobeck was a marvelous freelance artist. With twinkling eyes, red beard, and a whimsical sense of humor, he was also an excellent musician, playing clarinet and cornet.

I talked with Don during his break and told him I was playing the banjo. He said, "Bring it in and play a couple of songs with us."

In a classic example of hubris gone wild, I said, "Sure!" Big Mistake!!

The Red Mill was a small frame house in the residential area of New Berlin, a Milwaukee suburb. It had been converted into a "roadhouse" tavern years earlier and was grandfathered into the regulations for bars. On Wednesday nights with Nedobeck's band, it was often wall-to-wall people.

I retrieved my banjo from the car and came back to sit in with the band. The band was crammed into one corner, and I was squeezed into the group next to the tuba player.

Here, I have to explain the extraordinary extent of my ignorance and hubris. I had taught myself how to play a number of songs in the key of C and F—and I just knew that if I could hear a melody, I could find the chords to play along with it.

With little ceremony, the band launched into "Muskrat Ramble" and I started desperately trying to match chords to the melody, which I knew. It

Joyce and me, and our daughter, Denese, right, with country-western star Tom T. Hall, for an afternoon of music and barbecue at his home in Franklin, Tennessee.

was painfully obvious to me that none of my chords in C or F were anywhere near the familiar melody.

I tried to ask the tuba player what key they were playing in, but the din made it impossible. Jimmy Christiansen, the band's virtuoso banjo player, looked at me and held out his hand with two fingers pointing downwards. I thought he was pointing at the floor for some reason that totally escaped me. What he was communicating was the hand signal for the key of B-flat, but I had no clue.

Finally, I started faking it—strumming the air in front of the stings on my banjo and hoping no one would know the difference. When the song was over, I hastily excused myself and retreated to my car, vowing never to do that again unless I actually knew what I was doing. It was a most embarrassing lesson.

In the following months, I became a slave to learning chords from a Mel Bay chord book and practicing by playing with recordings of traditional jazz songs. In that process, I also committed to memory a dozen or so songs of the standard Dixieland variety.

With Woody Herman, center, at a concert at Tennessee Tech University, 1952.

About that time a good friend and trumpet player, Pete Wood, introduced me to another band with the unlikely name of Six Friars and a Monk. Doug Gmoser, clarinet player and leader of the Friars, was generous enough to let me sit in with them from time to time.

Pete, like me, played "by ear." Unlike me, he was really good at it, plus he had a really mellow Louis Armstrong style and knew a ton of songs. He would later become a key member of the band that I organized.

It was after learning to play the banjo, and playing with some regularity, that I decided a good deal of my enjoyment came from playing particular songs in a style and tempo that appealed to me and that I thought would appeal to a diverse audience. So I decided to put together a band. Besides, if I had my own band, I could avoid the embarrassment of struggling to play songs that I didn't know.

That was the beginning of the Basin Street Saloon Band, a seven-piece group that included piano, bass, drums, trumpet, trombone, clarinet, and banjo/tenor guitar. While I made

no claim of being an accomplished musician, I did know something about entertaining and had a knack of choosing songs that appealed to our audiences. I was also fortunate to have as players accomplished musicians who were willing to put up with me as the front man.

The Basin Street Saloon Band became a regular fixture at the Red Mill's Friday night fish fry and the place was constantly packed with standing-room-only crowds.

In July 1984, the *Journal* sent me to cover the Democratic National Convention in San Francisco. I had been there ten years earlier to cover the Republican Convention that nominated Barry Goldwater, and I loved that city—with its ethnic diversity and its unique character. However, it wasn't until the 1984 trip that I discovered the Gold Dust Lounge, one of America's great bars that was home to my kind of music.

The Gold Dust was then on Powell Street just off Union Square, a few doors north of the Manx Hotel, where *Kansas City Star* columnist Bill Vaughan and I stayed while covering the 1964 convention. We suspected that some of the Manx's rooms were rented by the hour. Bill's first "tweet" back to the paper read, "Help! I'm trapped in a tailless cathouse!"

The bar has since moved to Fisherman's Wharf, but it has been a San Francisco watering hole since 1906. On February 20, 1933, Congress proposed the 21st Amendment to repeal the 18th, marking the beginning of the end of Prohibition. That same year, the watering hole became the Gold Dust Lounge.

At one time Bing Crosby owned a piece of the action, and the lounge appeared briefly in the Steve McQueen movie, *Bullitt*. However, the Gold Dust's legendary status in 1984 was largely due to the entrepreneurship and management skills of Tasios and Jimmy Vovis, who made the turn-of-the-century bar into a San Francisco institution.

The Democratic National Convention started on Monday and I arrived in San Francisco around noon on Sunday. When I walked through the swinging doors of the Gold Dust later in the afternoon, it was like stepping back in time. The long wooden bar was right out of the 1930s. Red banquettes lined the gilded walls. Gaudy chandeliers hung from a ceiling painted with Rubenesque nudes and cherubs.

The atmosphere was that of a festive neighborhood party, with mostly local patrons enjoying each other's company and the music of a Sunday jam

A change of pace . . . playing "blues harp" at the Big Horn Jazz Festival in Chicago.

session anchored by three musicians. I sat in playing a few tunes on blues harmonica. Later, I adjourned to a Pier 39 eatery and returned to the Lounge around 9 p.m.—when the featured entertainers were Pete Clute and Carl Lunsford, and the music style was San Francisco traditional jazz by way of New Orleans. Clute was the piano player and Lunsford the banjo player for Turk Murphy's Jazz Band during its legendary tenure at Earthquake McGoon's.

In a city that was about to play host to a major national political convention, it was not surprising that some of those politicians might discover the Gold Dust. On this night it was Kentucky's Governor Martha Layne Collins and two of her young administrative assistants who squeezed onto the red banquette next to me. It turned out to be a very pleasant evening of casually talking politics and occasionally playing a little music.

After the '84 trip, San Francisco became a semiannual destination for me to get away for a three-day musical R&R at the Gold Dust Lounge, where I met and came to know a number of West Coast jazz musicians. The delight of those excursions also had to do with the Gold Dust's environment and its regulars—some were like Damon Runyon characters.

There was the older white-haired gentleman who looked like a retired banker, immaculately dressed in a gray pinstriped suit and a bowler hat. He had a fixed routine. After finishing one glass of wine, he would stroll to the back of the bar room, where he would roll out a round tabletop from behind an old telephone booth. He would place it flat on the floor and give Pete Clute the high sign for a musical introduction, then perform a sophisticated tap dance on the table top to the tune of "Bye Bye Blues." Then—old vaudevillian that he was—he would take a bow, retrieve his bowler, and head for home.

One of the standard attractions was the longtime bartender "Chuck." In addition to being the consummate dispenser of mixed drinks, he had the uncanny ability to take a square paper receipt chit from an old-time cash register and sail it like a miniature Frisbee seven or eight feet down the bar, where it would gently land in front of the customer who had just paid his bill.

It was during these trips that I learned about the jazz festival tradition that was flourishing along the West Coast in places like Sacramento, Redding, San Diego and Fresno, where traditional jazz bands played for enthusiastic fans who were more than willing to pay for the privilege of hearing the music.

These three- and four-day festivals attracted bands from across the U.S. and in some cases from Europe and Latin America. To earn an invitation, you had to submit a request along with samples of your music

The Sacramento Jazz Festival was hands down the largest and most diverse, with thirty-seven venues and bands from England, France, Russia, and Latin America as well as the U.S. I put together a promotional packet and sent it off and the Basin Street Saloon Band was fortunate enough to get an invitation. One of the reasons for our acceptance, aside from the fact that we played a good "swing" style of traditional jazz and blues, was the reputation of our trombone player—Ralph Hutchinson was a big-league player in the jazz revival of the early fifties.

Born into a musical family in Newcastle, England, Ralph learned to play trombone and worked with several bands in northern England before migrating to Chicago at age twenty-three. There, he lived with an aunt and worked at a factory that manufactured phonograph needles, where he earned enough money to buy a trombone.

Pat Harris, one of Chicago's top jazz reporters, heard Ralph sitting in at an amateur jam session and wrote a feature piece about him in *Down Beat* magazine under a subhead, "Genius found among the needles." After its publication, Ralph began to get regular gigs with Chicago bands. At that time, the top jazz bands in the U.S. were Louis Armstrong's band and the Muggsy Spanier Band. On one of his stops in Chicago, Spanier heard Ralph and hired him on the spot.

Ralph toured with Spanier from 1951 to 1956 and along the way learned to play golf well enough to

Trombonist Ralph Hutchinson, a crowd favorite, during our five-year stint at the Chilliwack Jazz Festival (near Vancouver).

get his card qualifying him to become a club professional. Ralph left the band after Spanier's heavy drinking affected their schedule and their income.

In 1959, Louis Armstrong's agent, Joe Glaser, offered Ralph a spot in the Armstrong Band. But by that time Ralph had settled down, was married and working as a golf pro as well as playing music, and had a three-month-old daughter. He declined the offer.

Along his career path Ralph played with such jazz greats as Art Hodes, Bobby Hackett, and Milt Hinton and was the lead trombone player in the Jackie Gleason Orchestra as well as orchestras that backed shows featuring Edie Gorme and Frank Sinatra.

After a divorce, he married Jane Peck and settled with her in her home town of Milwaukee. In his semi-retirement, Ralph brought his years of experience to help shape the Basin Street Saloon Band's style and arrangements. We did not play with written arrangements, however. We just decided how we wanted to work a song, depending on our taste and feel for expressing it.

Our initial piano player, Hal Kelbe, was a classically trained, retired music teacher who made our first trip to Sacramento. However, he developed some health problems and on his doctor's advice had to drop out. I had to find a new player for our next trip to Sacramento. Ideally, I wanted a piano player who could play traditional jazz à la Louis Armstrong but traditional blues à la Muddy Waters. As the old saying goes, someone who could "play blues in the cracks."

In the winter of 1986, Joyce and I took a vacation in the Fort Myers, Florida, area looking for warm weather, golf courses and perhaps some music. Friends had suggested our kind of music was to be heard down the road in the Naples area and mentioned the Marco Lodge, an old waterfront restaurant-saloon in the small village of Goodland, on the tip of a barrier island just south of Marco Island. The Marco Lodge was not to be confused with the historic Olde Marco Inn, built by Bill Collier on Marco Island.

Joyce and I drove down to eat and take in the advertised Sunday Jam Session at the old waterfront saloon. It turned out to be a fateful decision.

The saloon was faded gray and "cracker casual" with an abundant fried seafood menu. The place was packed and the band was outstanding. During a break, I introduced myself to the piano player who seemed to be in charge and asked if I might sit in and play a little blues harp. The piano player's name

was Bobby Gideons, and he generously agreed to call me up sometime during the next set.

Quite frankly, I was nervous as I ascended the stage to play with total strangers. However, Gideons, who, by the way, is white, laid down a gutsy blues introduction that blew me away. It was as authentic and "in the cracks" as any licks heard in Chicago's blues district. Playing with Gideons behind you was like a country bumpkin's first ride in a Cadillac.

In the off-season for festivals, I would occasionally sit in with Bobby Gideons, an icon of South Florida music, at the Marco Inn on Marco Island, Florida.

I knew he was outstanding at traditional jazz, but his skill (and soul) at blues was also superb. I had found what I was looking for.

After returning to Milwaukee and confirming that Hal Kelbe would not be going to Sacramento, I phoned Gideons to ask if he would join the Basin Street Saloon Band for our gig at the Jazz Festival. He agreed and it was the beginning of a music and personal relationship that would last through the years.

Gideons was a fixture in the southwest Florida entertainment scene. A native of Dade City, Florida, and a self-taught musician, Gideons started playing piano in high school. His first gig was playing at the Joylan Theater during movie intermissions. After high school, he played country-western gigs in the Tampa area and in 1953 was playing for Slim Whitman and his WFLA radio show. By the time Hurricane Donna slammed across the tip of Florida in 1960, Gideons had moved to Fort Myers and was playing for a variety show, Jamboree Country, on WINK-TV.

While his career was rooted in country music and venues like the Long Branch Saloon in LaBelle, Florida, his talent and technical abilities for diversity took him to more citified venues like the Olde Marco Inn, where his piano styles and his personality were magnets that brought fans back year after year.

He gave the Basin Street Saloon Band style alternatives and driving tempos that made our group popular at jazz festival circuits in California, Canada, Iowa, Wisconsin, and Florida.

Jamming with actor Stanley Tucci in his home in upstate New York.

The other band member who enjoyed great popularity with festival fans was clarinetist Joe Aaron. Joe was a short, energetic, irrepressibly witty man who was a classically trained musician and the oldest member of the group. Joe had toured with the Clyde Mc-Coy Sugar Blues Orchestra in the 1940s and served a lengthy stint with the Holiday on Ice Orchestra. He had also been a featured soloist with the Milwaukee Symphony.

During our run on the festival circuit we played at Redding, California; Chilliwack, Canada; Medford, Oregon; Cedar Falls and Davenport, Iowa; Schuss Mountain, Michigan; and St. Louis, Missouri, as well as Milwaukee and Sacramento.

The formula for the jazz festival circuit was air fare, hotel expenses, and pay per gig. The band would usually fly out on Thursdays, play Friday, Saturday, and Sunday morning and catch a Sunday afternoon flight back. The gigs were two forty-minute sets, played at three or four different venues each day except Sunday.

The audiences were appreciative and enthusiastic, though the money was nothing to write home about. However, we could sell our recordings at each venue and make an extra thousand dollars or so.

When I retired and moved to Florida, the Basin Street Saloon Band played one last gig at Sacramento. Since then, I have been fortunate to have professional musician friends who are willing to make an exception to George Bernard Shaw's dictum, "Hell is full of amateur musicians!" My friends still let me occasionally sit in with them.

25

Enter Stage Right

My mother, an amateur theatrical ham, enlisted me to play the "bad boy" in her little theater group's performance of *Peck's Bad Boy*, when I was about seven or eight years old. The only thing I remember about the experience was the notation before my first line of dialogue. It said "Enter: Stage Right." Mother told me that meant I was to come onto the set from the right wing of the stage.

On second thought I also remember being encouraged by a veteran actor who told me that by memorizing funny and clever lines, I could use them later with my peers and appear to be extemporaneously funny and clever. I didn't like acting, which is probably why I could never bring off the funny and clever bit.

George Burns once said, "Acting is all about honesty. If you can *fake* that, you've got it made," which brings me to Ronald Reagan.

In November 1975, I met Ronald Reagan at the National Headliner Awards Dinner in Atlantic City. He was at the end of his term as governor of California and was the guest speaker at the event. He was publicly maneuvering for a run at the presidency.

This is not to imply that our meeting was an extended or particularly personal encounter. It was more like a fly-on-the-wall experience. I was part of a small group in a conversational setting and later was seated with one person between Reagan and myself at the head table during the dinner.

I found Reagan to be a genial sort who appeared to genuinely enjoy social intercourse with people. His humorous, conversational one-liners were delivered with an aplomb that could only come with years of practice. That is not a negative assessment. Indeed, I recognized that as a talent coveted by many political and public figures.

However, on serious issues, his comments appeared to spring from a carefully honed mental script that divulged little of substance. For example, he

remarked to a Chamber of Commerce type, "Unemployment insurance is a pre-paid vacation for freeloaders." This was a typical example of his scripted, oft-repeated "issues" assessments.

As a governor, Reagan had not been prominent on my cartoonist's radar, but with his two presidential campaigns, I had to deal with him. In 1980, I could not imagine voters would elect this man of so little substance as their next president, even though his Democratic opponent was Jimmy Carter. I was well aware of Carter's negative political balance sheet—his personality and administrative flaws—not to mention Carter's burden of Iran having taken fifty-two American hostages.

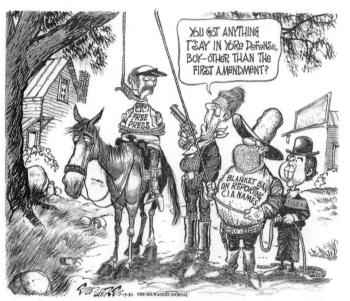

I also vastly underestimated the mainstream media incompetence that gave Reagan his famous so-called Teflon coating.

Witnessing Reagan's ascendancy was much like watching Peter Sellers in the 1979 movie, *Being There*. Sellers played the role of Chance, a simpleminded gardener who lived all his life in an old man's mansion in Washington, D.C. When the old man dies, Chance is turned out into a world that he only knows from watching television. A wealthy, politically connected family takes him in, thinking his name is Chauncey Gardiner and that his simple TV-sourced utterances are profound insights.

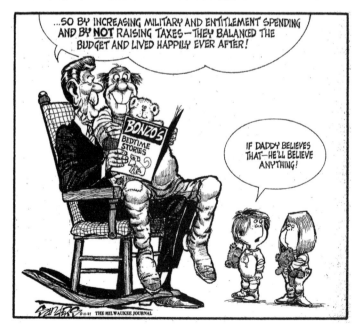

But while Chauncey Gardiner was guileless, President Reagan was not.

Their parallel lies in the fact that there was no *there* there, in either case.

It is true that Reagan was a likable person, but it is a myth that he was a "great communicator." He *was* great at learning his lines, standing on his mark and delivering them with the stamp of sincerity. It is also a myth that he was, as the *Washington Post* put it, "one of the most popular presidents of the 20th century." These were myths carefully crafted by his handlers and fertilized by timid media.

A much different perspective is found in polling data. Gallup's 52 percent average approval rating for the Reagan presidency places him in sixth place among the past ten presidents, behind Kennedy (70 percent), Eisenhower (66 percent), George H. W. Bush (61 percent), Clinton (55 percent), and Johnson (55 percent).

Another myth is that Reagan's "get tough" posture and his pursuit of the hawkish Strategic Defense Initiative ("star wars"), singularly caused the collapse of "the evil empire." Most historians with a broader view than the city limits of Washington, D.C., credit the implosion of the USSR with a number of internal factors predating Reagan's "evil empire" speeches and proposed "star wars" spending. Moreover, if one man

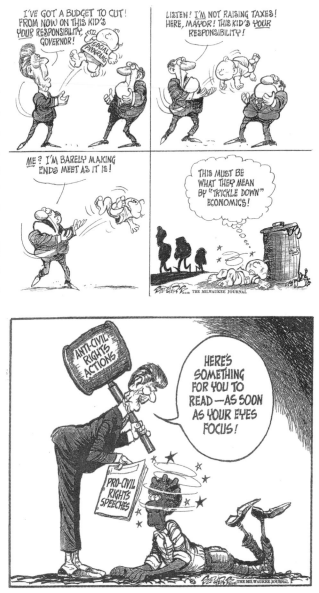

deserves the preponderance of credit for the demise of the Soviet Union, it would be Mikhail Gorbachev.

Under Leonid Brezhnev, USSR president 1980–82, Russia was continuing to spend huge amounts of its national budget on military and space exploration. Russian academics—prominently, Tatyana Zaslavskaya, a well-known

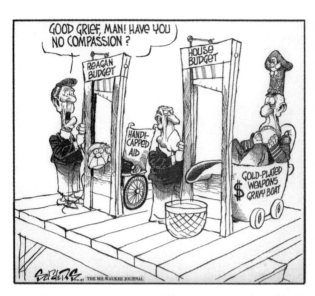

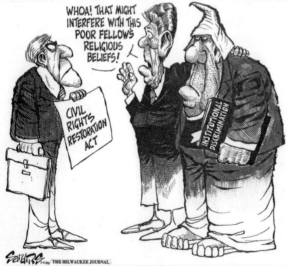

sociologist—were warning of the impending economic disaster. They correctly predicted that Russia was bankrupting itself with its nuclear arsenals, missions to outer space, and support of satellite nations like Cuba and the Soviet bloc in Eastern Europe. They saw as unsustainable the "Brezhnev Doctrine" that led to the invasion and occupation of Afghanistan, which intellectuals labeled as Russia's Vietnam.

Three years after Brezhnev's death, Mikhail Gorbachev was chosen by the Russian Politburo to run the government. He became the force behind *perestroika*, the restructuring of Russia's government and *glasnost*, the opening of that government.

Hedrick Smith, Pulitzer Prize-winning reporter for the *New York Times*, wrote of President Reagan's summit meeting with Gorbachev:

> For Americans, Reagan's venture to the Kremlin was big news. His strolls on Red Square with Gorbachev, his luncheon for Moscow dissidents, his speech to university students, all made great television soap opera: the old Cold Warrior playing in the heart of "the evil empire." But the Russians I talked with then were blasé about the summit. They saw Reagan's visit as a sideshow; the much more compelling battle was the one within their own country, over internal change.

Americans have never been inclined to examine the details behind the sound bites on important issues or to peek behind the curtain of self-serving political rhetoric to see what is waiting in the wings. Basically, we are a nation of analytical ignorance, content to accept at face value that which is fed

to us by the mainstream media, which are, in turn, not particularly adept at challenging misleading assertions.

Dan Rather once said that Ronald Reagan had a rare understanding of the power of myths and storytelling, which was true. His campaign stump speeches were often a soaring mix of made-up facts, stories, clichés, and fantasies that lodged in voters' memories, later to flow out of their fingertips on election day.

Leslie Janka, a deputy White House press secretary under Reagan, would later write about his ascendancy:

> The Reagan administration was a PR outfit that became president and took over the country. And to the degree that the Constitution forced them to do things like make a budget, run foreign policy and all that, they sort of did it. But their first, last, and overarching activity was public relations.

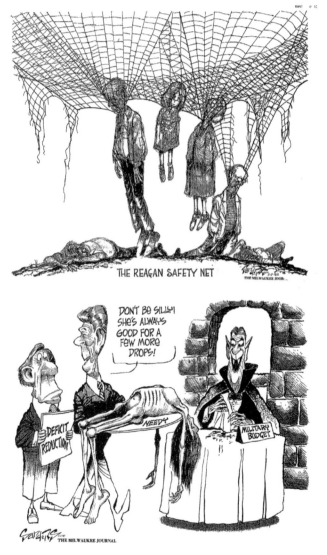

Polishing the President's image was a 24/7 job for White House spinsters Michael Deaver, David Gergen, and other media strategists. Their witless collaborator was the Beltway press corps that found Reagan's mistakes, fictional facts, and gross distortions amusing but unworthy of public discussion.

For example, in February 1980, Reagan announced to the voters of Burlington, Vermont, and the nation, "All the waste in a year from a nuclear power plant can be stored under a desk." What the voters did not hear on television or read in conjunction with that statement in print was that the average nuclear reactor produces thirty tons of nuclear waste every year.

Never one to miss an opportunity to expound on his mantra about big, bad federal

government regulations, Reagan was not beyond using a tragic event to make his conservative point on a given issue. For example, regulating automobile emissions that were eating away at our environment. After Mount St. Helens erupted, he told the nation that he had flown over the mountain twice and suspected it "has probably released more sulfur dioxide into the atmosphere than has been released in the last ten years of automobile driving or things like that."

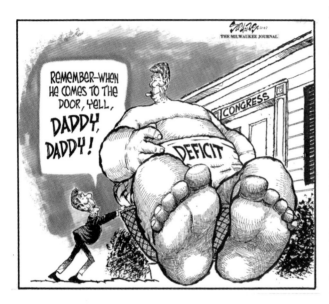

What we didn't hear from the media was that, according to scientists, Mount St. Helens emitted about 2,000 tons of sulfur dioxide per day at its peak eruption, compared to 81,000 tons per day produced by cars.

Fanciful facts tripped easily from his tongue to adoring ears without so much as a speed bump to hinder their progress. "I've said it before and I'll say it again. The U.S. Geological Survey has told me that the proven potential for oil in Alaska alone is greater than the proven reserves in Saudi Arabia." Actually, according to the U.S. Geological Survey, the Saudi Arabia reserves were estimated at 165.5 billion barrels, while the Alaska reserves were estimated at 9.2 billion barrels.

The point, of course, is that Reagan was never one to be confused by the facts.

While his fantasy world was sold to the media and public with a quip and a smile, there were those who, privately, saw him without the benefit of rose-colored glasses. British Prime Minister Margaret Thatcher reportedly once said of him, "Poor dear, there is nothing between his ears." Clark Clifford was once quoted as referring to him as "an amiable dunce." French President François

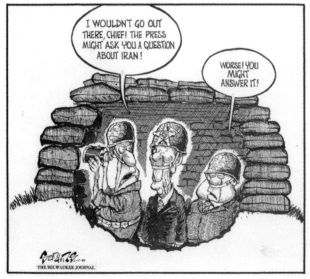

Mitterand asked Canadian Prime Minister Pierre Trudeau, "What planet is he living on?"

Representative Lee Hamilton of Indiana was interviewed by Haynes Johnson for his book *Sleepwalking Through History: America in the Reagan Years*. In detailing a meeting to discuss the viability of the MX missile, Hamilton said, "Reagan's only contribution throughout the entire hour and a half was to interrupt somewhere at midpoint to tell us he'd watched a movie the night before, and he gave us the plot from *War Games*, the movie."

Reagan regularly called Hollywood soldiers front and center when he felt their emotional appeal was useful. My friend Herblock of the *Washington Post* cited a wonderful example and later used it in his book *Through The Looking Glass.*

Herblock's story described how, in a presidential address to winners of the Congressional Medal of Honor, Reagan told of a B-17 bomber being hit in World War II as it was returning to its base in England from a raid over Europe. He went on to tell about the ball-turret gunner being wounded and unable to parachute out with the rest of the crew. The pilot, instead of jumping out of the plane, went to the gunner and said, "We'll ride down together." Reagan concluded by saying, "Congressional Medal of Honor, posthumously awarded." Reagan claimed to have actually read the medal's citation.

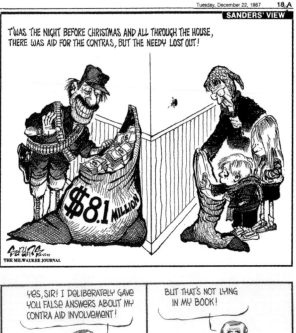

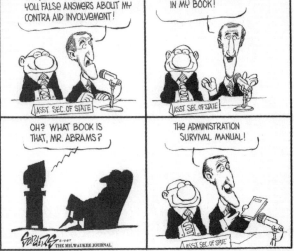

However, a *New York Daily News* reporter wondered about the melodramatic story. He researched the 434 Medals of Honor awarded during World War II. Each had a description of the precise circumstances and reasons for its award; the Reagan story was not among them.

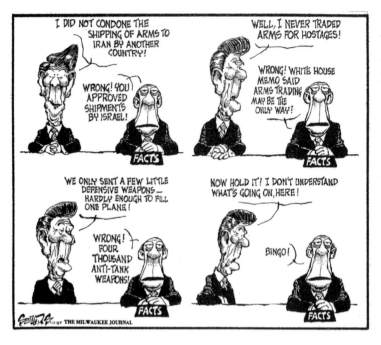

What the reporter discovered was that Reagan's story fit not a B-17 bomber in Europe, but a Navy torpedo bomber over the Pacific. The wounded man was a radio operator. The pilot did say to the wounded man, "We'll take this ride together, " and both then went down with the plane.

Sadly, the incident mangled in Reagan's retelling was not about a real Medal of Honor award, but was only a part of the plot from a 1944 movie, *Wing and a Prayer*.

When Ronald Reagan rode into the sunset of his presidency, he was showing symptoms from the onset of Alzheimer's, a tragic and horrific condition that one would not wish on another human being. The paradox of his legacy was a lingering aftertaste which many refused to acknowledge or define. Was he a simpleton or simply shallow and detached from the real-time, real world over which he presided?

In a nationally televised campaign speech that same year, Reagan chastised President Jimmy Carter, saying, "Mr. Carter is acting as if he hasn't been in charge for the past three and a half years; as if someone else was responsible for the largest deficit in American history."

When Reagan came into office, the national debt was 32 percent of the gross domestic product. Under his presidency the debt rose to 45 percent. In January 1981 the deficit had reached almost $74 billion and the federal debt was $930 billion. By 1988 the debt totaled $2.6 trillion. Those eight years saw the United States go from the world's largest international creditor to the largest debtor nation.

In the well-planned and ongoing canonization of Reagan, the popular myth today is the mantra that his tax cuts set us on the road to prosperity—despite the fact that the Reagan deficits and "voodoo economics" bequeathed a recession to President George H. W. Bush and forced him to raise taxes.

The fact is the common folks not only did not see prosperity but saw their taxes raised by Reagan. Big businesses got tax cuts as did the wealthiest individuals among us. The general population saw their payroll taxes for Social Security and Medicare raised significantly. Social Security taxes are capped, and thus the effect of cuts for the wealthy plus FICA increases was to shift the economic burden to lower-income taxpayers.

Andrew Chamberlain of the Tax Foundation accurately called Reagan's "trickle down" tax law a "watershed event in the history of federal taxation," because it reversed the historical concept of progressive tax rates.

Moreover, after 1981, Reagan continued to raise taxes with the Consolidated Omnibus Budget Reconciliation Act of 1985 and the Tax Reform Act of 1986. Reagan never proposed a single cut to the total budget.

The most accurate picture of the man behind the myth can be viewed in the public album of the Iran-Contra scandal. In violation of U.S. policy and laws, the Reagan administration sold arms to Iran in order to secretly fund guerillas in their efforts to overthrow the democratically elected but leftist government of Nicaragua. The gue-

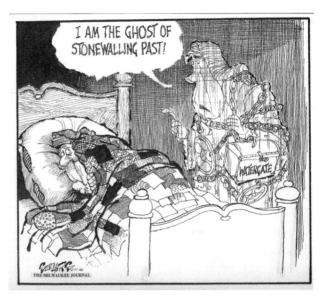

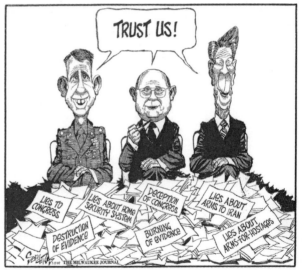

rillas, known as La Contra, systematically used murder, torture, mutilation, rape, arson, and kidnapping as their tactical strategy.

A Human Rights Watch report found that the Contras had targeted health care clinics and health care workers for assassination and tortured and executed civilians, including children, who were captured in combat. The Contras financed their war by running cocaine into the United States via Mexico, an operation that was later exposed to have been secretly facilitated

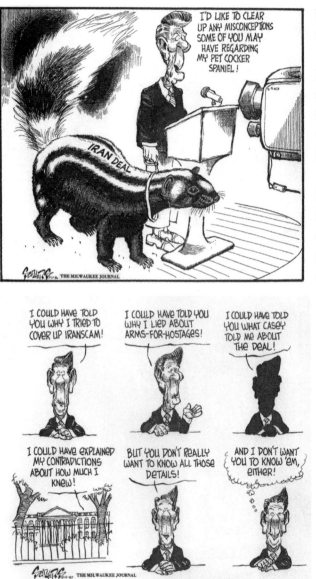

by members of the Oliver North operation that was supporting the Contras.

In President Reagan's Hollywood world, Nicaragua's Sandanista government was a communist regime—i.e., bad guys—and the Contras were the good guys. In Reagan's words, "the moral equivalent of our Founding Fathers."

Fourteen Reagan administration figures involved in the Iran-Contra conspiracy were convicted or pleaded guilty for destruction and removal of records, obstruction of Congress, lying and perjury before Congress, altering records, conspiracy to defraud the United States and accepting bribes—but President Reagan claimed to know nothing about any of it.

Reagan's successor, President George H. W. Bush then pardoned six of the highest-ranking Iran-Contra felons: former Secretary of Defense Caspar W. Weinberger; Elliott Abrams, a former assistant secretary of state for Inter-American affairs; former National Security Adviser Robert McFarlane; and Duane Clarridge, Alan Fiers, and Clair George, all former employees of the Central Intelligence Agency.

So much for accountability!

The independent counsel said President Reagan *"set the stage for the illegal activities of others by encouraging and, in general terms, ordering support of the contras during the October 1984 to October 1986 period when funds for the contras were cut off by the Boland Amendment, and in authorizing the sale of arms to Iran, in contravention of the U.S. embargo on such sales."*

When Reagan finally made a definitive statement about the entire scandal,

he spoke volumes about his presidency: "A few months ago I told the American people I did not trade arms for hostages. My heart and my best intentions still tell me that's true, but the facts and the evidence tell me it is not."

Never mind that his heart and best intentions failed in their presidential duty to "take care that the laws be faithfully executed."

The polishing of the Reagan legacy was a carefully orchestrated operation launched in the spring of 1997 by neoconservative Grover Norquist, the Washington, D.C., activist and president of Americans for Tax

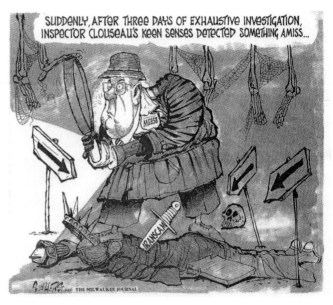

Reform, with the help of a few select Republicans and supporters.

The first project was to rename Washington National Airport as Reagan National. Georgia Republicans Bob Barr in the House and Paul Coverdell in the Senate spearheaded the project on Capitol Hill. In 2011, there was a celebration of the centennial of Reagan's birth. Today the ghost of Reagan is trotted out at every Republican opportunity.

There were, in fact, some positive Reagan postures that the general populace is not aware of.

Reagan was a staunch opponent of torture as a tool of warfare. He was a supporter of civilian trials (as opposed to military tribunals) for terrorists, whom he considered criminals, and he rejected anti-terrorism tactics when the prospect of civilian casualties was high, calling those type of casualties "acts of terrorism." However, don't look for those attributes to be highlighted any time soon, as that does not fit the Republican narrative.

Ironically, Reagan himself best described his legacy: "Politics is just like show business. You have a hell of an opening, coast for a while, and then have a hell of a close."

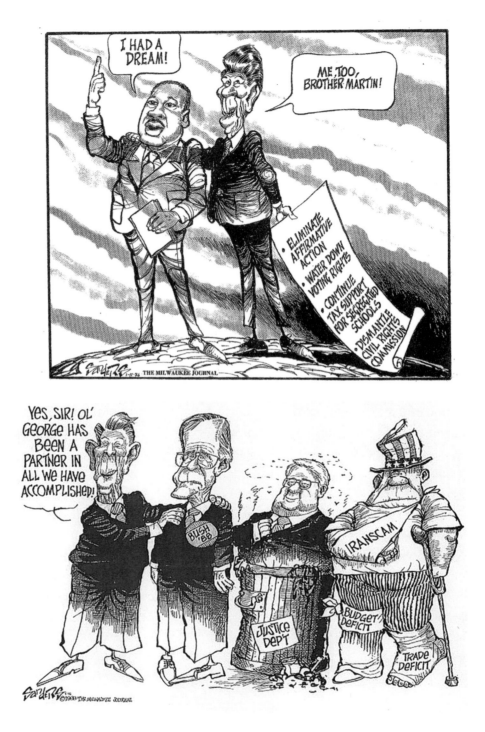

Hiatus, Then George W. Bush

There lurks in the makeup of any decent political cartoonist a tiny gene that shouts, "Warning! Warning! Injustice approaching!"—much like the precocious robot warnings to young Will Robinson in the old TV series *Lost In Space*. However, a cartoonist's gene mainly detects monsters such as hypocrisy, ignorance, greed, or other political chicanery. That warning triggers an insatiable hunger for expression against real or perceived threats of wrongdoing.

Admittedly, maintaining a high level of indignation over the years can take the edge off our insatiable hunger system and put the cartoonist on cruise control, which in turn contributes to less than sharply focused critiques.

My cruise control started kicking in during the administration of President George H. W. Bush.

In August 1988, I was working the Republican National Convention in New Orleans. It was an event that, metaphorically, had the same characteristics as its nominee—bland, bordering on boring and noncontentious. The only discernible nightly struggle was that of print media reporters who descended from the press box and waded through the sea of delegates on the convention floor, hoping to grab an interview before their fifteen-minute floor passes expired.

By 1988, the national political conventions were run as much for television as for the party delegates. While print media reporters struggled to collar a potential news source in their allocated time, television celebrities and movie stars, enabled with permanent floor passes, cruised the crowded convention floor, dispensing tidbits of fame to fawning politicians.

During one such effort to reach the Wisconsin delegation before the first ballot vote, I bumped into a woman as I squeezed through the shoulder-to-shoulder crowd. Literally pressed against her, my first view was of the unrestricted press pass around her neck. When I looked up to ask her pardon as I forced my way between her and a chunky delegate, I found I was excusing

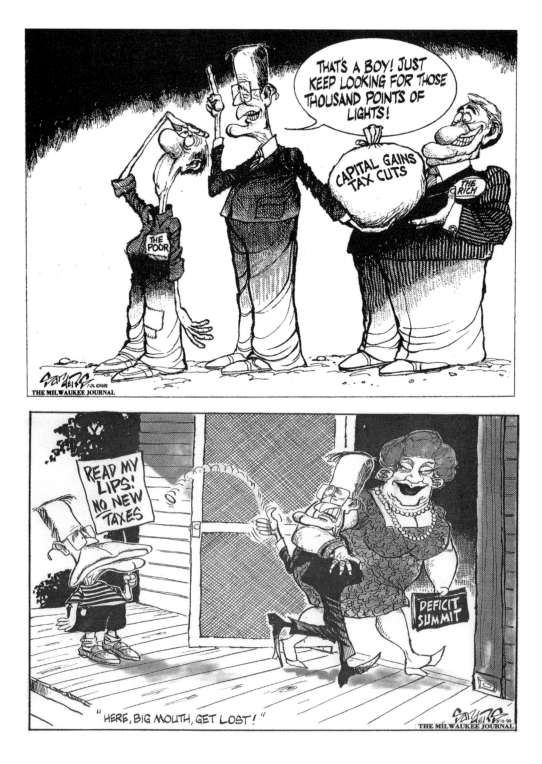

myself to Margot Kidder, who played Lois Lane in the movie *Superman*. As I moved on, I thought, what is she doing here? Then, I thought, silly me—after all she is a reporter for the *Metropolis Daily Planet*. I wondered if Clark Kent was also somewhere on the floor.

This was the convention that saw Bush select U.S. Senator James Danforth Quayle of Indiana to be his vice presidential running mate. Dan Quayle would become another mile marker on the road to dumbing down in America.

However, "Read my lips: no new taxes!" would be the Bush verbal legacy. Under the weight of the record deficit and debt he inherited from the Reagan presidency, plus his own fiscal conservatism, America heard Bush's lips finally proclaim "tax increases" before he left office.

As the Papa Bush presidency entered the 1990s, my internal voices were frequently whispering, "Been there, done that." Wisconsin winters seemed to be getting longer and colder—and the fire in the belly burned less intensely than I had ever experienced. Meanwhile, the *Milwaukee Journal* was slowly morphing into a right-of-center, corporate-bottom-line opera-tion run by bean counters with no fealty to its history of major-league journalism. The trend was a microcosm of the coming destiny of newspapers.

The cover of the Milwaukee Journal Sunday Magazine *announces my retirement in 1991.*

By 1991, at age sixty-one, I decided to dismount from tilt-ing at windmills, put Rocinante out to pasture, and head for a warmer climate—Fort Myers, Florida, where I could play a little golf, make a little music, and do a little traveling and perhaps create some nonpoliti-cal art. I had already given up my syndication because of the extra work required if I wanted to draw on a local issue after

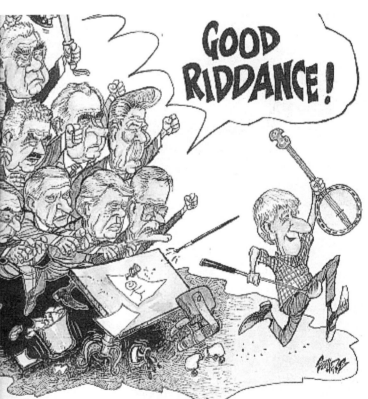

The bronze sculpture of E. A. "Uncle Ed" Diddle, legendary basketball coach at Western Kentucky University, now on display at the Augenstein Alumni Center.

finishing a cartoon for national distribution. When I retired and was unleashed from the daily deadlines, I hit the road for Florida, imagining the tune from *Born Free* riding the wind around me.

THE EARLY RETIREMENT YEARS were spent doing those things, intermingled with designing another house, again drawing the blueprints and acting as the general contractor. As for nonpolitical art, I could not muster the motivation that I had envisioned—other than sculpturing, but that I did find interesting and challenging.

I completed two bronze sculptures. One was of the legendary basketball coach at Western Kentucky University. By his retirement in 1964, Ed Diddle had coached his Hilltopper teams to 759 wins—second only to University of Kansas coach Phog Allen, who had 771. The Diddle sculpture is displayed at WKU.

The other sculpture was of a Calusa Indian warrior. I made that one for Joyce, who had adopted Florida with gusto. It was on display for a year at the Southwest Florida Museum but is now back on her coffee table.

Ironically, as I drifted through the Bill Clinton administration years, detached from politics, Joyce became the political activist of the family. She brought her boundless enthusiasm for nature to bear on environmental politics in southwest Florida. She became a volunteer naturalist at the Six Mile Cypress Slough wetlands preserve and was later president of a Friends organization dedicated to preserving and protecting the wetlands. She was instrumental in raising $500,000 and persuading the county to build a $3.7 million interpretive and educational center that is a gateway to Six Mile Cypress Slough.

Over six years, her knowledge and articulate expression put her on the front lines in the battle to stave off detrimental development in and around the wetlands. She became the "go to" public interest representative when the county needed advice and support in environmental conflicts.

Meanwhile, I began to find it difficult to read newspapers casually and

even more difficult to ignore the constant exposure of television's hybrid news-pundit programs.

The Clinton era was coming to a close, and the Monica Lewinsky "scandal" brought Republican hypocrites out in mass to vent their moral outrage with a frivolous impeachment effort. It made for a "tainted exit" of an administration that could claim record-high surpluses, the longest economic expansion in history, and record-low poverty rates.

The 2000 Democratic National Convention chose Vice President Al Gore as its nominee for president and the Republican National Convention nominated former Texas Governor George W. Bush.

As that campaign got underway, and the Florida political pot started boiling, I began to feel my fire in the belly rekindling. But to what end? I had no outlet, even if I decided to saddle up Rocinante and ride back into battle.

I could and did draw an occasional cartoon for the *Fort Myers News-Press*, but that was a spasmodic publication process at best, and research sources were limited to the confines of my little office at home.

Then I discovered the amazing vistas of the Internet. Early on as a journalist, I had learned the value of clipping and filing as a reservoir of ideas and resource of facts. Also, I learned the vital importance of a selected regular information diet—magazines such as the *Nation, National Review, Time,* and *Newsweek,* plus newspapers such as the *New York Times, Wall Street Journal,* and the *Los Angeles Times*. Research was labor-intensive.

When I moved to the *Milwaukee Journal* I had access to its LexisNexis research source, a precursor to the Google and Wikipedia concepts, but it rarely lured me from my hard-copy files or the newspaper's hard-copy information center (referred to in the old days as the morgue).

When the *Journal* switched from typewriters to computer word processors, the curmudgeon within me opted not to join the electronic age. After all, I was a brush and ink man and had a secretary to type letters.

Up to my retirement in 1991, newspapers and magazines provided most of my information and research. However, in retirement, I slowly began to realize the computer could be so much more than a word processor and tool for storing, processing, and transmitting drawings. The Internet superhighway and burgeoning websites opened research opportunities heretofore unimaginable.

I knew about Al Gore, son of Tennessee's Albert Gore. The younger Gore had worked at the *Nashville Tennessean* when my wife's uncle and my mentor, Gene Graham, was one of its editorial writers. Gore's future wife, Tipper Aitcheson, also worked there. Because of those connections, I was familiar with his political leanings and philosophical posture.

Using the Internet, I set about finding background information to get some sort of picture of George W. Bush. What I learned triggered more and more insistent internal warnings.

W's PREPPIE BACKGROUND AT Phillips Academy in Andover, Massachusetts, and his privileged entry to Yale University (he was rejected by the University of Texas Law School) were not particularly defining negative vibes—nor was I especially bothered by his drinking or collegiate antics. However, some warning bells were rung by his jocularly dismissive explanation of his use of alcohol and drugs into his forties as simply an episode of his "youth." Moreover, while young American men, mostly poor and disadvantaged, were being drafted and were dying in Vietnam, Bush was a draft dodger who made the most of his lineage of wealth, entitlement, and influence.

A close family friend of Papa Bush had contacted the speaker of the Texas House, Ben Barnes, and told him Representative Bush's son needed to get into the Texas Air National Guard. Barnes then used his influence with Brigadier General James Rose, commanding officer of the Texas Air National Guard, to secure a slot in the unit. At that time 100,000 men were trying to get into the Guard and there were 150 pilot applicants. Bush got a direct commission and one of the state's two pilot spots despite scoring the absolute minimum on the qualifying test.

When he became governor of Texas, the state had a multibillion-dollar surplus. Six years later, the state was not only broke but in a giant deficit hole. Governor Bush's contribution to environmental protection and cleaner air was essentially to give the project to Marathon and Exxon oil companies. The governor's 1999 bill to clean up the refineries was written by oil company lobbyists. Sound familiar? Fast forward to the secret writing of environmental policy when the Bush-Cheney team came to Washington.

Bush's cozy relationship with and manipulation by corporate and oil interests on a broad range of economic and regulatory issues prompted legendary

Texas journalist Molly Ivins to refer to "Dubya" as a "CEO's wet dream."

Moreover, his personal wealth had come not from his own business acumen but from the benevolent generosity of his daddy's wealthy friends and political handlers.

The background picture of George W. Bush was that of a shallow "good old boy" with limited verbal skills and zero intellectual curiosity—a "good old boy" cruising down the road of entitlement and political wheeling-dealing, with a juvenile macho mentality better suited for an eighth-grade playground than running a state government, not to mention the most powerful nation on the globe.

IN SHORT, THE MORE I learned about Dubya's background and the issues exposed in the Bush–Gore campaign—the more my old drawing board beckoned. I moved a notch out of retirement when I figured out how to set up a "blog" (*Sanders Cartoon-Commentary*) on the Internet.

Unlike the fixed audience of newspapering, blogging is limited to its creator's ability for accruing a following. It will attract some viewers who simply cruise the Internet, but, for the most part, the burden of attracting viewers falls to the blogger. The Internet political cartoonist must aggressively pursue an audience by circulating work over social networks like Facebook or Twitter or on specialty websites with political or social agendas. I had already seen that newspapers' mainstream media influence was dissolving under the relentless glare of 24/7 television. Now the entire mass communications audience was being blown away by the high-speed Internet—scattered by a confluence of social networks, multiple digital domains, and specialty agenda webs.

Working on the staff of a major newspaper puts you automatically in touch with the daily lives of its readers—who often feel personally involved and who will sit in judgment on your work and make no bones about their sentiments, like tearing out a cartoon, using it for toilet paper, then mailing it to you. My blog was an outlet for rejoining the national conversation, even though I didn't feel from it the personal connection to a defined readership that I had enjoyed in my newspaper work. Maybe my critics didn't know where to mail their used cartoons.

My early use of the blog was occasional in nature. "Dubya's" public persona appealed to the traditional hot-button issues of the Republican Party—priva-

tization of Social Security, anti-abortion rhetoric, government deregulation, and opposition to gay marriage. On the other hand, there was undisguised rhetoric intended to grease the skids for Saddam Hussein as a "threat" to our security.

However, the prevailing image of the 2001 election was a member of the Florida Election Board vainly squinting at a ballot as it was held it up to a light. It was a time of "hanging chads" and voter suppression.

Someone once said, *"The road to Hell is paved with good intentions."* No one has ever said, *"The road to Iraq was paved with hanging chads."* But someone should have!

While the hanging chads fluttered in the sultry breezes of Dade County, few in the media—and certainly none of the nation's voters—felt the cold winds of war that were headed in their direction.

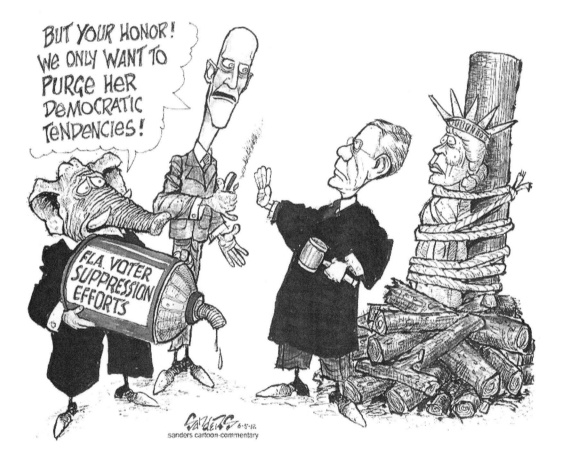

While I could see the humor in hanging chads, I could not find much humor in hanging voting rights.

It was beyond my comprehension that American voters would select this man as their president, and I was right—American voters preferred Al Gore by more than 500,000 votes.

However, the U.S. Supreme Court preferred ol' "Dubya" by one vote.

THOSE POLITICAL CARTOONISTS WHO are ever alert for the latest "gag" subject jumped on the metaphorical opportunity like hound dogs on a ham hock. They looked on the U.S. Supreme Court's "hanging chads" decision as fertile joke material rather than a voting rights travesty.

There are two approaches to our profession. There are those who look at a situation as a vehicle for a joke. Then there are those who look at a situation

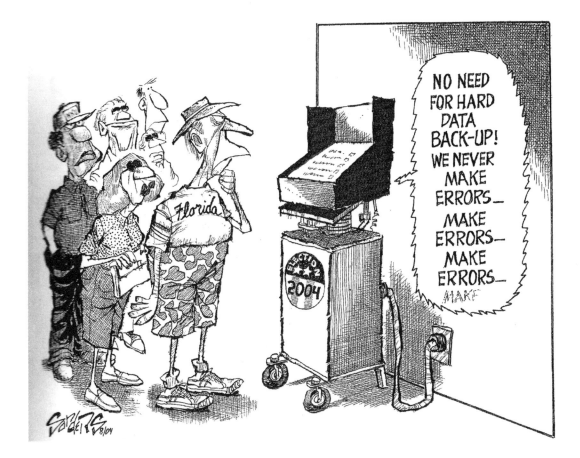

as a vehicle for opinion, expressed with an element of humor. Gone were the days of somber symbolism and labels that dominated political cartooning of the 1940s.

The 1950s brought a new trend with the style of Herbert Block (Herblock) of the *Washington Post*. His modern composition, political savvy, and rapier-like wit sliced and diced politicians and their hypocrisy without remorse but with wonderful, ironic humor.

In the 1960s, the *National Observer* (an innovative weekly newspaper owned by the parent company of the *Wall Street Journal*) wrote that there was a "new breed, with new bite" coming onto the scene—those who eschewed labels for literary dialogue and discarded ponderous symbols for humor and satire. I was stunned when their summary included me in the company of New York playwright and cartoonist Jules Feiffer and Hugh Haynie of the *Louisville Courier-Journal*.

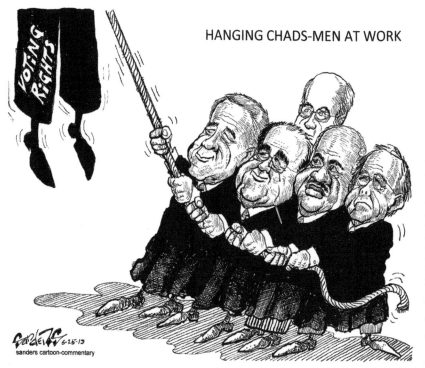

HANGING CHADS-MEN AT WORK

The Herblock style for critical commentary had been hijacked in the '70s and '80s when an influx of humor-for-humor's-sake political cartoonists approached the job with a formula akin to standup comedy. This formula was well-entrenched when the "hanging chads" decision came down.

27

The Road to Iraq

Early in the morning of September 11, 2001, I stepped away from the drawing board and drove over to an art supply superstore in the small East Coast town of Overland Park, just south of Pompano Beach on "Old Dixie Highway." It was just another sunshiny day in paradise with a mild breeze gracing the palm trees.

After a brief survey of the exotic side of new art products, I purchased my supplies, loaded them into the car, and drove out I-75 to pick up Alligator Alley heading back to Fort Myers.

In my rush to get out of the traffic, I was almost at the end of I-75 when I realized I needed gas and pulled over to what appeared to be a "last chance" mom and pop station. After filling my tank, I went in to pay and get a candy bar. It was a small, cluttered store, and I was the only customer.

When I stepped to the counter to pay, the young clerk was staring intently and smiling at a television on the wall. He appeared to be of Middle East or Indian extraction. I glanced at the screen to see black smoke billowing from a tall metropolitan building. The volume was barely audible as I turned and paid the clerk.

I asked, "Where is that?" After he took my money, he looked at me, shrugged his shoulders and turned back to the television screen. Slightly irritated at the clerk's attitude, I returned to the car. It was not until I arrived home that I was boggled to learn that I had witnessed one of the World Trade Center towers burning after al-Qaida's suicide attack.

As the tragedy and horror of 9/11 unfolded in the following days and weeks, it sent a visceral shock wave of reality through the American psyche that we were not exempt from the derangement of religious-political zealots like Osama bin Laden and al-Qaida.

After mourning the loss of lives and honoring those first responders for their bravery in the face of death, the national sense of outrage and hunger for

revenge was palpable. The attack on American soil by rogue religious terrorists from the Middle East was not only murderous in its results but insolent in its planning and execution. It was a clarion call to arms—and President Bush declared "war on terrorism!"

He went on to announce that "our war on terror begins with al-Qaida, but it does not end there" and vowed that he would make no distinction between the terrorists "who committed these acts" and those who harbor them.

In retrospect there is little dispute over the manner in which we were led down the road to Iraq. It is a matter of record. In real time, the road to Iraq was also a matter of record for those willing to sort through the political minutiae designed to obfuscate the truth of what was taking place.

George W. Bush brought with him to the White House a proclivity for "Bubba"-style exaggeration. That, combined with a John Wayne instinct for macho hubris, led me to suspect his public pronouncements on the Middle East prior to 9/11. Having done a little homework on Saddam Hussein's role in the area, I concluded that Bush was just reverting to character when he would go on a rant about the Iraq dictator.

One of the first cartoons I did prior to 9/11 was when Bush launched the fearmongering express by inflating Saddam Hussein's image as a threat to our security.

The beating of war drums was a carefully calculated concert by the Bush

neocon cadre who were marching to the cadence of right-wing radio and television pundits, state legislative politicians, Fox News, congressional Republicans, and nationwide hawks of the Tea Party and National Rifle Association.

After 9/11 the fearmonger express worked up a full head of steam, warning Americans and the world of Saddam Hussein's possession of nuclear and biological weapons. Dick Cheney—a man who had obtained five draft deferments to avoid Vietnam because he had "other priorities than being in the military"—was a leading chicken hawk in the administration as well as the Machiavellian author of President Bush's invade-Iraq agenda. On August 26, 2002, Cheney told the audience at a VFW national convention in Cleveland, "Simply stated, there is no doubt that Saddam Hussein now has weapons of mass destruction."

In the relentless effort to spread that gospel, Bush announced over Polish television, on May 29, 2003, "We have found the weapons of mass destruction. We found biological laboratories. For those who say we haven't found the banned manufacturing devices or banned weapons, they're wrong, we found them."

But it was Bush himself who was wrong; no such weapons or labs capable of making them were ever found. Instead, President George W. Bush and his band of neocons carefully wove deceptions, outright lies, and cherry-picked intelligence into a shining replica of the American flag and hoisted

it high for Congress and the rest of us to salute. The road to a unilateral preemptive invasion of Iraq was paved with jingoism and fearmongering that resulted in parents sending their sons and daughters to fight and die in a bait-and-switch war on Iraq that had nothing to do with 9/11.

The war proponents' initial campaign was designed to appeal to Americans' love of freedom and proud willingness to export our democratic values to the Iraqi people—and it would be called "Operation Enduring Freedom."

Paul Wolfowitz recognized the thin ice of "Operation Enduring Freedom" as a slogan for war with Iraq. In an interview, he explained, "For bureaucratic reasons we settled on one issue, weapons of mass destruction, because it was the one reason everyone could agree on."

Bush, who had suggested that God chose him to be president, often maintained that as a Christian and a man of peace, he only thought of war as a last resort. However, *Time* reported that Bush shared his confidential thoughts with three unidentified U.S. senators, saying "Fuck Saddam, we're taking him out!" That was in March 2002, a year before invading Iraq.

Sadly, the disastrous run-up to the 2003 invasion of Iraq, a period during which newspapers and networks should have intensified their investigative reporting and editorial questioning of politicians' assertions, was a harbinger of what was to come.

Then, in April 2003, television viewers were entranced with the unfolding story of Private Jessica Lynch, who was reported to have heroically survived an ambush when her unit's vehicle took a wrong turn in Iraq. Her dramatic

story occupied the major news shows for more a week, plucking the patriotic heartstrings of U.S. viewers.

The story that was reported had all the elements of a Hollywood movie—a brave female soldier firing back at an overwhelming enemy, ultimately stabbed, shot and captured, then kept prisoner in an Iraqi hospital where she was slapped around and interrogated before she was rescued by a daring midnight assault into enemy territory by Army Rangers and Navy Seals.

The official narrative went on to say that though the U.S. forces were under fire, the rescue unit found Lynch and whisked her out of the hospital to a waiting helicopter. A segment of this heroic drama—the carrying of Private Lynch on a stretcher down the hospital stairs—was captured for posterity by a military night-vision video camera.

Television viewers were treated to endless replays of the video and narrative, plus speculation by pundits like Sean Hannity of Fox News that Lynch had also been raped.

The original hyped-up story had been disseminated at a briefing for correspondents in Iraq by Jim Wilkinson, the Bush White House's deputy national security advisor for communications. This heroic tale was repeatedly aired with pundit and anchor-reporter buzz about the brave female soldier and the troops that rescued her, while under fire, from Iraqi bad guys.

One difference between drawing for a daily newspaper and the Internet is that in a newspaper I could never have gotten away with the language in this cartoon. (Remember, I was only quoting Cheney.)

A question that occurred to me at the time—and I wrote about it in my blog—was what commander in his right mind would take a video camera crew with him during a secretive combat mission? I wondered why that question seemed not to have crossed the minds of the pundits and anchorpersons.

As it turned out, the story that later emerged was quite different from the heroic version disseminated by the White House and military brass and repeated 24/7 by an unquestioning U.S. news media. The subsequent version of the events was ultimately confirmed by Jessica Lynch herself,

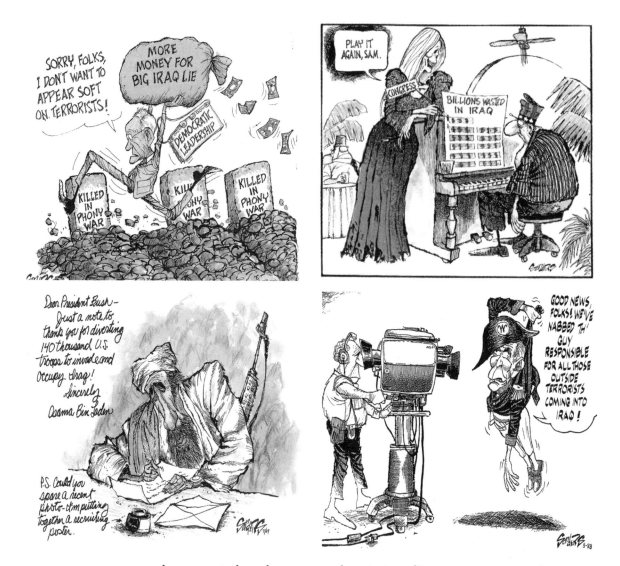

who seems to have been as much a victim of Pentagon propaganda as were American television viewers.

The real story was that Lynch did survive an ambush, and she was taken captive and transported to a hospital in Nassiriya by Iraqi soldiers. However, she had no stab or bullet wounds—rather she was suffering from broken bones that were the result of the vehicle wreck. She was not abused.

By the time the U.S. forces advance team moved into the area of the hospital, followed by the rescue team in helicopters, the Iraqi guards had long

since fled. It turned out that Private Lynch had been treated well medically and otherwise, and there was no resistance to the rescue mission.

However, those facts didn't deter General Vincent Brooks from releasing the video footage to a correspondent's briefing with the claim, "Some brave souls put their lives on the line to make this happen, loyal to the creed that they know that they'll never leave a fallen comrade."

At the time, the Iraq war news was grating on the American psyche. The death rate was steadily climbing and Saddam Hussein was nowhere to be found. The Bush administration desperately needed a diversion. What could be a better message than an American hero story from the battlefield?

Fast forward to April 2010 when WikiLeaks exposed a classified video of an Apache helicopter crew gunning down a dozen unarmed civilians, including two Reuters journalists, in the suburb of New Baghdad, Iraq. Reuters News Agency tried and failed to get the video through the Freedom of Information Act—"national security" was cited as the reason the FOIA request was denied—before WikiLeaks released it.

The Apache's video camera footage also showed the murder of two men who drove up in a van to rescue a wounded civilian. Two children in the van were seriously wounded as the Apache riddled it with bullets. The Apache crew can be heard laughing and joking about "those dead bastards" and chomp-ing at the bit to kill the wounded, crawling civilian. Watching the children being taken from the van, one crew member remarked, "That's what they get for bringing their kids."

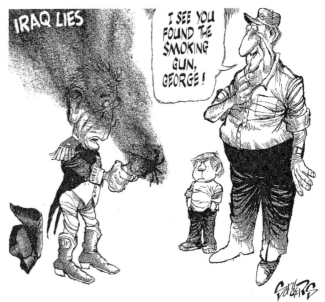

Most Americans—if they saw this video at all in the brief time window when it aired—viewed a sanitized version on the major news outlets. They heard none of the comments from the jubilant Apache crew. They did not hear the Apache crew say that the two reporters were carrying automatic weapons, even though the video clearly showed the reporters had cameras, not guns, on their shoulders.

Television viewers heard none of the

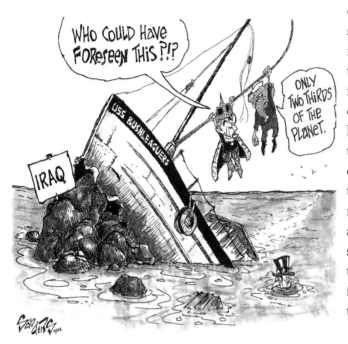

callous commentary nor saw the bloody shooting down of the unarmed civilians—those details were censored by the major media outlets. News anchors introduced the WikiLeaks video by describing it as "unlawfully acquired" highly classified material. They reported the authorities' claims that exposing the clip was a threat to national security and the lives of U.S. servicemen. The major media news anchors presented the story as a dispute between the Pentagon, which stated that the Apache crew acted within the rules of engagement against armed insurgents, and WikiLeaks, which called the encounter "collateral murder."

The only members of the public who saw the uncensored version were those who logged on to YouTube or WikiLeaks. In the weeks after the sanitized version was shown on major news programs, it dropped off the radar screen in the wake of hand-wringing over "the threat" that an outfit like WikiLeaks posed to America and the free world. That was the message beamed to the American public.

FORMER CIA OFFICIAL PAUL Pillar coordinated U.S. intelligence on Iraq until 2005. The 28-year veteran was considered the agency's leading counterterrorist analyst, responsible for pulling together assessments on Iraq from all 15 agencies within the intelligence community. He later said it became clear that intelligence "was misused publicly to justify decisions already made." He wrote that the Bush administration "repeatedly called on the intelligence community to uncover more material that would contribute to the case for war"—particularly the alleged connection between Saddam Hussein and al-Qaida, which analysts and Middle East experts discounted.

If Oscars were awarded for performances during this period of American history, the best supporting actors would be congressional Democrats and

the media. They shamefully went belly up under the pressure of patriotic correctness after 9/11. Congress voted to give President Bush—and all future presidents—unfettered authority to unilaterally commit U.S. military action anywhere in the world.

President Bush bragged about his authorization to torture prisoners and vowed he would do it again under similar circumstances. In a 2013 interview related to the dedication of his presidential library at Southern Methodist University, Bush said he had no regrets. He said, "I am comfortable with what I did. I'm comfortable with who I am."

Unfortunately, thousands died to provide Mr. Bush with that comfort.

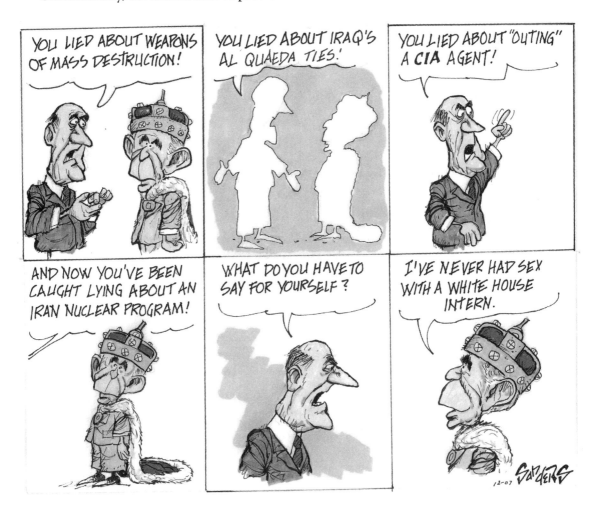

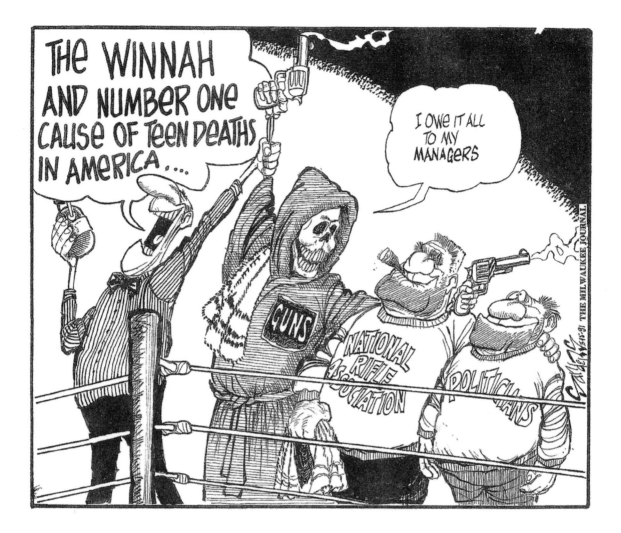

The Government We Deserve

I sometimes feel I am living in a real-life version of *Groundhog Day*—the movie where the main character, played by Bill Murray, wakes up every morning to find himself reliving the previous day.

There's a stunning repetitive pattern to the parade of social and political events I have been privileged to witness and participate in. One cannot help contemplating why that is true and why we do not learn from the past. I suspect the answer lies in the fact that when each "next" event takes center stage, its primary audience is new and therefore the event seems fresh and not to be judged through the prism of the past.

Hence, we are forced to fight the battle for health care again and again. We must constantly refresh our vigilance for civil rights and civil liberties. We are forced to endure mass murder repeatedly because of our tolerance for the National Rifle Association and its puppets in Congress—and we entreat our youth to die in serial wars that are started and glorified by draft dodgers.

Today's political deja vu sensations seem to involve two interrelated phenomena. First: the decline of traditional media, the rise of online and social media, and the stratification of cable news and talk radio have led to a dangerous polarization of information in which facts simply do not matter to about 40 percent of the electorate. Second: the rising influence of corporate and moneyed interests, especially ultra-conservative and right-wing interests, have corrupted and perverted the political process to an extent we have not seen since the robber baron era of the late 1800s and early 1900s.

IT WAS LESS THAN a decade from 1991, when I retired from the *Milwaukee Journal*, thus beginning my "hiatus" from political cartooning, to my return to the fray with the coming of George W. Bush, but in that interval the nature of communications and journalism changed markedly. Witnessing "the dumbing down of America was both exhilarating and depressing.

"Why has government been instituted at all? Because the passions of man will not conform to the dictates of reason and justice without constraint."

—ALEXANDER HAMILTON

On the one hand, the expanded influence and ubiquitousness of cable television news made cartoonists' work much easier. Political faces and mannerisms that once were little known to the general public became more recognizable, meaning we often didn't even need labels on our cartoons. The 24/7 news cycle and satellite technology brought once obscure countries and cultures into our living rooms—planting images in the public mind that were doorways for the political cartoonist's imagery. "Afghanistanism," for instance, was no longer simply a shorthand allusion to some irrelevant, distant political boundary.

On the other hand, there was the depressing gradual demise of newspapers as a general information source. Along with newspapers' slide in influence came a parallel diminishing of the written word as a conveyor of knowledge. Today, the fundamentals of good reporting often seem to be a lost art, and the loss contributes to the dumbing down of America.

Television reporters and news anchors are the worst offenders, often framing controversial issues with a "he said, she said" context that begs the question. Euphemisms become anesthesia for the brain: *waterboarding* instead of *torture* becomes the standard for their language. To me, celebrity, wealth, and the hybrid mix of entertainment and pancake makeup have always seemed strange bedfellows for what is called "journalism." There are, of course, good reporters working in broadcast, but they are a minority, given the number of Kens and Barbies that populate America's TV stations. Moreover, network anchors with multimillion-dollar contracts relate more easily to the lifestyles of the wealthy and powerful than to those whom the wealthy and powerful govern.

Historically, journalism has been rooted in the environment of the common man and woman—not in the high-roller world of moneyed and political elites. The pamphleteers and caricaturists of the 17th century in England and the American Revolution were the forerunners of newspapers. They were rabble-rousers against establishment pomp and power. In that respect they served the same purpose as today's bloggers.

However, today's television journalism is celebrity-driven. Ratings are based on the public's response to imagery rather than substance, which is no revelation, given that the medium is based on visuals. Celebrity TV "journalists" often become part of the story, rather than a vehicle for the story. The success of the interview-pundit type programs—*Hardball, O'Reilly Factor, Glenn Beck Show, Countdown, Ed Show, Rachel Maddow Show*, to name a few—is measured not by quality of information but rather in establishing a

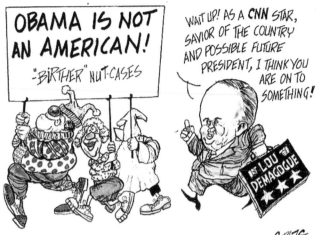

brand, which further encourages creeping hubris. Moreover, these and similar programs recycle the same clique of guests ad nauseam; an uncritical viewer could come to believe no expertise of any kind exists outside the Washington Beltway. (To be fair, Rachel Maddow sets herself apart from the pack. She is intelligent, does her homework, and effects tough commentary with wit and irony. She is a political cartoonist by nature but doesn't know it.)

The celebrity factor also elevates mediocre talent and incompetence to "star" status, which says more about the taste and intelligence of the consumer audience than we want to admit. Can anyone rationally argue that U.S. senators, representatives, and otherwise intelligent government officials would have spent thirty seconds in serious conversation with Don Imus were it not for their exposure gained on his show?

Television in the hands of a single-minded individual with an agenda and corporate support can elevate an issue to crisis level in our collective minds. Lou Dobbs proved that on CNN with his night-after-night demagoguery on immigration. His hubris, fed by his celebrity, compelled him to prattle about his viewers wanting him to run for president—until his discourse became so biased and self-serving the he was finally dumped.

There is a media clique that rotates around the Washington-New York axis and is embedded in the establishment that governs us in much the same way its reporters are "embedded" in the armed forces in Iraq and Afghanistan. Too often, members of this clique are so enamored with their "insider" status

that they are reluctant to pursue and report unvarnished stories for fear of alienating their power-broker sources.

For the sake of transparency, I concede that there is a celebrity factor for print journalist, including political cartoonists, and I concede getting a smidgen of pleasure from it. However, ours is an anonymous celebrity. Political cartoonists are often well-known by name because of their signature, the nature of their work, and its publication. But most readers would not recognize a political cartoonist if they were seated next to one at a bar (I confess we get an occasional surreptitious kick from hearing strangers at the next table discussing one of our drawings).

However, our tweaks of pleasure are mitigated by the fact that we—like traditional newspapers—are dinosaurs in the tar pits.

OVER FOUR DECADES OF covering politics, I have learned that some bromides do contain considerable truth: One, you get what you pay for. Two, we deserve the kind of government we get from the kind of people we elect.

Politically, getting what one pays for has been embedded in our system of government since its origins, but recently the corrupting influence of money has grown more insidious. The price of political influence has traditionally outpaced the growth of ethics, but wariness of corporate power to influence elections has been around since the 1890s, when states began setting legal limits on companies' campaign spending. In 1907, the Tillman Act banned direct corporate contributions to political candidates in an effort to thwart possible corruption and curb misuse of shareholders' money.

But in 2010 the influencers hit the jackpot with the U.S. Supreme Court's decision in *Citizens United v. Federal Election Commission*. The court reversed a century of law, thus unleashing unlimited spending by special interests and domestic and foreign corporations to support candidates and influence policy. The court equated corporations with "persons," defined corporate campaign spending as Constitutionally protected free speech, and allowed tax-exempt entities to keep secret their funders' identities.

The decision laid bare the hypocrisy of the court majority's lip service to respect for precedent and was breathtaking in its potential for sending us down the slippery slope toward governance by, of, and for the wealthy.

Under the U.S. Tax Code, nonprofit organizations with "501(c)(3)" status

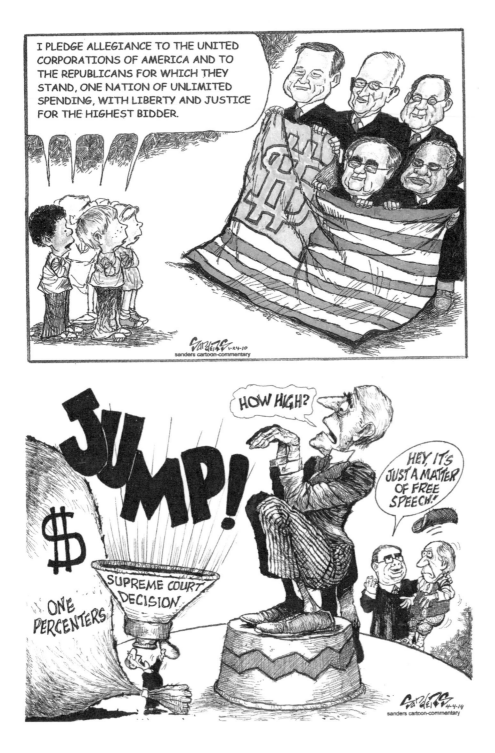

have long been prohibited from engaging in political activities, although traditional political action committees (PACs) could directly contribute member donations to a candidate. But now, as a result of *Citizens United*, so-called Super PACs are free to raise unlimited money from corporations, associations, and unions, as well as individuals, and to spend unlimited sums to advocate for or against political candidates.

Besides the *Citizens United* largess, there evolved a blatant abuse of the "501(c)(4)" status that was originally set up to encourage social welfare support. The law as passed by Congress specified that any such group had to be *exclusively* engaged in promoting the common good and general welfare of the community. However, *exclusively* was later changed to *primarily*, opening a loophole through which that metaphorical truck could be driven.

Now "social welfare" organizations such as Karl Rove's Crossroads Grassroots Policy Strategies can collect unlimited amounts of money and spend 49 percent of it on a political agenda, without disclosing the source of donations. Thanks to the proliferation of these bogus organizations, Democrats, Republicans, and Tea Partiers have tripped down the draconian pathway to the darkest side of American governance.

The biggest abusers—conservative and right-wing groups affiliated with the GOP—spent more than $300 million on a steady drumbeat of ads in the 2012 election cycle and, according to the *Washington Post*, were more secretive than ever about the sources of the money. Democratic-aligned groups were outspent by 7 to 1. At this writing, the relative numbers for the 2016 cycle were not known.

In 2012 in Florida, evening news viewers were deluged with issue ads such as those featuring a "typical" couple at the breakfast table lamenting the prospects of being unable to choose their doctor with "this government health care" bill coming at them. Never mind that the content was totally misleading—the underlying message was plain: vote for the candidate opposed to Obamacare! Few viewers noticed the small-print attribution of a front group that was largely funded by a health insurance giant.

West Virginia and Kentucky coal mining interests were solicited by Roger Nicholson, senior vice president and general counsel at International Coal Group, to unite under *Citizens United* to defeat anti-coal incumbents in select races and to elect pro-coal candidates to open seats.

It does not require a clairvoyant to see that huge amounts of money can buy an elective office.

Multimillionaire Rick Scott spent a staggering $73 million of his personal wealth to become governor of Florida. The jingling of his campaign coffers drowned out coverage about his past: Scott was CEO of Columbia/HCA Healthcare when the corporation pleaded guilty to fourteen felonies and paid a record $1.7 billion in criminal and civil fines for billing taxpayers for expenses that Medicare did not cover. The hospitals, under Scott's leadership, kept a double set of books. The books with the inflated costs were sent to Medicare, while the other books were marked "Confidential: Do Not Show to Medicare Auditors."

Scott claimed he was unaware of what was going on. When questioned under oath in a tangential case involving Columbia/HCA in 2000, he took the Fifth Amendment seventy-five times when asked about the Medicare fraud case, even refusing to acknowledge that he was the CEO. That damning background was shrugged off by Floridians in the face of Scott's hurricane of dollar bills and resulting contrived media exposure. Even the Florida Medical Association blindly endorsed him. As Groucho Marx once said: "A child of five would understand this. Send someone to fetch a child of five."

While Scott's purchase of political office was made with personal spending, imagine what the tainted fruit of corporate spending could do.

Exxon Mobil reported a record $45.2 billion profit in 2009 and paid no U.S. taxes. Since the U.S. Supreme Court has granted the corporation personhood, Exxon could invest a mere one percent of its largess in purchasing one or two senators sympathetic to deregulation and the watering-down of pesky environmental standards.

The U.S. Chamber of Commerce received a $2 million do-

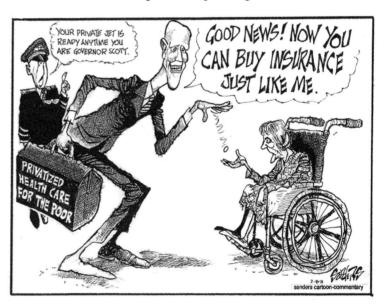

nation from Prudential Financial in 2009 to support the Chamber's campaign against financial regulations. Dow Chemical coughed up $1.7 million to help the Chamber fight tighter security requirements on chemical facilities.

One can only imagine the donations that will be made to the Chamber in the coming years to help cripple social programs that corporations deem anathema to their bottom line. One can only imagine the potential for influencing the election of judges more suitable to the biases of religious and political fringe thinking or that could be influenced by corporate interests when the price is right.

There have been precursors to just such activity.

In 2009, a West Virginia coal company executive spent $3 million to help elect a new justice to the West Virginia Supreme Court. Subsequently, the court threw out a $50 million jury verdict against the executive's coal company, with the newly elected justice casting the deciding vote. The U.S. Supreme Court ultimately narrowly ruled that the West Virginia judge should have recused himself from the case, but justices John Roberts, Samuel Alito, Clarence Thomas, and Antonin Scalia saw no conflict of interest.

While it is true that the torrent of spending by billionaires and super PACs in the 2012 elections did not get them the presidency nor what they wanted in certain congressional districts, there were subtle but effective changes altering the political landscape, changes that were aided and abetted by the Republican Party, which paid off in 2016 with the election of Donald Trump.

As WE HAVE SEEN, along with the tsunami of political money, there also has been a malignant growth eating away at our body politic—the manipulation of ignorance about our form of government and its premise.

The seeds of this know-nothingism, long dormant in the under-educated, ill-informed, and anti-government ideologues, blossomed under the careful nurturing of David and Charles Koch and organizations like Americans for Prosperity and Freedomworks. Both groups sprang from Citizens for a Sound Economy (CES), an organization founded and financed by the Koch brothers in 1984.

The underlying vision was to reshape public support for a government like that which existed in the era of unprecedented, lopsided prosperity in the late 1800s and early 1900s, an era when corporations, Wall Street, and banks were

unregulated, when caveat emptor was the standard, and when the federal government was a spectator. And of course it led to the Great Depression.

A century later, the system had evolved by the late 1990s to pack state legislatures with "Republican" Tea Party acolytes who then gerrymandered political districts to stack Congress with their own brand of Republican conservatism. Thus was the morphing of the Grand Old Party.

The result was an extremist GOP—the party of "No"—whose only legislative goal was to defeat President Barack Obama. The result was a GOP that railed about nonexistent voter fraud to justify measures that reduced minorities' access to the ballot, a GOP that embraced right-wing orthodoxy to nominate Mitt Romney for president in 2012, then went even deeper into the abyss in 2016.

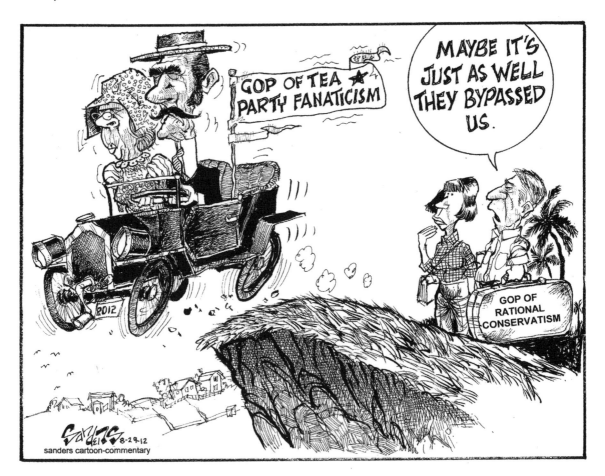

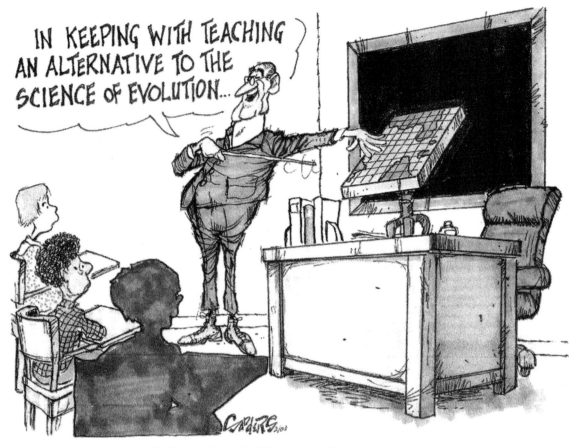

IN KEEPING WITH TEACHING AN ALTERNATIVE TO THE SCIENCE OF EVOLUTION...

Sadly, the Grand Old Party had become populated by true believers who wanted to bestow the legal rights of "personhood" on a 100-cell zygote, who redefined rape, who denied climate science, who clung to discredited economic theories, who deplored separation of (Christian) church and state, who ignored our history of immigration, and the list could go on and on.

IN AN EARLIER TIME, Oscar Wilde presciently observed, "By giving us the opinions of the uneducated, journalism keeps us in touch with the ignorance of the community." More recently, the philosophically stunted guru of the new GOP was radio talk show host Rush Limbaugh, whose success in pandering to a right-wing audience soon led to a host of imitators in broadcast media and on the Internet. The rise of fact-free news coincided with the emergence of the Tea Party.

Any assessment of the direction and quality of our government over the last two or three decades must consider the changing nature and role of our media. Thomas Jefferson famously said, "Were it left to me to decide whether we should have a government without newspapers, or newspapers without government, I should not hesitate a moment to prefer the latter." Less remembered is the Jefferson rant, "The man who reads nothing at all is better educated than the man who reads nothing but newspapers!"

Jefferson's contradictory views lurk in the hearts of most American newspaper readers, even as they celebrate a free press as the foundation of our democracy. However, the significance of newspapers as an information provider has been steadily eroded by radio and television, and now traditional journalism in both print and broadcast has been left in the wake of cable networks and the Internet—the so-called blogosphere, Twitter, Facebook, and other social media.

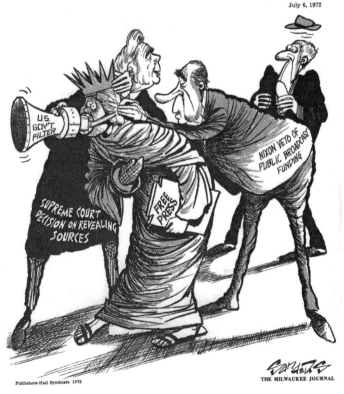

July 6, 1972

'Goodness! We're not trying to stifle her voice! We're just trying to purify it!

The brave new communications world of 24/7 television and the Internet and blogosphere had the potential to peel back layers of ignorance and reveal vistas of knowledge and ideas. Sadly, that potential seems to have been subverted by its countering potential to perform a lobotomy upon the body politic.

Which brings me to Tea Party activists.

They describe themselves as a populist grass roots uprising. They are anti-government, anti-tax, anti-deficit, anti-communist, and anti-socialist—or, in the words of one Tea Partier, "I know something is not right and I want to change it!" In a National Public Radio interview, Tea Party activist Shelby Burnett of Virginia put it this way, "I was unaware of what was going

NEW AMERICAN GOTHIC

sanders cartoon-commentary

on around me until I retired and we started watching Fox News and getting more informed on what was going on in our nation."

That almost says it all!

Thankfully for him, Thomas Jefferson never had to watch the Fox News network. A University of Maryland study found that Fox News viewers were "significantly more likely" to believe false information about current events and issues than were the audiences of other news outlets.

The American cowboy sage Will Rogers, one of the best-known celebrities of the 1920s and 1930s, could have been talking about Tea Partiers when he observed, "It isn't what we don't know that gives us trouble, it's what we know that ain't so."

The 1950s and '60s spawned fringe, know-nothing radicals that rivaled the Sarah Palins, Christine O'Donnells, Sharron Angles, and Rush Limbaughs of today. A key difference was that the earlier crowd's "15 minutes" of fame was mostly localized for lack of 24/7 obsessive coverage by national television. Another key difference was that there was no Internet conduit for bloggers to fill with lies, bogus facts, and bigoted, fanatical opinions—all of which has fed into the discontent of recent years, leading up to the Trump era which was just beginning as I was finishing this book. It has been mind-boggling to watch Tea Partiers and right-wing Republicans elevate ignorance as a desired quality of leadership.

A facilitator of the dumbing-down process—and a Tea Party darling—was former Fox News star Glenn Beck. He appealed to racism and found conspiracies behind cultural artifacts the way swamis read the future from crystal balls at a circus sideshow. Tea Partiers listened raptly as he explained how progressives and liberals have been leading us down the path to a totalitarian government for years.

He also was a serial liar. Beck dramatically claimed he went to the National Archives and held in his hands George Washington's handwritten first inaugu-

ral address. There was only one little problem with that awesome moment. It was a flat-out lie. Beck did get a VIP tour that was arranged by an anonymous congressman. However, a National Archives spokeswoman confirmed that Beck did not touch any historical document. She explained, "Those kinds of treasures are only handled by specially trained archival staff." Confronted with the truth, Mr. Restore-Our-Honor said that the real circumstances would "have been too complicated" to explain.

Beck has since somewhat recanted his role in it, but the danger he and his fellow right-wing bloviators represent is reflected in the response of the collective Tea Party profile, typified by those white, older, angry, conservatives who were so short on racial tolerance and so long on despising President Obama. They are also long on contradictions.

They carried signs that said "Hands off my Medicare!" while protesting "Obamacare" as socialized medicine. They drove over federally financed Interstate highways on their way to rallies to denounce the value of the federal government's use of taxpayers' money. They denied being bigoted racists while carrying signs depicting President Obama as an African with a bone through his nose, declaring "Obama-nomics = monkey see, monkey spend," and

proclaiming "Somewhere in Kenya a village is missing it's [sic] idiot!" Other expressions of their sentiments included: "Impeach Muslim Marxist," "White Pride," "Obama's plan, white slavery," "race mixing is communism," and "White People Are Pissed!"

Of course, Tea Party leaders assured us that those bigoted, sign-carrying folks were just hangers-on and did not represent the majority of their movement. One was left to wonder then why any Tea Partier would stand shoulder to shoulder with such sentiments while smiling for the camera?

A 2010 *New York Times*/CBS poll of self-described Tea Partiers revealed that 57 percent said that too much was being made of the problems facing blacks, 73 percent said social welfare benefits encouraged the poor to stay poor, and 75 percent claimed Obama did not share the values that most Americans live by.

The Center for the Constitution did a national survey titled "The State of the Constitution: What Americans Know." Less than half of Republican respondents agreed that the government is empowered to act for the common good, although that role is one of the central tenets of the Constitution.

In 1849 waves of immigrants from Ireland and Germany washed ashore in the United States. Opponents of immigration, mostly Protestant working-class descendants of English immigrants, whipped up resentment toward Irish and German Catholics by saying they were responsible for increased crime, drunkenness, and poverty. They claimed America would be overrun by people who held different values and who marched to the drumbeat of the Pope in Rome. Protestant working men formed a secret fraternal organization called "The Order of the Star-Spangled Banner." Horace Greeley, founder of the Re-

publican Party and editor of the *New York Tribune*, labeled them the "Know Nothings" because when members were questioned about the organization's activities, they were pledged to reply, " I know nothing."

The fruition of the dumbing-down process has brought us full circle from the historical know-nothings to the present-day know-nothings who occupy a good deal of Congress and have hijacked the Republican Party. Their ultimate goal is to repeal the progressive gains of the twentieth century, along with everything the Obama administration accomplished.

They have placed in power politicians who are eager and willing to decimate the U.S. and global economy. Their platform stands against science, evolution, Social Security, worker's rights, global warming, women's rights, civil rights, voting rights, consumer rights, and environmental protection. That is the government they believe we deserve.

All of which brings me to a line in one of my favorite movies, *Harvey*, starring James Stewart as Elwood P. Dowd. The title character was Dowd's companion, Harvey, a six-foot tall invisible rabbit. When Dowd's older sisters managed to get him a psychiatric evaluation, the doctor asked if he was fearful of reality. Elwood replied, *"Well, I've wrestled with reality for thirty-five years, Doctor, and I'm happy to state I finally won out over it."*

If the "past is prologue," one does not require a crystal ball to be concerned that in this rearview mirror we might have glimpsed the future.

AMID ALL THESE ALARMING trends, critics (and cartoonists) have a role. In some corners, critics are accused of not loving their country—particularly if criticism is in the form of imagery and directed at the president. In times of war, critics are called unpatriotic. However, patriotism does not equal fealty to public sloganeering and chauvinistic hyperbole. Rather, patriotism is a consistent allegiance to the promise of our value system.

I confess to being an idealist when it comes to the nobler aspects of our Constitution and the Bill of Rights. I also believe that our nation fulfills its promise more often than almost any other nation on earth.

Having said that, I believe that we should not be blind to our shortcomings. The age-old debate about the degree to which punishment is a deterrent has an added dimension when it comes to criminal behavior and betrayal of public trust at the highest levels of our government. Unfortunately, accountability

comes on an unlevel playing field: At the bottom of the pecking order, you do time for the crime. At the top of the pecking order, it is a crime if you do time.

The con artist is at heart a common thief who considers himself above the rules of society and has no regard for his victims. The high politico is also a common thief when he considers the values of our democracy as impediments to his own agenda.

Confidence in the integrity of government is central to our faith in democracy. That faith is eroded when those elected or appointed to run our government are unfaithful to its laws and principles. Worse, that faith is rendered meaningless when transgressors are not held accountable.

Too often, we stand by as special and/or moneyed interests and tunnel-vision politicians undermine our constitution and fundamental democratic values. After every scandal and disaster, we have an epiphany and vow not to be taken in again, but like Charlie Brown in *Peanuts*, we never learn. The elected public official (Lucy) tees up the football and says to the voters (Charlie Brown), "*This time you can trust me.*" Good ol' Charlie Brown, confident that Lucy has changed her nature, runs up to kick the football. Of course, Lucy pulls it away at the last moment and Charlie Brown lands flat on his back.

"IT'S A BILL FOR ALL THIS SNAKE OIL YOU'VE BEEN BUYING THE PAST TEN YEARS!"

In the 1970s, we discovered that the Richard Nixon administration was so ethically and morally flawed that Vice President Spiro Agnew had to resign for accepting bribes and forty more officials, including the attorney general and top White House staffers, went to jail for burglary, lying to Congress, obstruction of justice, perjury, conspiracy, and assorted other felonies.

Nixon himself was guilty of serious crimes, but he escaped impeachment and possible prosecution by resigning and then

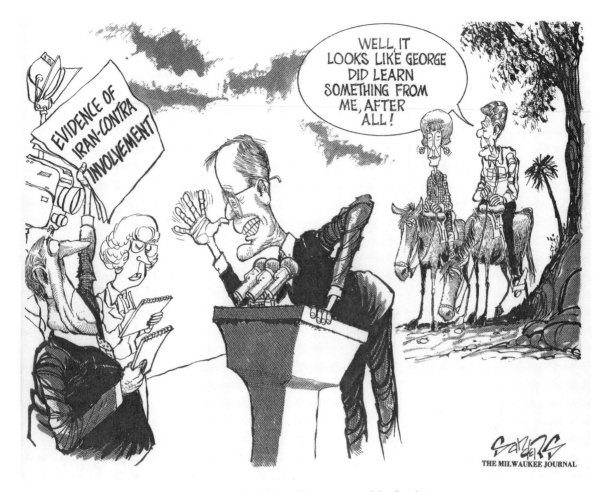

being pardoned. Thus he was never held legally accountable for his gross violation of the public trust.

Did we learn any lessons from Watergate? Apparently not. We subsequently elected an ex-actor as president and in 1985 Ronald Reagan gave us the Iran-Contra criminal conspiracy by secretly selling arms to Iran and diverting the money to support the rightist Nicaraguan Contras and their efforts to overthrow a duly elected but leftist government.

To this day, the general public has only the faintest idea about this trail of rogue behavior at the highest level of our government—and little if any outrage over the resulting events. It is as if the collective "we" do not comprehend what has been done to us. Moreover, we betray ourselves when we do not require equal justice for those charged with administering the laws that govern us.

Editorial cartoonists generally have finely tuned antennae for detecting such contradictions between what politicians say and should do and what they actually do. It is our role to absorb enough outrage on the public's behalf to call out the hypocrites and rogues and try to awaken similar outrage among our readers.

OF COURSE, SOMETIMES WE have a responsibility to criticize even presidents we like. Certainly there is the "spirit" of the law as well as the "letter" of the law—and both should be tempered by compassion and "common sense," but we still need accountability, particularly at the level of the presidency—which brings me to President Barack Obama and the legacy of the George W. Bush administration.

In a nod to transparency, I must confess that I voted for Barack Obama for president, because his political philosophy was closer to my own than was John McCain's. Also, who in his right mind could risk Sarah Palin being a heartbeat away from that office? (At the time, in our innocence, that was the worst we could imagine.)

After eight years of George W. Bush, I thought it would be refreshing to have a president who could use three-syllable words and not chew with his mouth open. Besides, it was about time we had a president whose color did not match that of the White House.

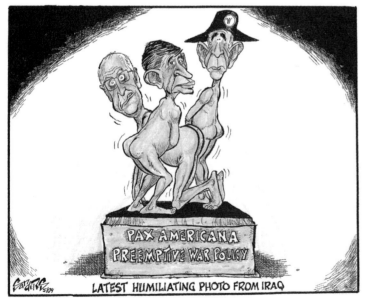

LATEST HUMILIATING PHOTO FROM IRAQ

Generally, I supported President Obama in his efforts to put the nation back on course with a progressive domestic agenda—particularly in health care. However, the "change" that he spoke of so eloquently during his presidential campaign turned out to be limited in the area of the administration of justice. Obama exacerbated a dangerous national trend of ignoring significant acts of wrongdoing by government officials when he said he wanted to "move forward" rather

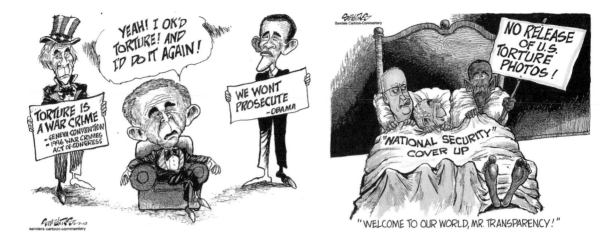

"WELCOME TO OUR WORLD, MR. TRANSPARENCY!"

than "look back" in the matter of prosecuting those who used and allowed torture during the wars in Afghanistan and Iraq.

As a senator, Obama had opposed the invasion of Iraq and was an articulate critic of the Bush administration policies that allowed torture to be used by U.S. soldiers on captured "enemy combatants" at Iraq's Abu Ghraib prison and by the American CIA at secret "rendition" camps in foreign countries.

Obama was rightly perceived as a champion of civil liberties. Early in his presidency, he did attack some key policies of his predecessor. He froze military commissions. He limited the interrogation techniques of the CIA. He banned CIA "black sites" and guaranteed International Red Cross access to detainees. And he and Attorney General Eric Holder agreed that waterboarding is illegal torture. Obama specifically said, *"I do believe that it is torture. I don't think that's just my opinion; that's the opinion of many who've examined the topic. And that's why I put an end to these practices."*

That was all well and good, but what about those who authorized, facilitated, and carried out the abuse and torture of detainees under the Bush "national security" umbrella? Was it right simply to absolve them of responsibility for their actions simply to avoid what admittedly would have been a wrenching public examination of illegal acts committed in the name of the U.S.?

The Geneva Conventions of 1949 say torture is a war crime. The War Crimes Act of 1996, passed by a Republican Congress, makes it a felony to violate the Geneva Conventions. The U.S. Supreme Court ruled in *Hamdan v. Rumsfeld* in 2006 that the Geneva Conventions and the Uniform Code of

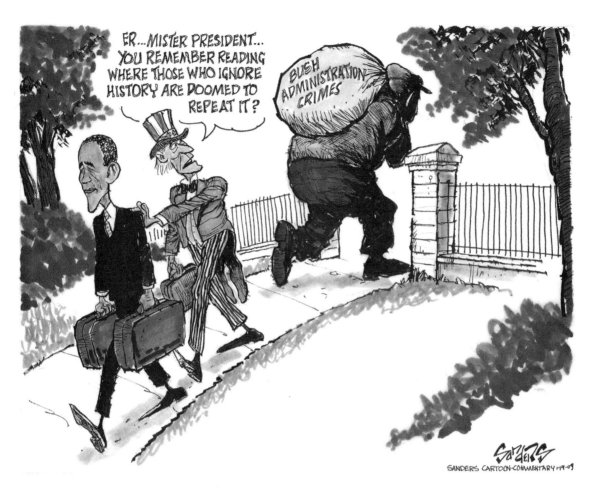

Military Justice—and both describe waterboarding as illegal torture—did apply to the "war on terrorism" detainees.

Yet on June 3, 2010, former president George W. Bush stated to a business audience in Grand Rapids, Michigan, "Yeah, we waterboarded Khalid Sheikh Mohammed." By almost any measure save that of the Bush Justice Department sycophants John Woo and J. S. Bybee—who wrote the controversial secret legal memos justifying waterboarding—Bush's braggadocio was an admission of a war crime.

In his Grand Rapids speech, Bush added, "I'd do it again to save lives," despite the fact that military expert after expert, such as Brigadier General David R. Irvine, a former strategic intelligence officer who taught prisoner of war interrogation and military law for 18 years, asserted that *"it cannot be*

demonstrated that any use of waterboarding by U.S. personnel in recent years has saved a single life."

Describing waterboarding as"unequivocably torture," General Irvine added, "As a nation, we have historically prosecuted it as such, going back to the time of the Spanish-American War."

Meanwhile, President Obama described the decision by the previous administration to sanction such interrogations as a "mistake" rather than a war crime. This was an insult to the legacy of the World War II war crimes trials in Nuremberg and an insult to the legal profession. The Obama administration then became a reluctant participant in a three-year investigation, often raising the old Bush caveat of "national security secrecy" to thwart revelations of torture details and forestall appointment of a special prosecutor.

Finally, Obama made it clear that even those who actually did the torturing should not be prosecuted: *"It is our intention to assure those who carried out their* duties *relying in good faith upon legal advice from the Department of Justice that they will not be subject to prosecution."*

President Obama was moving "forward," yet he was leaving a legacy of not holding accountable those responsible for apparent lawless behaviors and war crimes. If the Constitution has meaning, and if there is such a thing as American exceptionalism, then that legacy is a dangerous, slippery slope.

How slippery remains to be seen, but it is telling that waterboarding returned to the news in 2016 when then-Republican presidential candidate Donald Trump declared he would resume the use of torture. As president-elect, Trump semi-reversed himself on waterboarding after his designee for defense secretary, retired Marine General James Mattis, questioned its usefulness.

In the end, George W. Bush, Dick Cheney, Condoleezza Rice, and Donald Rumsfeld are comfortable in the knowledge that they can go about their business of rewriting history without anyone officially calling them to account for the facts. And that, apparently, will be the only lesson we will have learned.

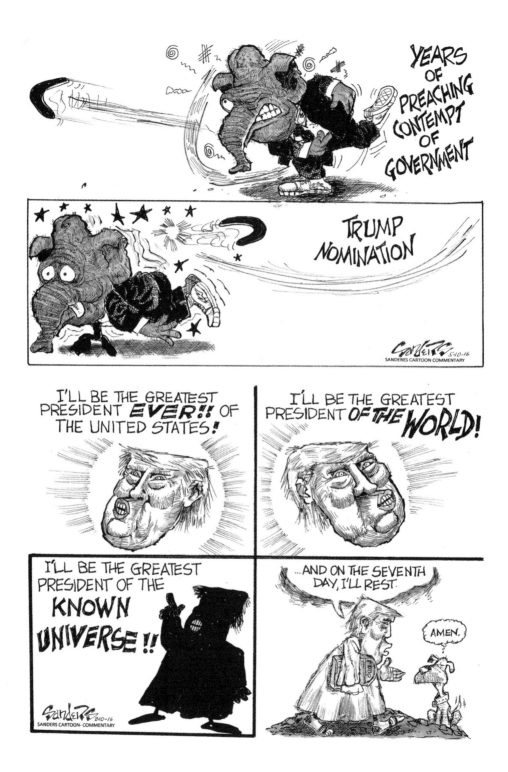

Epilogue

Although this book is also a personal memoir, its primary focus is political cartooning and the events and personalities that I have had the privilege to observe and draw about over the past six decades. In that sense, the book begins with the last year of the Eisenhower administration, and it was finished just a few weeks before the start of the Trump administration (no, I never imagined I would be writing "Trump" and "administration" in the same sentence).

Confucius was dead on the money when he said, "Choose a job you love and you will never have to work a day in your life." Cartooning was the job that allowed me to give expression to my views and opinions on what was going on in the world. It didn't make me rich but it provided a decent living and support for my family, and it continually exposed me to interesting people, important events, and significant ideas.

The process of cartooning—reading, researching and analyzing events— ultimately made me aware of the flaws in my education and motivated me to lobby for their correction. I came to realize, for example, that many of my generation could not pass an accurate test on the historical treatment of the American Indians. What we knew about Indians, we learned from the skewed version taught in our classrooms or from old Wild West movies. Similar deficiencies were inherent in the social studies curriculum: what we were *not* taught about the exploitation of labor, the greed of corporate robber barons, the second-class citizenship of women, and our government's sweetheart agreements with brutal dictators.

My country was presented to me as a place of liberty and justice for all.

We were taught that it deserved such status not only because of our founding fathers' moral imperative, but because God favored us. There were no serious side trips to "Whites Only" restrooms, restaurants, schools and voting booths—and certainly no photos of black bodies hanging from trees at the ends of ropes.

Meaningful reflection about my youthful education only came in slow revelations when I was well into adulthood and gradually discovered that I had been sold a tainted package.

The most damaging aspect of American education is that it has been carefully crafted to be controversy-averse and to avoid the rigors of critical thinking, of asking the annoying question—of questioning, period!

In my era, newspapers and good broadcast journalism were an antidote

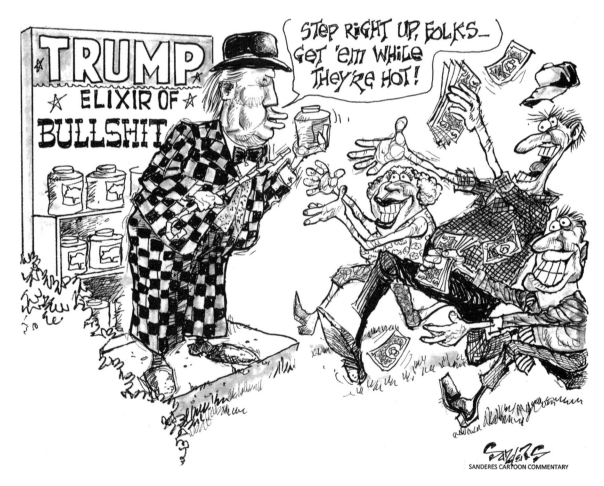

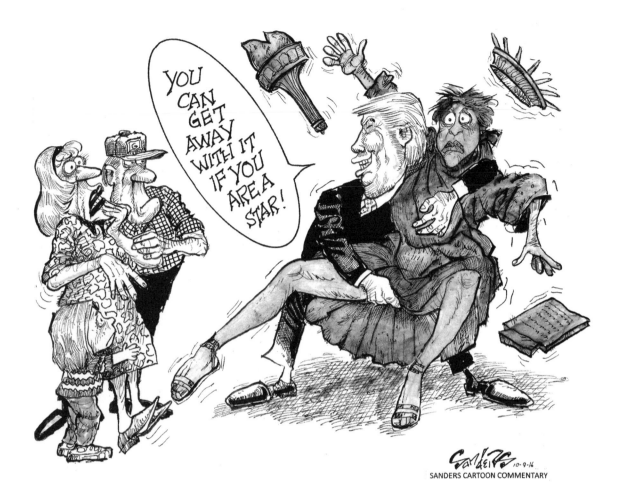

SANDERS CARTOON COMMENTARY

to uncritical thinking. Now, of course, in this age of texting and tweeting, the written word has become the poor stepchild of knowledge. Now we live in a Twitter world, where depth of thought can be measured in 140 characters. The loudest and most persistent buzz is taken as a fountain of gospel, and we collectively think in sound bites and worship at the altar of talking points.

Should we really be surprised that we had a vice presidential nominee who was a journalism graduate but in an interview could not name a single newspaper that she reads?

Donald Trump's campaign brought us full circle—leaving a trail etched in juvenile vocabulary and syntax, embellished with racism and locker-room obscenities, and sprinkled with liberal doses of misogynistic tradition—not to

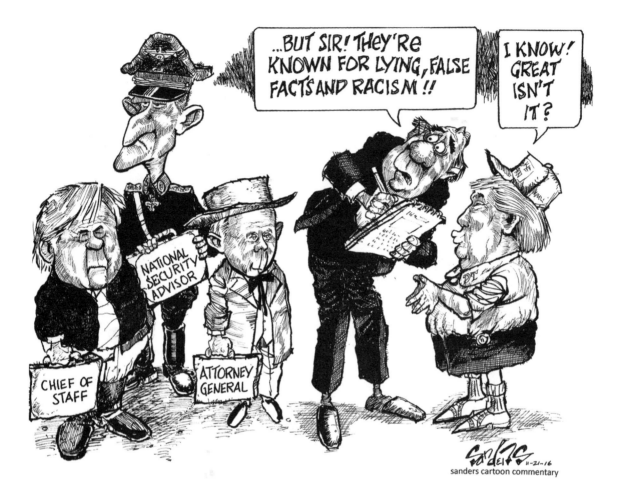

mention serial lies. We now have a president who is hermetically sealed in an impenetrable package of 100 percent narcissism that rejects differing views.

Such are the contradictions and ironies of American political life that editorial cartoonists have fed on since the earliest days of the craft. My job and that of my colleagues in the craft has been to use satire, humor, and outrage to puncture pomposity and expose lies. For more than two hundred years, it has fallen upon us to cry out when the Emperor is naked.

Ironically, what is good for cartoonists is not necessarily good for the country. As we enter the Trump presidency, I shudder at the damage a "fact-free" chief of state with ICD (intellectual curiosity deficit) could do to our country. However, I still strongly believe that we are a resilient people. In that spirit, I

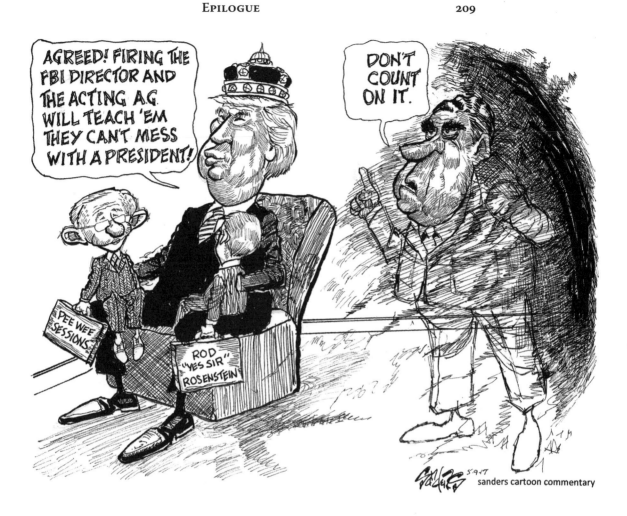

recommend that we collectively take to heart a comment on life's bottom line by the legendary baseball star and street philosopher, Satchel Paige:

"Work like you don't need the money. Love like you've never been hurt. Dance like nobody's watching."

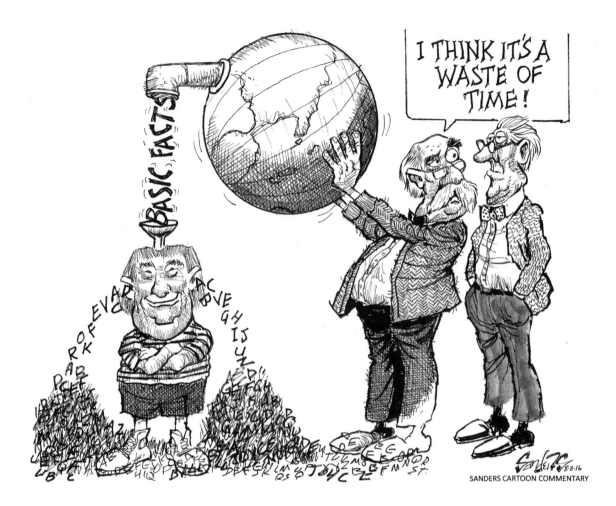

SANDERS CARTOON COMMENTARY

Index